RADICAL JUSTICE: LIFTING EVERY VOICE
ACCRA SHEPP

To Houston

Accra Shepp

FOREWORD BY SALAMISHAH TILLET

CONVOKE

meaningful content x meaningful form

CONVOKE is a collaborative publishing house that provides a foundation for vital conversation by redefining the hegemonic as a space of inclusion. Our projects connect diverse perspectives to encourage provocative exchange through conscious modes of seeing and thinking.

CONVOKE LLC
PO Box 250688
New York, NY 10025
www.convoke.nyc
www.opensea.io/convoke
www.instagram/convoke.nyc

ISBN: 9780999782149

Library of Congress Control Number: 2021946448

Designed by Studio Hi, New York, NY

Printed and bound in Italy by Printer Trento

Accra Shepp's "Radical Justice," is a vision. Clear-eyed and unique, Shepp's photographs are also a powerful record of hope and resiliency, framed by a compassionate eye interested in these times, and in times to come. An uplifting and necessary book.

Hilton Als
Pulitzer Prize-Winning Author and Staff Writer for *The New Yorker*

Brought together here with portraits made in 2020, Accra Shepp's 2011 portraits are revealed to be prophetic in their sensitivity to spatial politics and recognition of a dynamic and emerging social movement. Shepp's visual storytelling—grounded in an intrinsic respect for the individual and demonstrating a nuanced understanding of environmental and historical contexts—is a model for our time.

Makeda Best
Richard L. Menschel Curator of Photography, Harvard University Art Museums

One of the things that good portraits have the capacity to do is to reveal the human community to itself, creating a momentary sense of intimacy and familiarity between strangers. Accra Shepp's engaging portraits do this. Photographing at a moment of profound social upheaval, he brings us visually into a conversation with our fellow citizens. This is important and timely work.

Dawoud Bey
Photographer and MacArthur Fellow

Accra Shepp is a powerful artist— a funkmaster of human portraits who keeps it real shot through with rich technique and deep love.

Cornel West
Professor, Philosopher, Author, and Activist

RADICAL JUSTICE: LIFTING EVERY VOICE
ACCRA SHEPP

ONE BIG SWARM OF PEOPLE
By SALAMISHAH TILLET

"Alright, you 90,000 redeemers, rebels and radicals out there." So opened the inaugural call for Occupy Wall Street. Linked in a tweet that *Adbusters*, the Vancouver-based, anti-consumerist magazine and activist collective, posted on June 9, 2011, their charge went on: "The time has come to deploy this emerging stratagem against the greatest corrupter of our democracy: Wall Street, the financial Gomorrah of America."

Inspired by the Arab Spring; protests in Egypt's Tahrir Square; and 15-M, the mostly youth-led anti-austerity movement that erupted in Spanish cities in 2011 (including an outpouring of twenty-eight thousand protesters in Madrid's Puerta del Sol square, in 2011), the idea was for twenty thousand people to flood Lower Manhattan and occupy Wall Street for several months. "Once there," the text read, "we shall incessantly repeat one simple demand in a plurality of voices."

In a few short weeks, the forty who came on September 17 turned into four thousand, and what started as a message online turned into a movement. The demands originally aired at New York City's Zuccotti Park were echoed in demonstrations in London, Lima, Johannesburg, and Jakarta—all over the world.

Although I never made it to Wall Street, I joined protesters in Philadelphia, where I worked and had become a college activist a decade earlier. In those midday sessions at Thomas Paine Plaza next to City Hall, I was often struck by the breadth of our backgrounds—old and young, working-class and white-collar—as well as our racial and ethnic diversity. The mainstream media soon insisted on depicting Occupy as a mainly white and mostly male movement. But what I, an African American woman, saw with my own eyes contradicted such narratives. Instead of depending on a single leader or singular voice, we had, in many ways, embodied one of the ideas that inspired the original *Adbusters*'s message, a quote by 15-M activist Raimundo Viejo. Describing the non-hierarchical nature of their organizing in Spain, Viejo realized, "Now the model has evolved. Today we are one big swarm of people."

Ten years ago, when Accra Shepp went looking for such a swarm, he found himself at Zuccotti Park "under a patch of trees, surrounded by enormous skyscrapers on all sides." Initially, without his camera, he just observed, listened, and felt the pulse of the people. Many of them were camping out there indefinitely; others came briefly, on a lunch break or after work, to declare their solidarity to this cause.

When Shepp next returned, he knew the events unfolding before him were real, and thus worth documenting. A private park had become a testing ground for buzzing economic justice. So he used a view camera, typically used for large-format images, to make portraits of the protesters and to capture this history.

Appearing together in *Radical Justice*, these people represent the many citizens that made Occupy possible. In turn, Shepp's black-and-white photographs dissolve the boundaries between the individual and the collective, reminding us that each person who was present (even the police officers, the newscasters, and anti-Occupiers) was a fundamental player in this revolutionary movement.

Ten years later, as we strive to overcome the ongoing repercussions of the Trump presidency, the COVID-19 pandemic, and the brutal reality of climate change, we continue to confront the severe economic inequality that inspired Occupy Wall Street in the first place.

But we are also living out the power of their early call to action. Our two paramount social-justice movements, Black Lives Matter and #MeToo, continue to engage the horizontal structure (they have founders, but no one leader) and the political strategy (a blend of social media and old-school organizing) that they, in part, inherited from Occupy a few years earlier.

Similarly, the presidential bids of Senators Elizabeth Warren and Bernie Sanders in 2020, as well as the rise of the progressive Left within and outside of the Democratic party, are impossible to imagine without those two long months of organizing in Zuccotti Park.

There aren't many artistic renderings of Occupy. Anarchist Marisa Holmes's 2016 documentary *All Day All Week: An Occupy Wall Street Story* is a notable exception. As a result, we are often left with little more than anecdotes of how diverse and varied the demographic make-up of the movement was.

Radical Justice documents that history and reminds us that activists who have held our country accountable then are not so dissimilar from those who took to the streets in the summer of 2020. In doing so, Shepp's photographs channel the spirit of Occupy, and its biggest hope as expressed in that original email from *Adbusters* in 2011: to "[awaken] the imagination and, if achieved, propel us toward the radical democracy of the future."

THE REVOLUTION WON'T BE TELEVISED
By ACCRA SHEPP

Of Chance and Obligation

I consider myself an accidental documentarian. It was never my intent to chronicle social movements. As an artist, as a photographer, there is an implicit responsibility to see, a responsibility to examine, and make visible those things that might go unnoticed or unnoted. Historically, exercise of this responsibility has left us a rich record of human activity and information about the world around us. This obligation arises from the way images speak to us about our history, tell us who we are, and eventually become the fabric of the culture they describe. August Sander, who sought to make a record of the German people at the dawn of the twentieth century, is but one example. Others include the seminal work of Chauncey Hare, Wendy Ewald, and Zanele Muholi.

Ten years ago, in the fall of 2011, there were vague reports in the press of a protest downtown. Something unusual was happening on Wall Street, but the news was maddeningly short on detail. I had to see for myself what was happening. I had no idea where it was, and the area known as "Wall Street" stretches the entire width of Manhattan and runs about a half mile north to south. I reasoned that if this protest were significant, I would be able to find it. I took the subway to Wall Street and as I exited the station, I listened. I followed the faint sound that came increasingly into focus until I arrived at a little patch of trees surrounded by enormous skyscrapers on all sides, called Zuccotti Park.

I hadn't brought my camera with me, as I was there only to observe and learn. Inside the park, I witnessed a level of civic engagement I'd never seen before. Its directness and honesty were almost electric. At dusk, I experienced for the first time the "People's Mic," more commonly referred to now as a "Mic Check!" In the absence of electricity and microphones and speakers, the demonstration used call-and-response in place of amplification. The speaker would say a short phrase and the crowd closest to the speaker would repeat it in unison, with no small amount of gusto. Then, those a little further away would recite the phrase and so on, until the last band of people had heard the precise words. After this wave-like echo had washed over the last member of the audience, the speaker would continue, and the process would repeat itself.

That night of September 29, the speaker was none other than Joseph Stiglitz, the Nobel Prize–winning economist. He had come down to Zuccotti Park from Columbia University, where he teaches, to share his insights and lend his support. Although I did not know it was Stiglitz until sometime later, it was at that moment that I resolved to return with my camera the following day. Someone had to record what was happening. I've never been very good at predicting the future and I couldn't know for certain that this protest would be historically significant, but it felt like it might.

Talking Out Loud

The Right to Free Assembly is inscribed in Article I of the Bill of Rights. In 2011, in Zuccotti Park, I realized that I'd never understood its significance. I liked to be around people and yes, it would be terrible if you couldn't be near your friends. But that's as much as I truly understood. In a world where we live surrounded by phones, emails, texts, and videos, how much of a sweat could I build up over a meeting in person over coffee?

In Zuccotti Park that afternoon, I witnessed a conversation between a banker from one of the office buildings surrounding the park, and a protester. They weren't angry; they were just talking. The banker had seen the protesters for some time from above, through his office window, and wanted to know what it was all about. He had come down after work to find out. The two people were having a conversation, a conversation about America. Similar discussions were happening everywhere, and not about the weather or traffic or sports teams. People were talking about the shape of government, what it should do, what it should not do, what it *must* do.

In this modern-day agora, new ideas were minted. The words "income" and "inequality" were suddenly joined with such force that its collective meaning shattered the world of politics and business. Nevermore could a CEO or politician think that corporate excess would go unnoticed or might avoid public condemnation. The mathematical concept of 99%, which up until 2011 had been mostly known as part of an advertising campaign for soap, was now paired with a definite article —"the"— to a devastating effect. This simple declaration shifted the entire world. It gave us a new way to articulate what we'd been feeling for a very long time.

When people would come up to me later and ask dismissively, "What did 'Occupy' accomplish? What did it do?" I would point out that in a matter of a few weeks it changed how we thought. Without the aid of television commercials, billboards, focus groups, robocalls, or influencers, it changed the world.

And yet, because it didn't look the way people thought a protest should look, it was confusing to many. The press would arrive and ask to speak with the person in charge, only to find no one. Occupy famously had a horizontal structure, with no one person above another. In lay terms, this meant that if someone—anyone, myself included—showed up regularly and took an interest in some part of the protest, they would find themselves with other, like-minded people. And without any sort of formal contract, they would help make important decisions about how the protest should move forward.

page 56 There were certainly those whose voices spoke so clearly and convincingly that the press would find them. But the concepts that Occupy traded in were not reducible to soundbites, the lingua franca of modern news networks. Consider, for example, the young woman in a peasant skirt embroidered with a peace sign. On her sweater she wore a sticker calling for a ban on fracking. The public and the press would openly wonder, What does extracting natural gas from the ground, by forcing water and chemicals at high pressure into the earth, have to do with income inequality or the 99%?

The answer, of course, relates to the systematic impoverishment of farmers in rural areas. In parts of upstate New York and rural Pennsylvania and Ohio, farmers could no longer make a living. This was not because of bad luck or weather but, among other reasons, the result of a corporate tax structure tilted in favor of the wealthy and those whose earnings come from investment and not labor. It was a system in which the land on which the farms were located became more valuable than the ability of that land to feed its community. Into this unbalanced situation strolled the petrochemical industry, promising easy money to extract gas from that very ground. There were a few "minor" problems: the groundwater was made toxic, and in some areas, fracking caused earthquakes (yes, earthquakes). But the farmers, who were desperate, did not know this and were not in a position to find out. They needed money.

This was clearly a story of the 99% and economic inequality, but it is a large idea, too large for a soundbite and the forty-one seconds of the average television news segment. The major media networks' response was to not report the story. Certainly, Occupy Wall Street was in the news now and then. However, there was no sustained coverage seeking to establish a narrative that could articulate what was happening in New York and around the world, or why it was happening in 2011.

Rights and Wrongs

When I arrived at Zuccotti Park, where the protest began, I thought I would photograph for only a few days, maybe a week, until the heavy-weight photojournalists from around the world arrived. Then I would no longer be needed. But they never came. Instead, the first news outlet that I noticed was MTV. The journalist was filing a report about all the "hot, young, single guys" at Zuccotti Park. I was stunned. I kept thinking I would find a stringer for the *Wall Street Journal* or the *New York Times*, camped out in the park. But their presence page 79
page 43 was undetectable to me. I ran into a writer of note doing a piece for *Rolling Stone*. Another member of the press was there from a local news affiliate. The story that day was literally about the wooden shipping pallets on which people were pitching tents. I'm laughing as I write this, but it's not funny.

I learned that the right to Free Assembly is fragile and too easily trampled. Mayor Bloomberg wanted to shut down the protest, but his hands were tied by the United States Constitution. However, there are specific loopholes that serve to limit even the most important rights. One of them is health. The city was apparently concerned about sanitation and health in the park, and it was this concern that trumped the Freedom of Assembly.

The evening of November 14, 2011, I was riding a train back from New Jersey, where I was teaching. I received a text saying that everyone should come to Zuccotti Park and protest the clearing of the demonstration by the police.

I should note that I used a view camera to document Occupy. This is an early version of the camera, from the nineteenth-century, that sits atop a tripod and has an accordion bellows. Mine is made of wood and dates to the 1930s. My use of this camera does not constitute a rejection of modern technology (of which I am generally a fan); I used it because it was the best tool to accomplish my goals. The view camera economically provides an image ranging up to gigabytes in resolution. This great size permitted me to see as clearly as I felt was necessary. Because of the camera design, I would spend a great deal of time under a dark cloth, framing and focusing. It isn't possible for me to use this camera at night without the aid of powerful artificial lights, which I did not own at the time. I also anticipated a chaotic evening, not suited to this kind of picture making. I resolved to go to Zuccotti Park the following morning, on November 15.

The next morning, a mass of protesters was swirling around police barricades set up around the park, which was now empty except for the sizable number of police patrolling within its confines. The crowd was so thick I had to press through people, pushing them out of my way to move in any direction. I was down to my last two exposures when I spotted a beleaguered-looking man on the corner of Broadway and Liberty. He was an official observer, one of the volunteer lawyers associated with the National Lawyers Guild.[1] His presence, and that of his colleagues, served to safeguard the protesters. In the case of an arrest or other legal action against a protester, their testimony would be unimpeachable. There were so many people around us that I had no hope of standing far away enough to photograph him full figure, as I

[1] The National Lawyers Guild was established in 1937 by progressive lawyers. Among their first acts was the organization of the United Auto Workers Union and the support of Roosevelt's New Deal legislation. The better known (and historically conservative) American Bar Association was firmly opposed to the New Deal. See: Ralph Shapiro, "The National Lawyers Guild and the Labor Movement," *Guild Practitioner* 64, no. 180 (2007): 180; Rachel F. Moran, "The Three Ages of Modern American Lawyering and the Current Crisis in the Legal Professions and Legal Education," *Santa Clara Law Review* 58, no. 3 (April 2019): 453; Jules Lobel, "Transformational Movements: The National Lawyers Guild and Radical Legal Service," *National Law Guild Review* 193, no. 4.

intended. I managed to create a distance of a foot or two, and got his attention long enough for him to look into my lens.

As I was packing up, I looked across Broadway. There, next to the formidable private bank Brown Brothers Harriman was a phalanx of riot police, in full Kevlar, holding clear plastic shields in front of their helmeted heads. In my memory, there were at least 150 of them, if not more. They stood just out of view on Liberty Street, in the shadow of the bank. Coming towards them, marching down Broadway, was an enormous group of protesters—hundreds, maybe even a thousand—ready to join the hundreds already circling the park. I knew it was important to leave quickly. My job was to see, which meant getting home safely to process my film. Any further excitement would be for someone else to witness.

The Reports of Occupy's Death Are Greatly Exaggerated

As it turned out, there was no more excitement that day. The real event had occurred the evening before. In conversation with protesters, I heard different versions of the same story. The police had arrived in force. Helicopters had circled low over the park, shining spotlights on the scene, lighting it up bright as day. Reporters had also received text messages about the action and descended upon the park. However, before anything happened, the police stationed them several blocks away, hemmed in by barricades on all sides. They could see nothing and could only report what law enforcement told them.

Meanwhile, back at the park, the police were dragging protesters out of their tents. Those who fought back were beaten with police clubs. There was blood and mayhem. When the police were certain that no more protesters remained, Department of Sanitation trucks, fitted with snowplows normally reserved for winter, rolled through the park. Protesters told me about lost personal items, laptops, cameras—everything. The police bulldozed the tents as well as public areas like the People's Kitchen, which had been stocked with donated food and equipment from all over the country.

Also lost that night was the People's Library, which was written about widely.[2] According to *The Nation*, it held over five thousand volumes and was maintained by professional librarians. The mayor had the park scraped, and erected metal barricades around it to prevent anyone from re-entering. The destruction of the library alone caused an outcry from famous writers, such as Salman Rushdie, to staid institutions like the American Library Association. A donor

[2] William Scott, "The People's Library of Occupy Wall Street Lives On," *The Nation*, November 22, 2011; Karen McVeigh, "Destruction of Occupy Wall Street 'People's Library' draws ire," *The Guardian*, November 23, 2011.

page 112 to the library, a bookstore owner from Pennsylvania, told me about the books he had brought from his store, which were now lost.

To many, this is where Occupy Wall Street ended. It certainly ended for the press. However, the protest continued and even expanded. Evicted from Zuccotti Park, the protesters congregated in other parts of the city to denounce specific forms of economic inequality. On December 6, the protest took place in East New York, Brooklyn, standing up against evictions page 129 and for housing rights. A former Navy translator had traveled from Virginia to join the protest and make his voice heard.

On another day, events unfolded in Duarte Square, a small triangular wedge paved with bricks, on Sixth Avenue between Chinatown and SoHo. The focus that day was on finding the protest a new home. The owner of the little triangle is Trinity Church. Although its congregation is minuscule, its real-estate portfolio is valued in the billions of dollars. Its governing board, the vestry, is dominated by money managers who saw nothing good in supporting the 99% nor in their efforts to be heard. There that day was the noted radical page 121 lawyer William Schaap with his wife Ellen and their dog Bambu.[3]

The protest persevered through the winter, finding new strength in the spring, with its return to the steps of Federal Hall in Lower Manhattan.[4] On May Day, May 1, a crowd larger than I had ever seen in New York amassed in Union Square. And when that enormous expanse was filled, even more people arrived. I saw columns of protesters, each appearing to be at least one thousand strong, if not more, arriving on the side streets around the Square. After speeches were delivered, the crowd began to march down Broadway toward Battery Park. The marchers filled the breadth of both street and sidewalks, stretching over three miles from Union Square in the north to the Battery in the south.

In the days that followed, I scoured the newspapers for estimates of the crowd. However, not one major news outlet covered the event. It was as if it had never happened. I found one lone mention in the *Huffington Post*, taking New York's dailies to task for underreporting the event. The power and strength of that moment did not fit the established narrative, namely, that Occupy Wall Street was over. Wikipedia offers the broad estimate of fifty to a hundred thousand participants that day.[5]

[3] "William H. Schaap, 75, Radical Lawyer and Critic of C.I.A.," *New York Times*, March 6, 2016, Page A26.

[4] Federal Hall was the first seat of the United States Congress and it is located across the street from the New York Stock Exchange.

[5] Wikipedia, s.v. "Occupy Wall Street," accessed October 15, 2021, https://en.wikipedia.org/wiki/Occupy_Wall_Street.

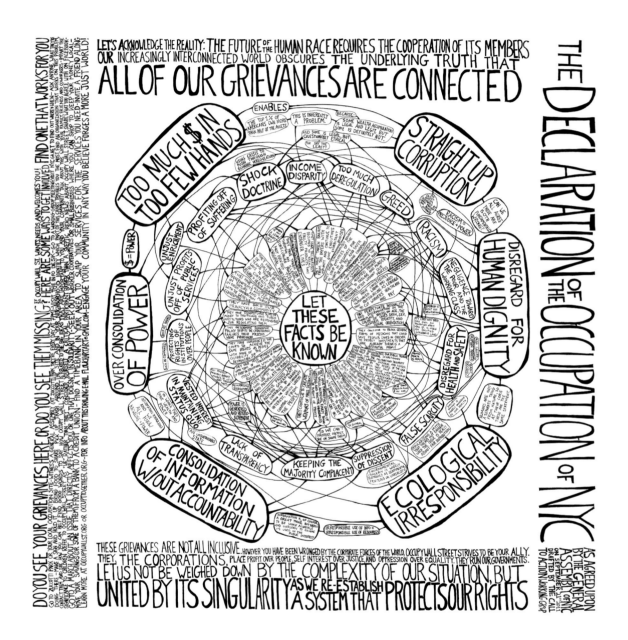

The Flowchart of the Declaration of the Occupation of NYC, 2011

Rachel Schragis with the Call To Action Working Group and members of the NYC General Assembly of Occupy Wall Street

Week after week I followed the protest. The first anniversary, in September 2012, was an enormous three-day event. Shortly after, in October, Hurricane Sandy devastated New York City. The protesters turned their efforts from denouncing economic inequality toward providing disaster relief. The movement was known as Occupy Sandy. It distributed, food, clothes, and blankets, and helped with reconstruction of damaged properties. When much of that work was done, after about a year, the protesters returned to their homes all over the United States.

Everywhere they went, these alumni of Occupy took their experiences with them and began to energize progressive movements around the country. They brought broadband Internet to poor communities in rural and urban areas. They became part of progressive political organizations. They campaigned for marriage equality and prison reform. They helped spread the word that Black Lives Matter. Occupy not only changed how we talk and how we think, but it also began to change how we live.[6]

2020–The Year of Seeing Clearly

On June 9, 2020, I posted three images on Instagram with the following description:

> Two weeks ago, when we learned of the murder of George Floyd our already too-full hearts overflowed into the streets. In spite of the contagion, in spite of the pandemic, people raised their voices to say, "No more."

May 25, 2020, two weeks before I posted, had been a moment of national exhaustion. New York City had just awoken from a month-long lockdown begun in mid-April. During that time, New Yorkers everywhere awoke and went to sleep to the sound of ambulance sirens bringing our family and neighbors to hospitals already filled to capacity. By May, we were searching desperately for masks, gloves, and hand sanitizer—the new, required elements for life out-of-doors.

And from just beyond the periphery of our attention, it came, like the sound of someone fast approaching you from behind. Breonna Taylor: March 13, shot by police while she slept.

[6] Accra Shepp, "Occupy Wall Street: Where Are They Now," *New York Times: The Sunday Review*, September 18, 2016, 6–7; Josh Harkinson, "Occupy Wall Street—Where Are They Now," *Mother Jones*, September 17, 2012, https://www.motherjones.com/politics/2012/09/occupy-wall-street-anniversary-where-are-they-now/; Michael Levitin, "The Triumph of Occupy Wall Street," *The Atlantic*, June 2015, https://www.theatlantic.com/politics/archive/2015/06/the-triumph-of-occupy-wall-street/395408/; Michael Levitin, "Occupy Wall Street Did More Than You Think," *The Atlantic*, September 2021, https://www.theatlantic.com/ideas/archive/2021/09/how-occupy-wall-street-reshaped-america/620064/.

Ahmaud Arbery: on April 26 we learned of the very late-breaking news of his savage murder, committed weeks earlier in February. And the final footfall that caught us all off-guard came on May 25, Memorial Day: George Floyd.

We couldn't breathe, for so many reasons—for fear of contagion, from the confusion brought on by social isolation, and out of the callous and casual nature of the violence we witnessed and re-witnessed in the video of George Floyd's murder, over and over again. The response was not thought out, it was a gut reaction. People donned masks and went into the street demanding justice. Justice for George, for Breonna, for Ahmaud, for Tamir, for Sandra, and on and on.

I had begun my project "The Covid Journals" nearly two months before. I was documenting the shape of the pandemic in New York City, my hometown. After days of confusion and reflection in the wake of George Floyd's killing, I realized that this, too, was part of the narrative of the pandemic. I realized that this movement also arose from an extraordinary set of shared experiences.

So many of us, of all races, were at home. And in this makeshift quarantine, many of us suddenly became aware of how dependent we were on others, others we may have barely noticed before. We were suddenly not the captains of our own ships, but a community. We shared isolation, grief, concern. And after May 25, we shared outrage. And for the first time in my memory, everyone—Black, white, Latino, Asian, indigenous, gay, trans—everyone came together as a community to say, "No." No to police violence, no to racism, no to every "norm" that supported the underlying laws and social structures that permitted and supported this type of behavior. No more.

Contained within this wave that surged towards justice was an accounting of white privilege. White people began to openly critique the unequal system from which they have benefited. I use the verb "began" pointedly, as it remains to be seen what becomes of that initial spasm of honesty. White privilege, in its most common form, is subtle. Most white Americans, especially those of the 99%, cannot see it directly. It is a privilege that does not confer benefit, but instead one that withholds consequence.

White privilege means that a teenager gets a warning for smoking pot, instead of jail time. White privilege means that a man taking an evening stroll is not considered dangerous or threatening, or singled out for questioning or detention. It means that someone browsing in a store is not shoplifting. It means that a person standing on the corner, whether waiting for a friend or just taking the air, is not soliciting, or causing trouble.

White privilege is the shadow cast by racial discrimination. And as a shadow it is an absence rather than a presence, and difficult to grasp. How do you hold up and show a thing to the light of day when that very act causes it to become invisible?

page 208 It is no accident that in the final chapter of this book the images of whites and Blacks stand in apposition, not opposition. Apposition is the state of standing apart, but not necessarily in conflict. The young woman whose mask reads, "HUMAN" stands alongside a pale man whose T-shirt states, "BLACK LIVES MATTER." I see the directness and clarity of her gaze, and know her mind. The subtle tilt of the man's head is slightly ambiguous. Could it be questioning? There is no doubt about his beliefs, but rather questions arising from how a white man might fulfill the implicit demand of the woman. Every pairing proposes different questions. There are the two young men, white and Black respectively, protesting on pages 212 and 213. And what of the Black man and white woman on pages 220 and 221? Each of these groups frames the question from a different angle, highlighting challenges to how we have all been conditioned to understand these relationships.

On Empathy and Being Human

Throughout this work, I was guided by my interest in people, wanting to know who they were and how they found themselves protesting in public, and consequently, in front of my lens. Their motivation has empathy at its core. Too many confuse this term with its close relative, sympathy. While sympathy allows us to recognize others' feelings, empathy calls up within ourselves those same emotions and binds us directly to the other.

There is deep irony in the fact that a lack of empathy is the very thing that caused the injuries being protested in the pages of this book. In addition to being a poorly understood concept, it is not terribly popular in American culture. Social-media influencers have no use for empathy, nor do advertisers. It won't make you thin or rich, or help you sleep.

The traces of empathy's absence form a long trail in American history. The economic crash of 2008 that precipitated Occupy Wall Street was a consequence of this missing empathy. The crash of 2008 required that the bankers, who underwrote mortgages, treat people in need of homes not as individuals, or as mothers or fathers or sons or daughters. Instead, they were considered nothing more than bits in a digital spreadsheet, part of a system of dehumanized financial instruments that supported no one but the bankers themselves, as not even investors benefited from these transactions.

The trail leads on. The murders that set off the protests in the summer of 2020 could only happen because the victims were perceived as somehow less-than, seen as different and not deserving of compassion or charity, by those who killed them.

The protesters called out for change. The empathy that drove them into the streets was the call, and this call demanded a response. And the police responded. During Occupy Wall Street, they responded with violence and hostility. Again, during the protests of 2020, the response from police was the same: a lack of compassion and an absence of understanding.

How do you train the police—and the legislators and judges and mayors and governors who give the police their authority? How do you train them all to see the world with new eyes, to recognize that humanity is a trait shared by everyone? How do we move towards seeing each other as we see ourselves? Clearly, there are no easy answers. And though I have only photographs to offer as we seek resolution, a photograph can show, at least in part, who we are. And so, perhaps, these images are a place to start.

I

shit...

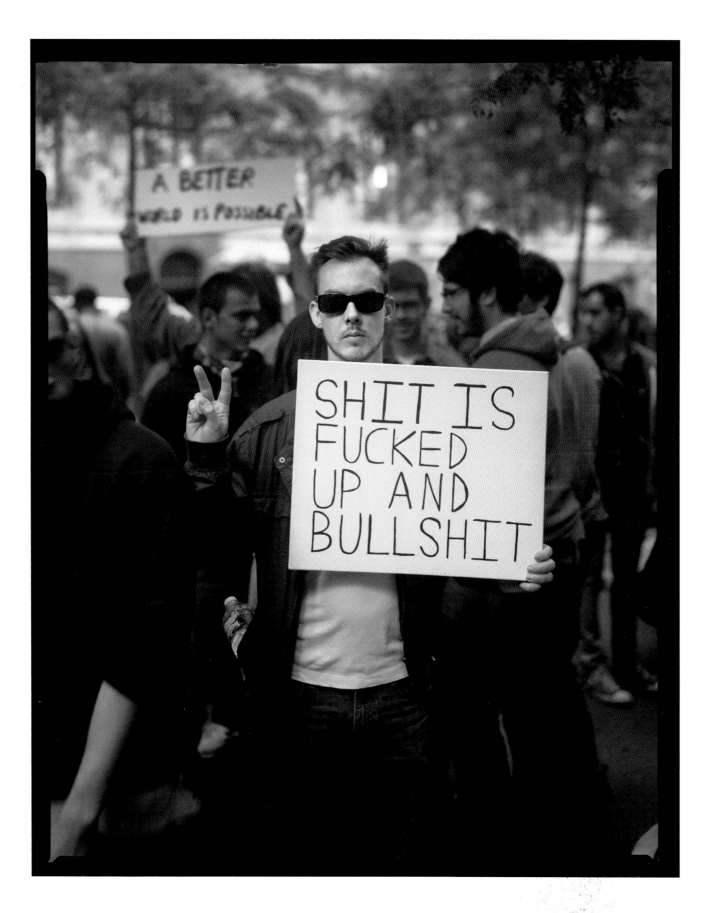

Mickey, day 14 of the protest, waiting to march over the Brooklyn Bridge, October 1, 2011

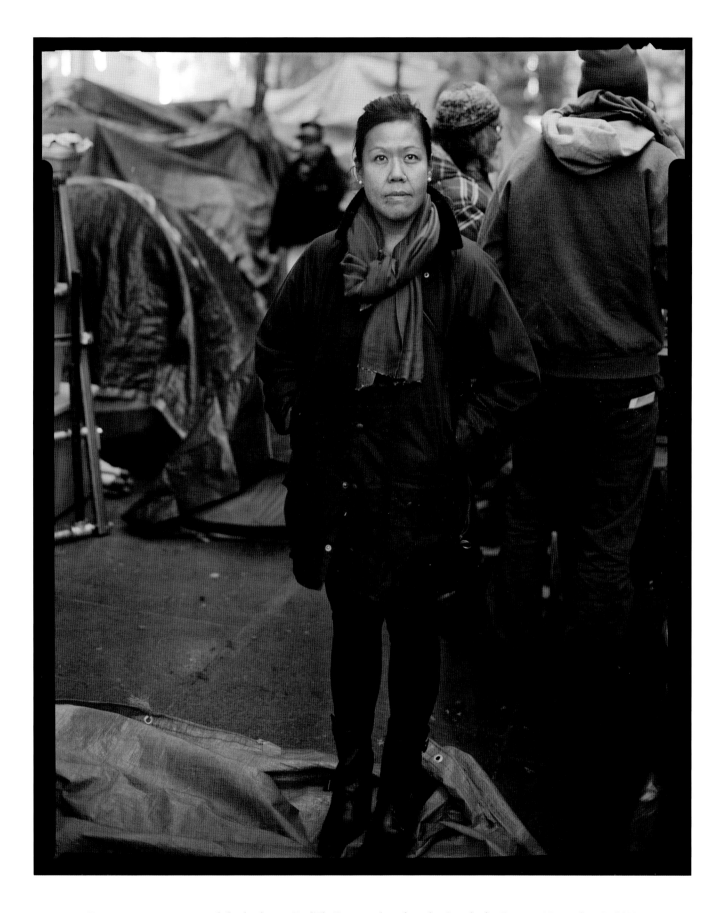

Winnie Wong, creator of the hashtag #FeelTheBern and co-founder People for Bernie, November 5, 2011

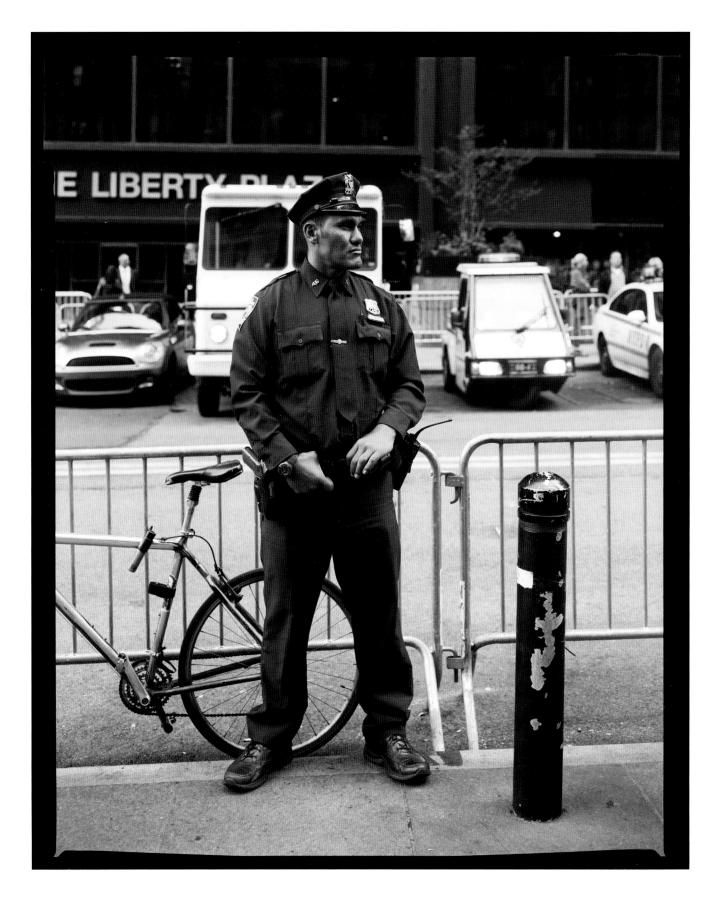

Officer Reyes, 46th Precinct The Bronx, October 21, 2011

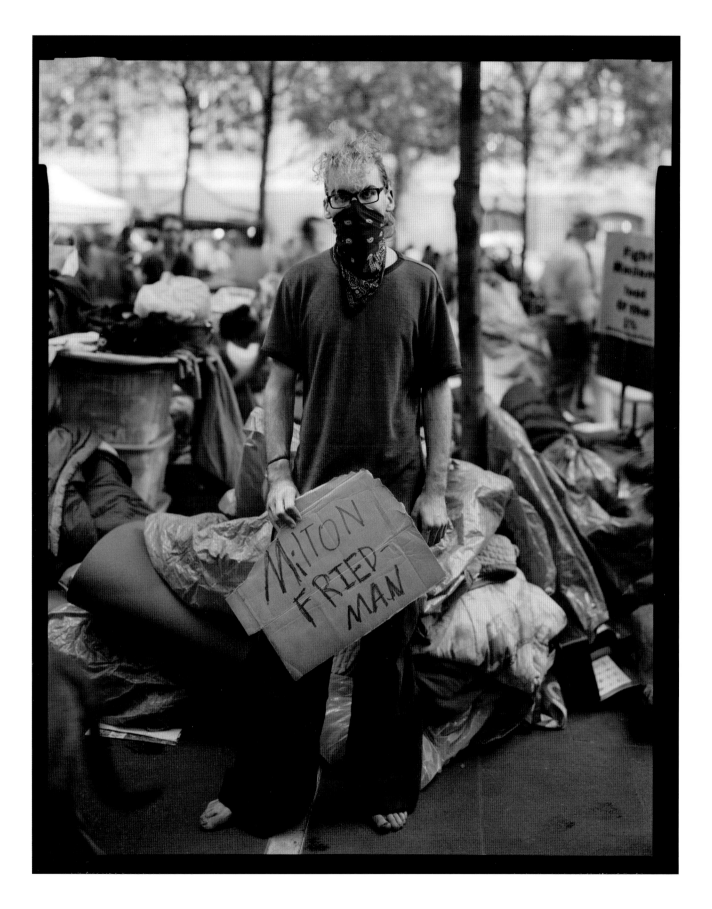

Barefoot protester from Michigan, October 11, 2011

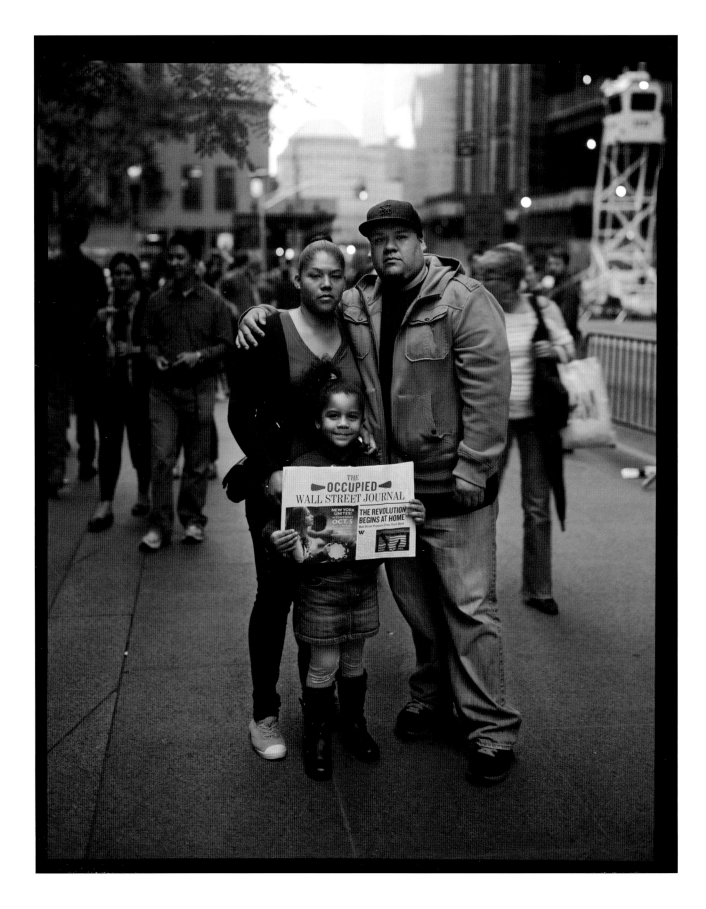

A family displaying the first edition of the *Occupied Wall Street Journal*, October 1, 2011

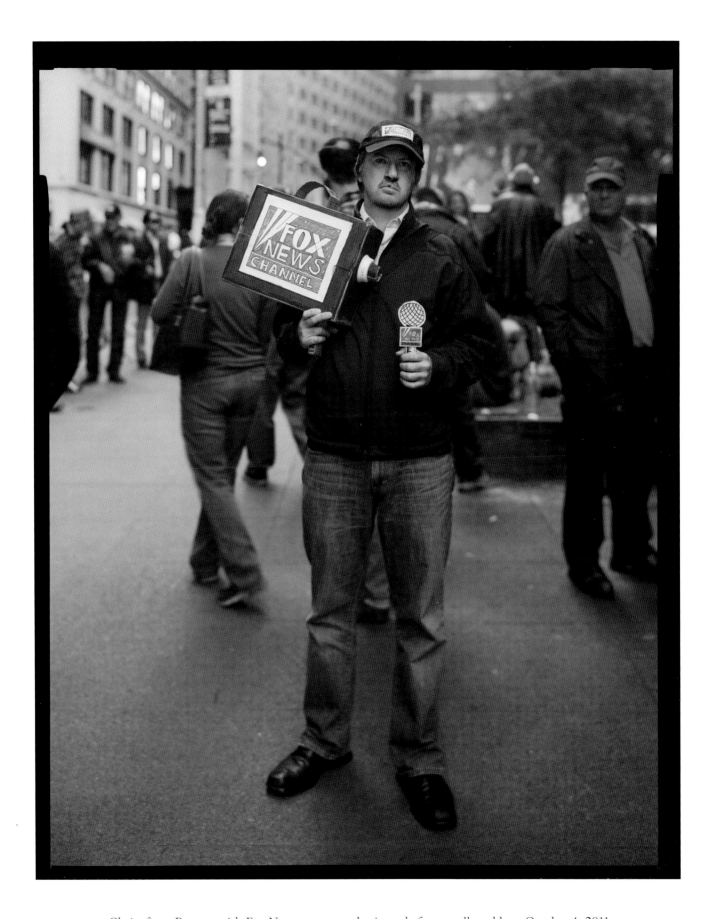

Chris, from Boston, with Fox News camera and mic made from cardboard box, October 4, 2011

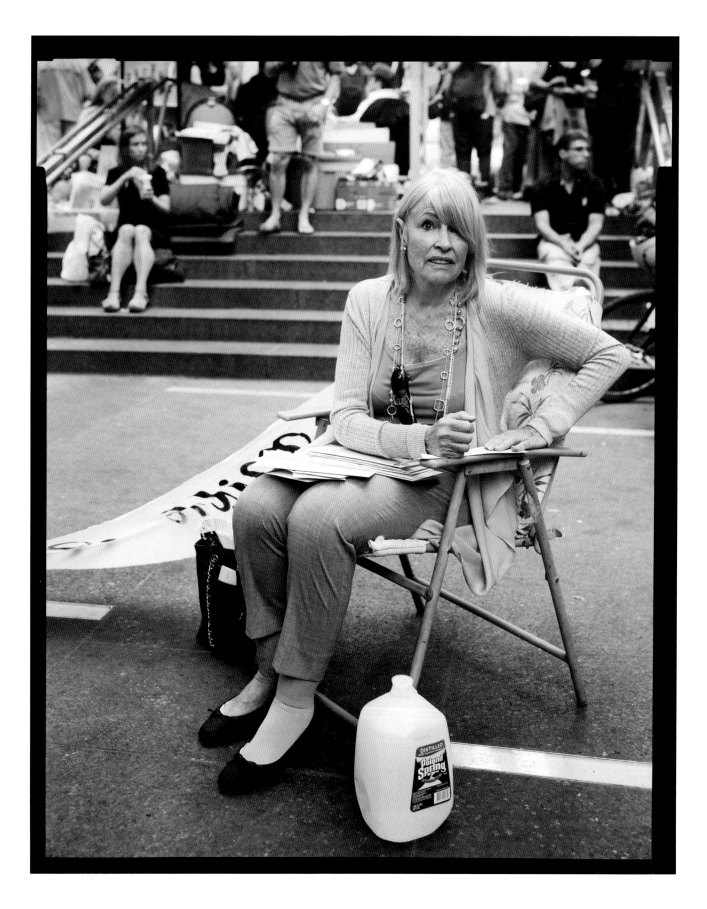

Woman addressing envelopes on a lawn chair, October 11, 2011

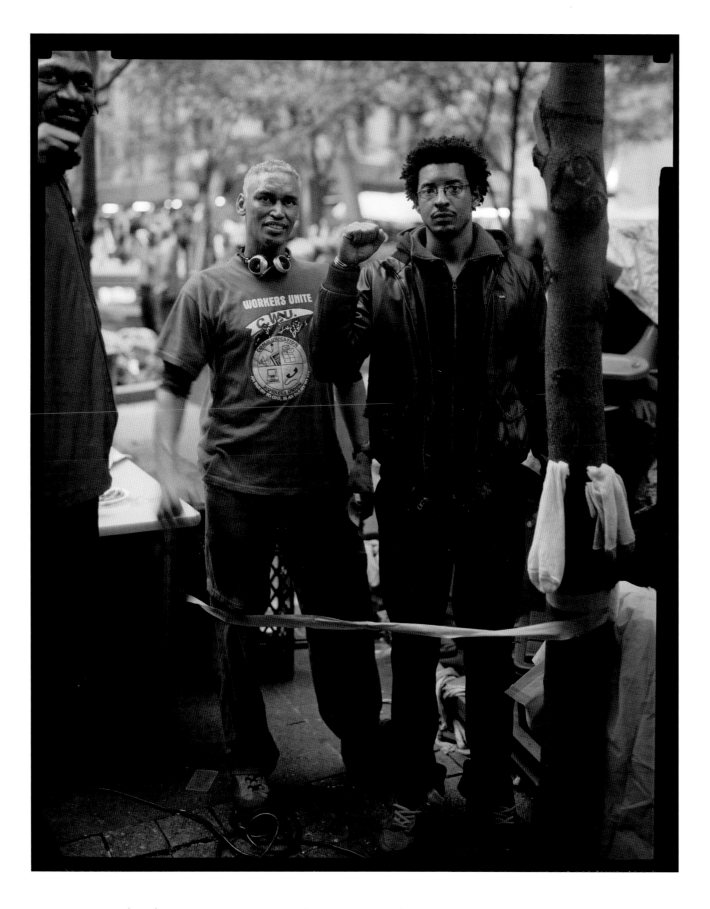

Craig (right) with two representatives of South Africa's African National Congress, October 1, 2011

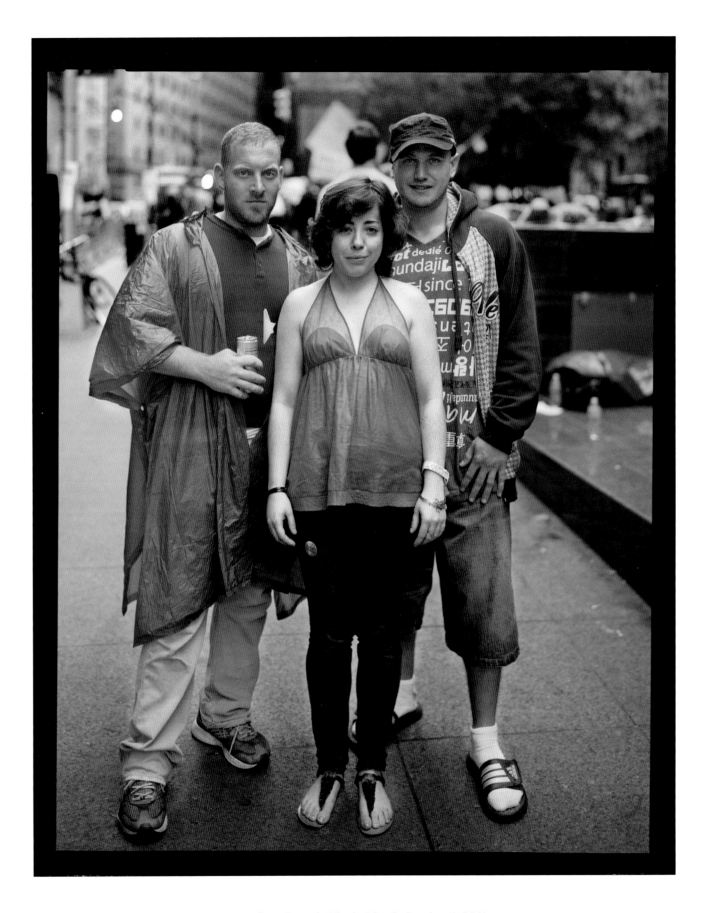

Group from Bristol, Rhode Island, October 1, 2011

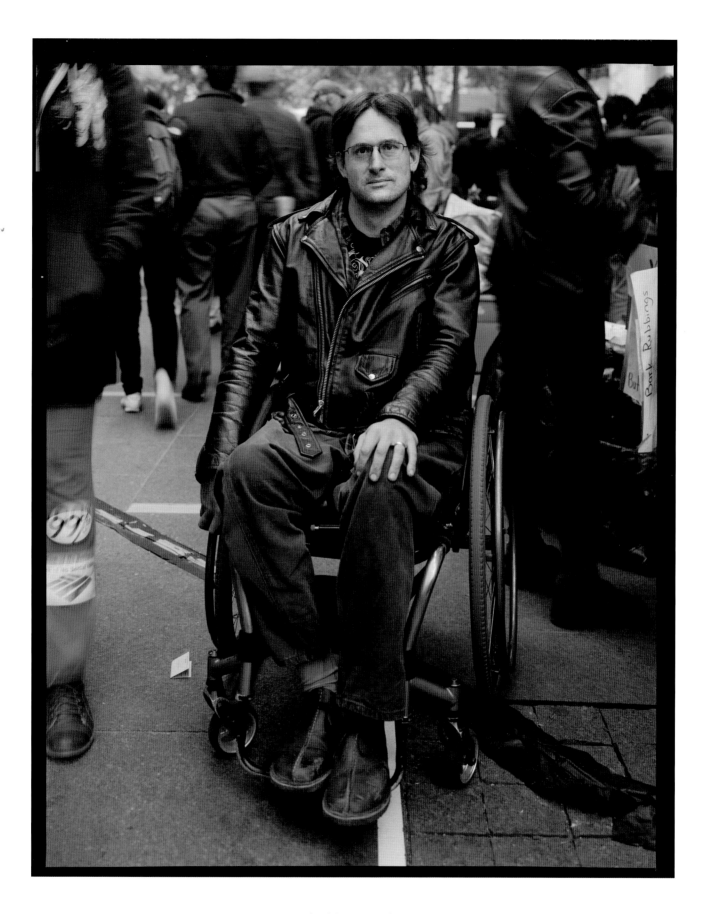

Man in wheelchair, October 22, 2011

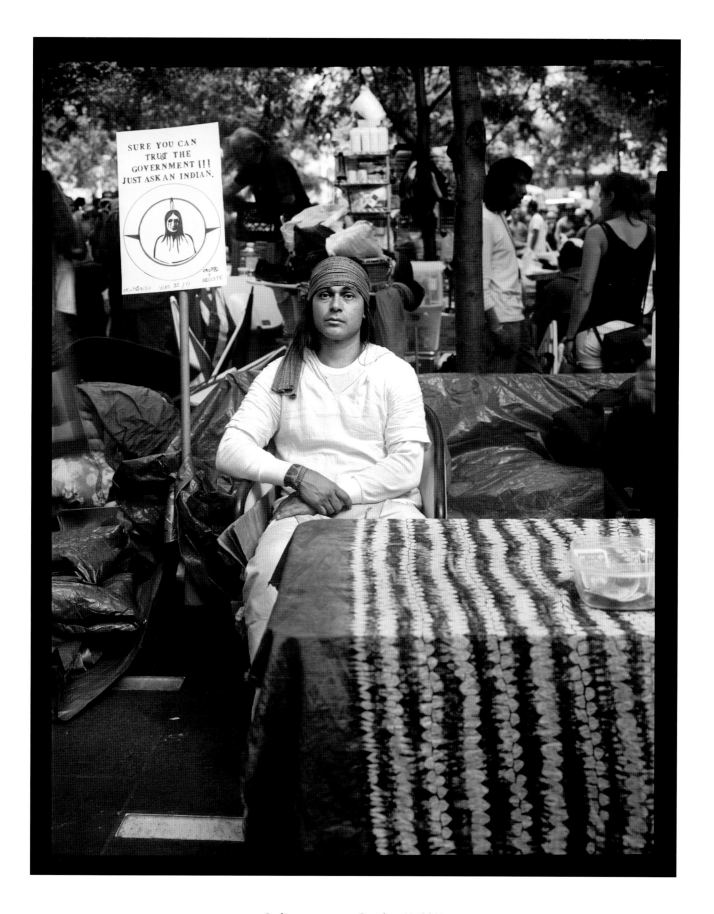

Indigenous man, October 11, 2011

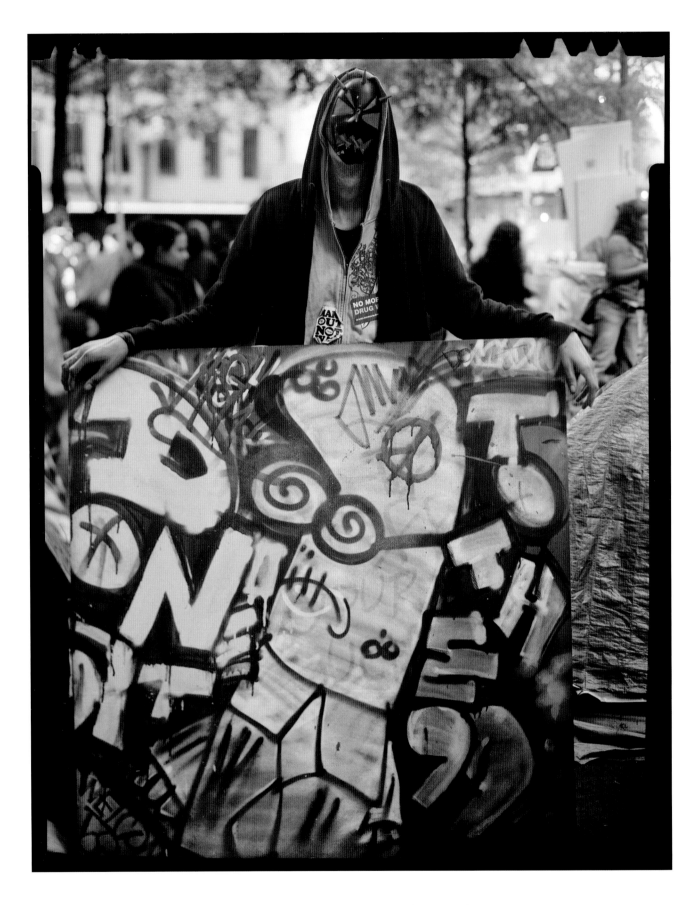

Masked painter with two pet white rats up his sleeve (not shown), October 21, 2011

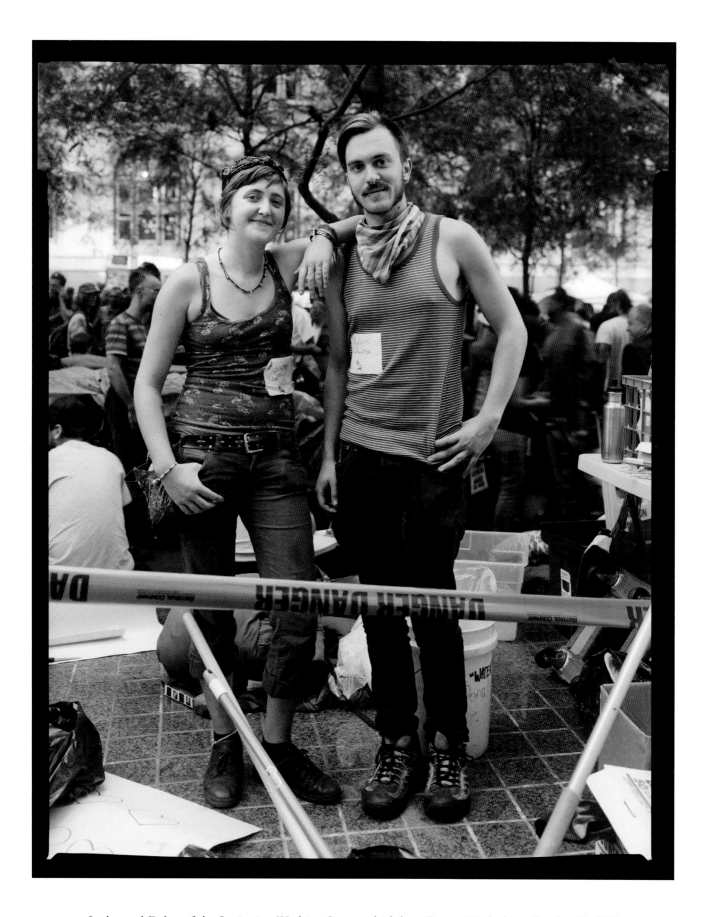

Jordan and Dylan of the Sanitation Working Group, which kept Zuccotti Park clean, October 11, 2011

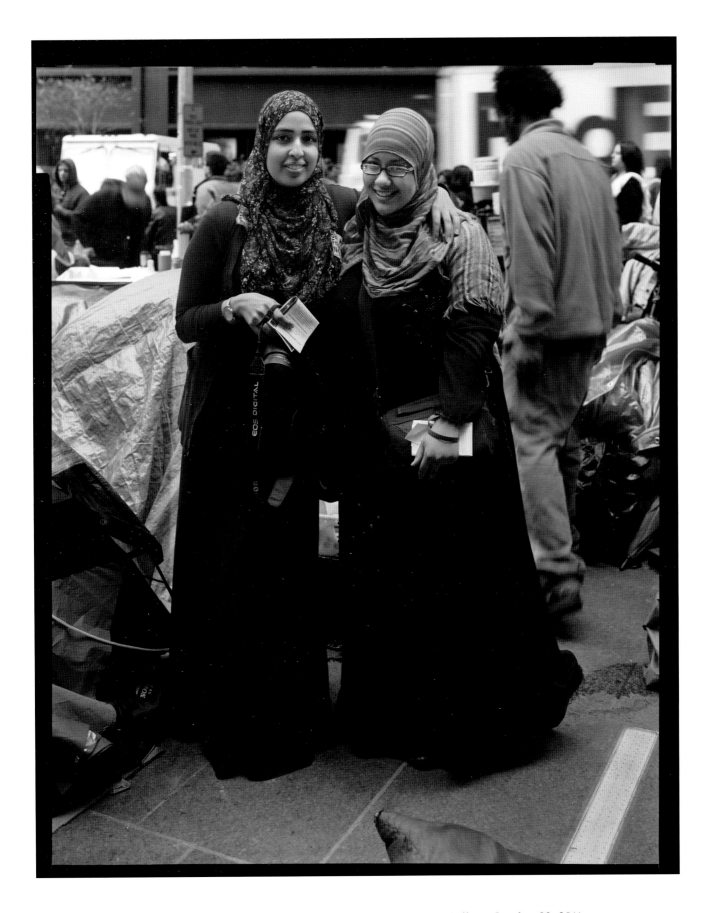

Two students from the Borough of Manhattan Community College, October 22, 2011

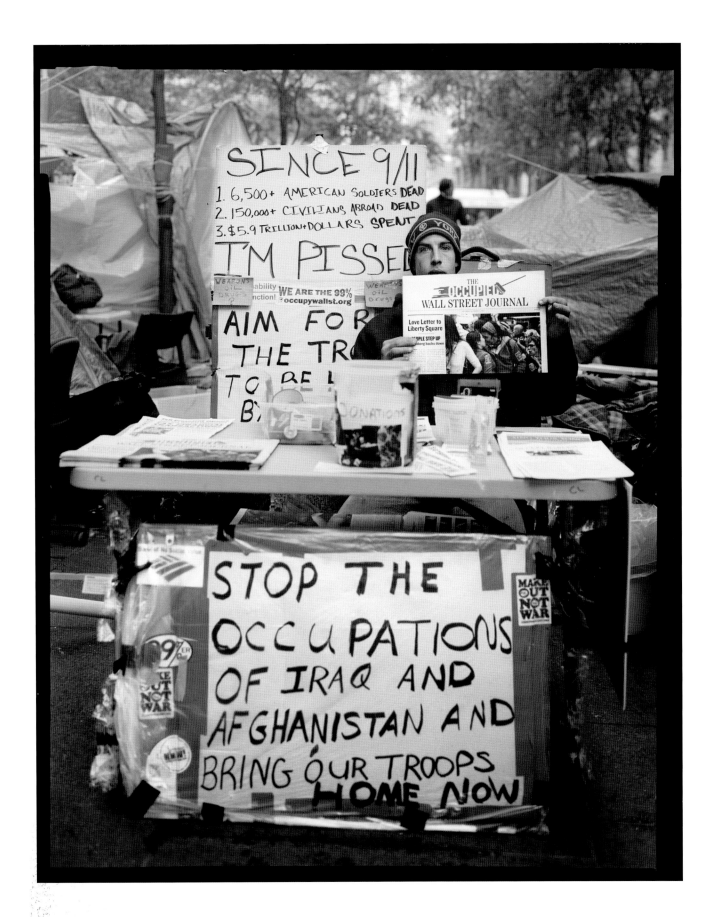

Dan, from Syracuse, whose friends joined ROTC to pay for college and wound up at war, October 28, 2011

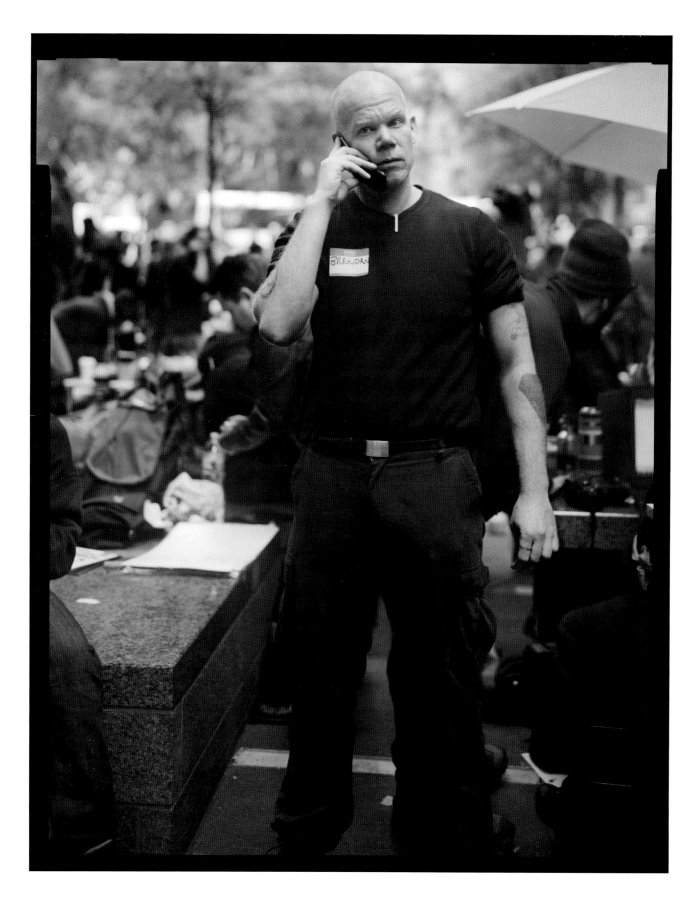

Brendan, an organizer working security, October 4, 2011

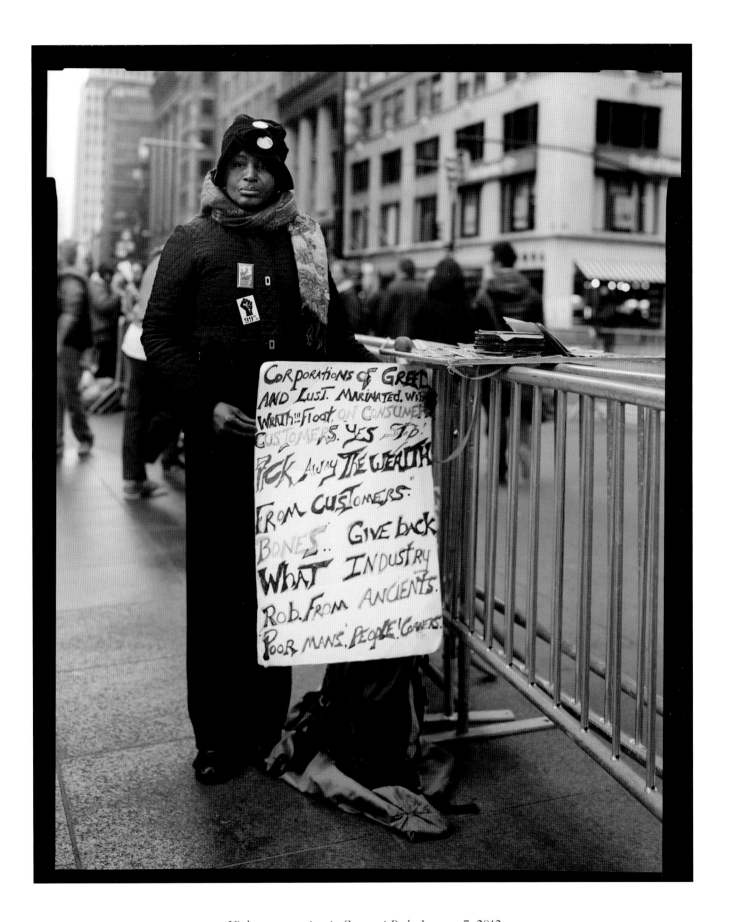

Violetta protesting in Zuccotti Park, January 7, 2012

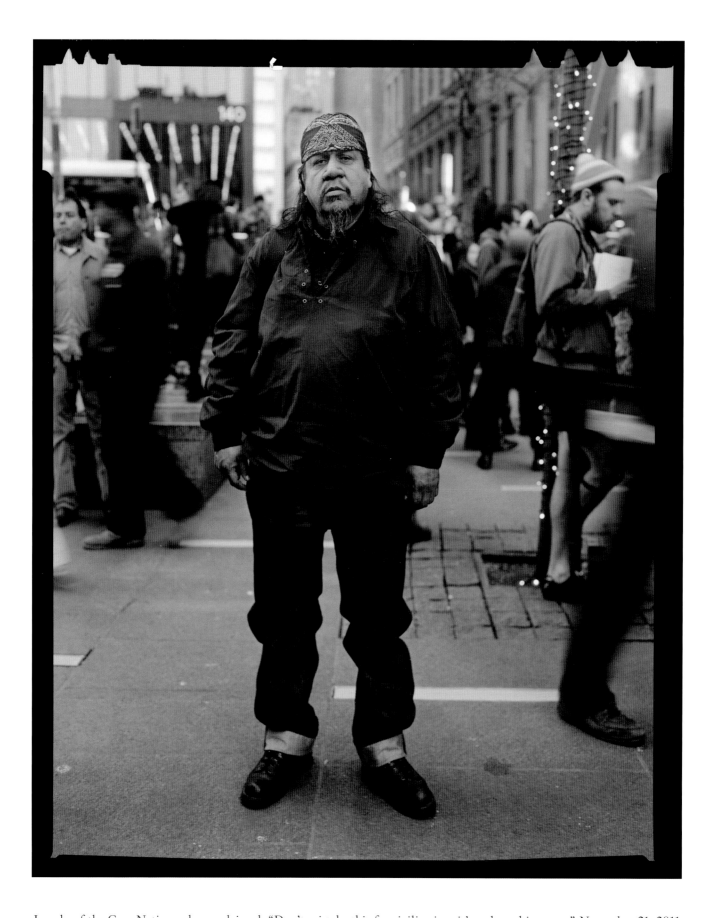

Joseph, of the Cree Nation, who proclaimed, "Don't mistake this for civilization, it's only architecture," November 21, 2011

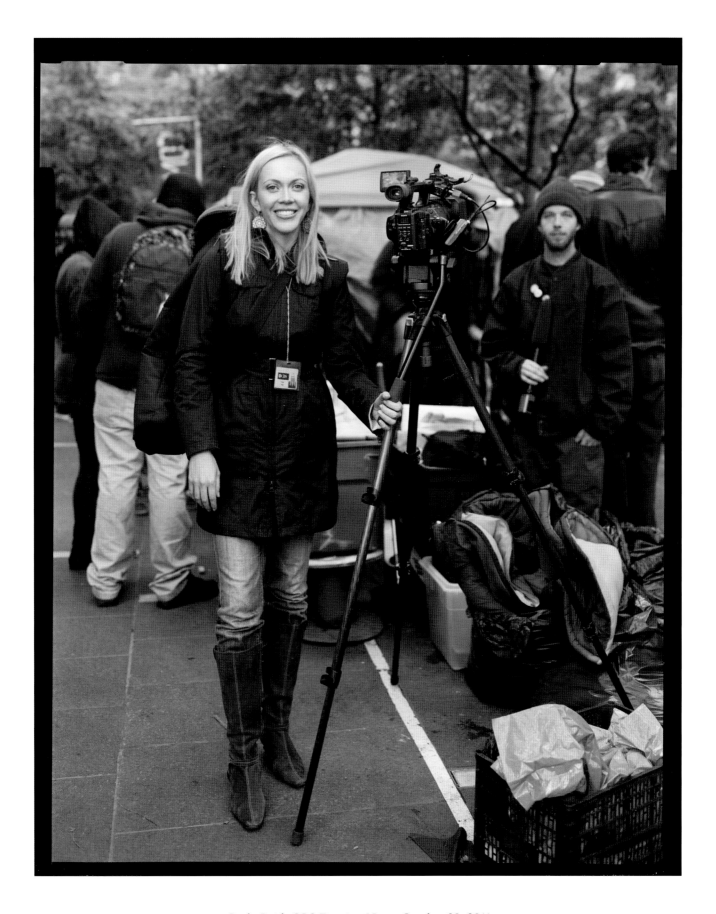

Paula Reid, CBS Evening News, October 28, 2011

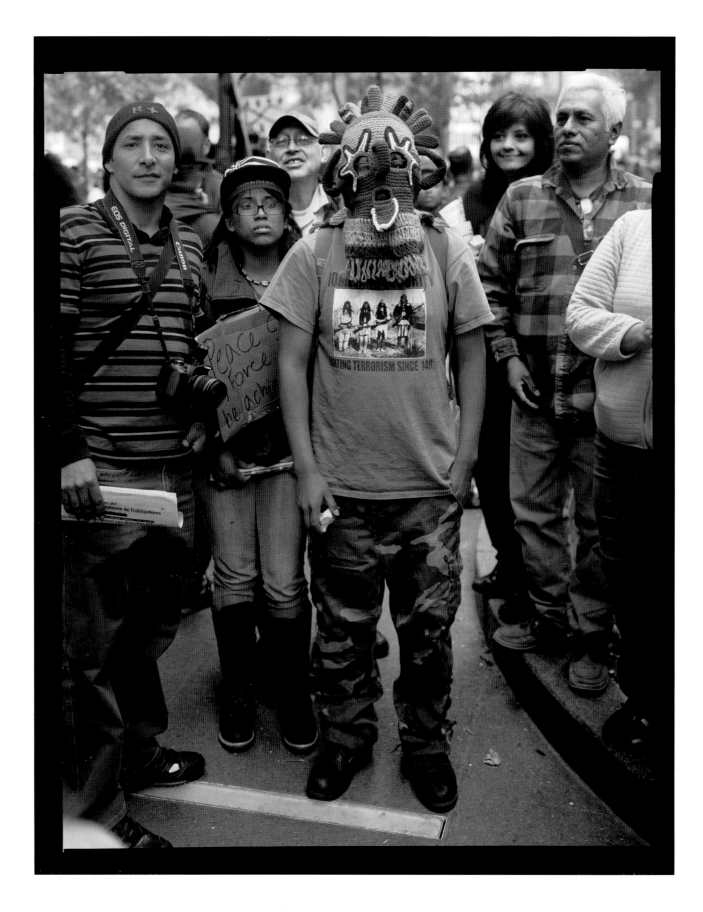

Group of Indigenous people, October 15, 2011

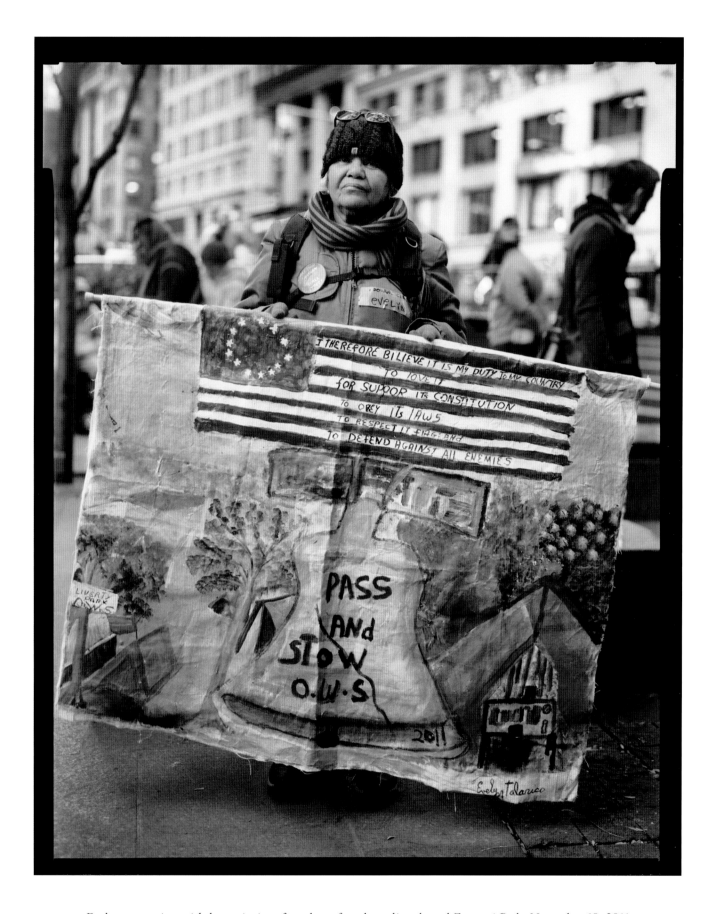

Evelyn protesting with her painting, four days after the police cleared Zuccotti Park, November 18, 2011

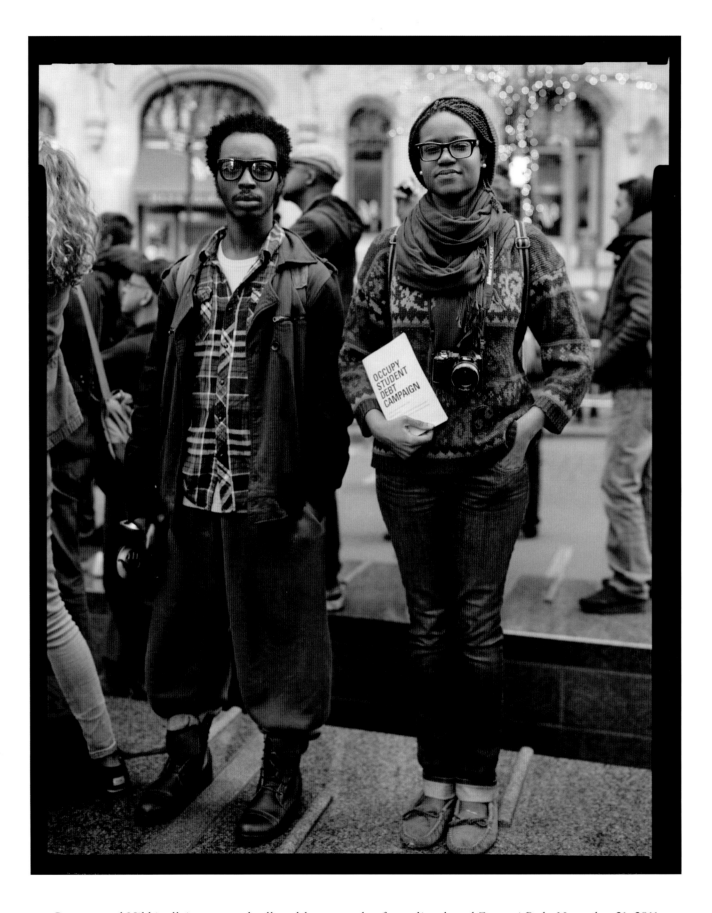

Rayvawn and Nikki rallying to cancel college debt two weeks after police cleared Zuccotti Park, November 21, 2011

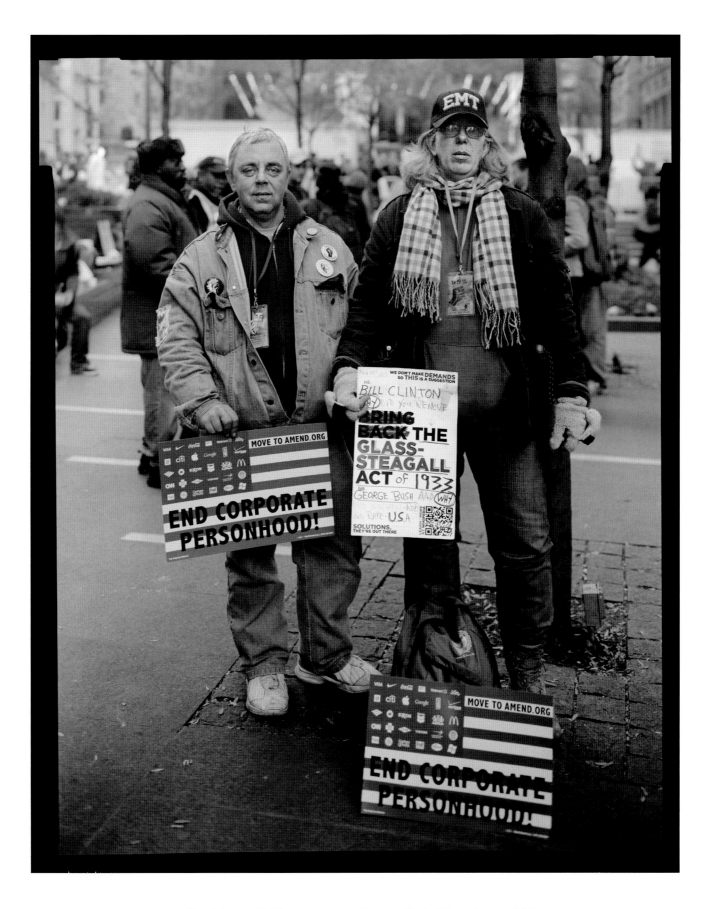

Jeff and Terri, EMTs protesting in Zuccotti Park, November 18, 2011

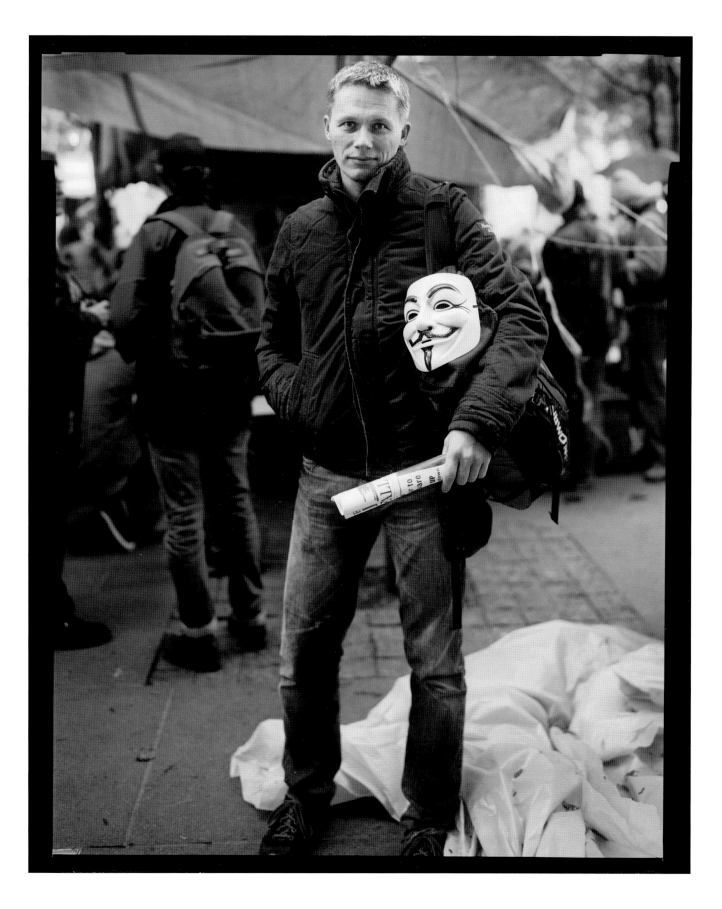

Tarmo from Estonia, former investment banker, who came to New York to join the protest, October 28, 2011

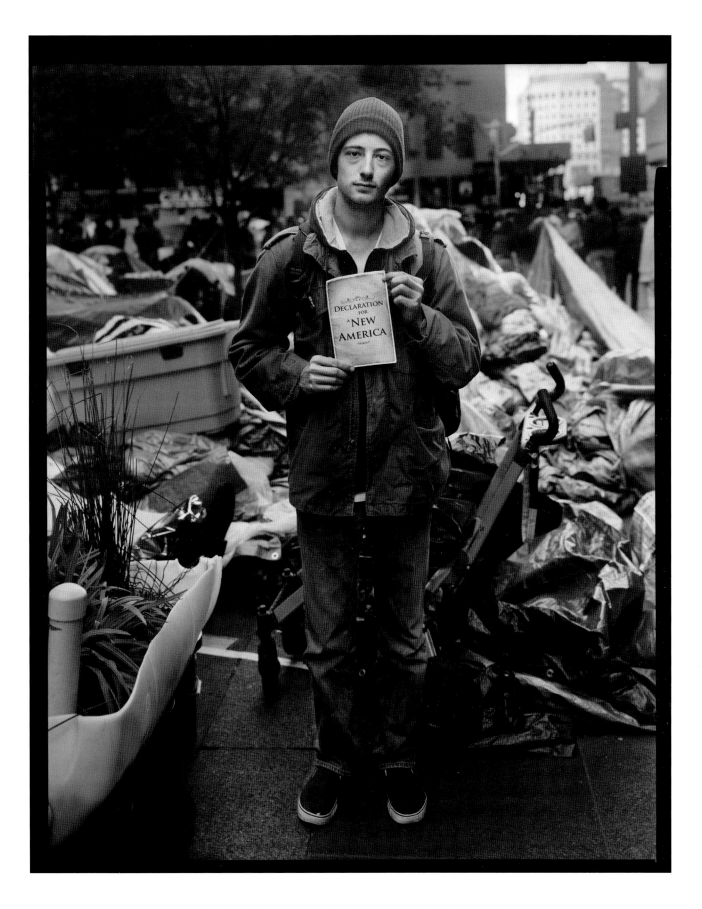

Patrick, who spent a week at the protest, October 21, 2011

II
echoes

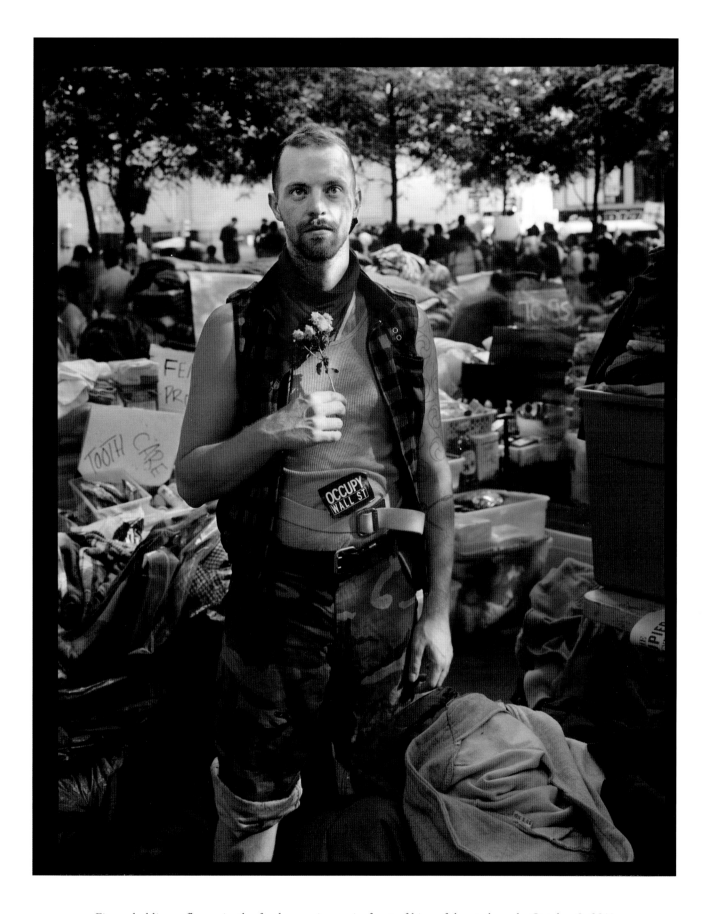

Figure holding a flower in the food commissary, in front of bins of donated goods, October 9, 2011

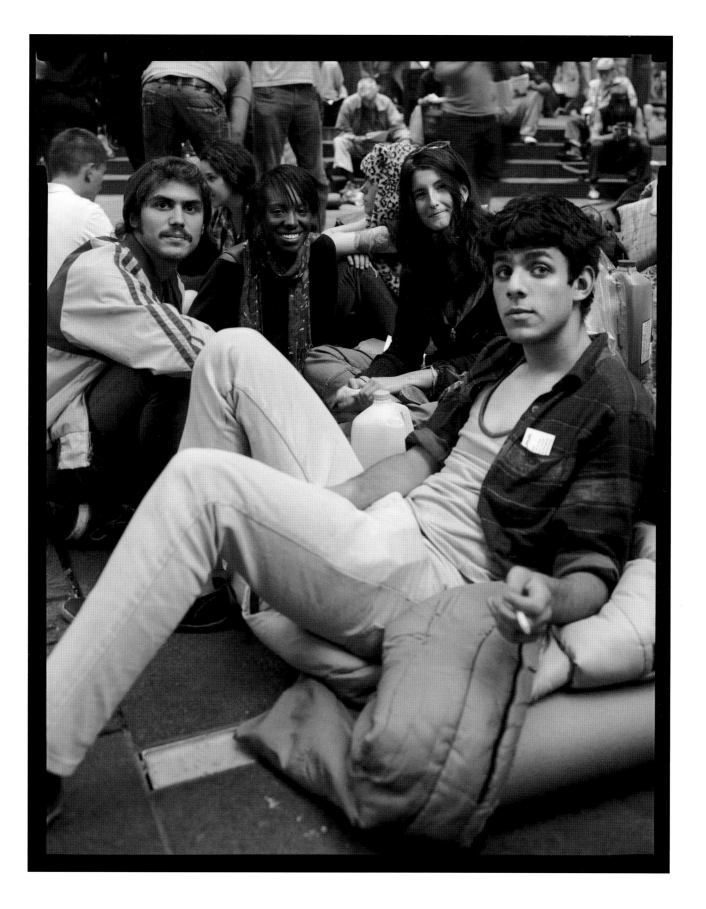

Group of students, who recently arrived from New College of Florida in Sarasota, October 11, 2011

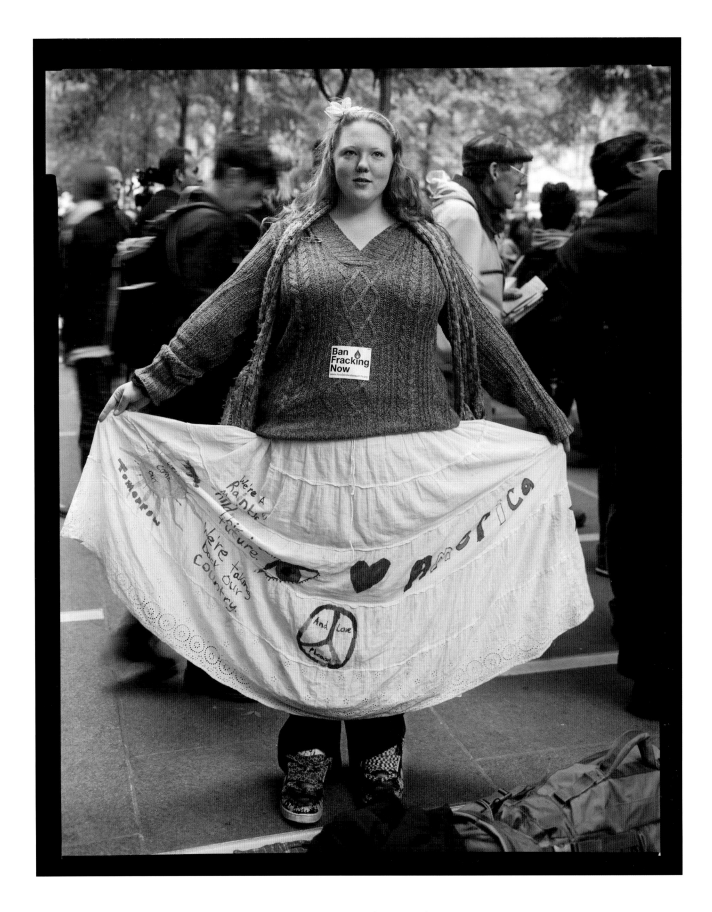

Young woman in a peasant skirt, October 22, 2011

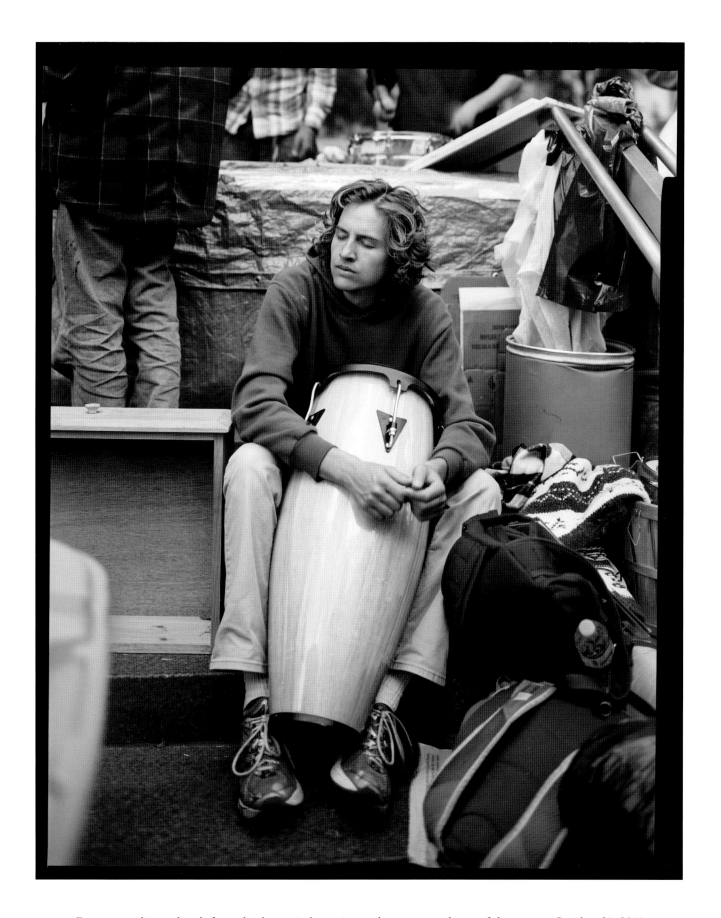

Drummer taking a break from the drum circle, an integral yet contested part of the protest, October 21, 2011

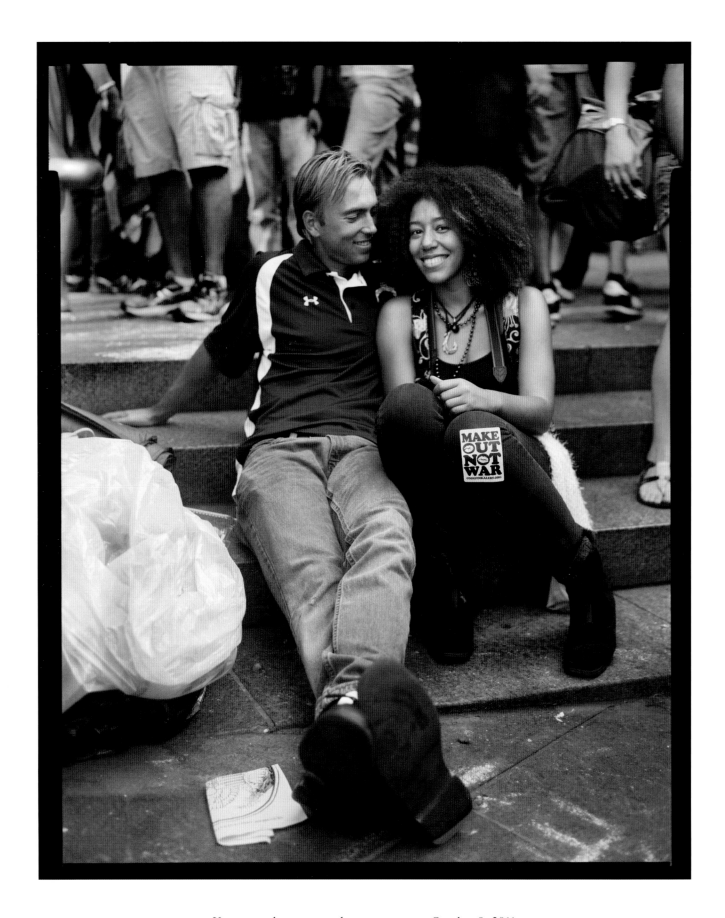

Young couple at rest on the western steps, October 9, 2011

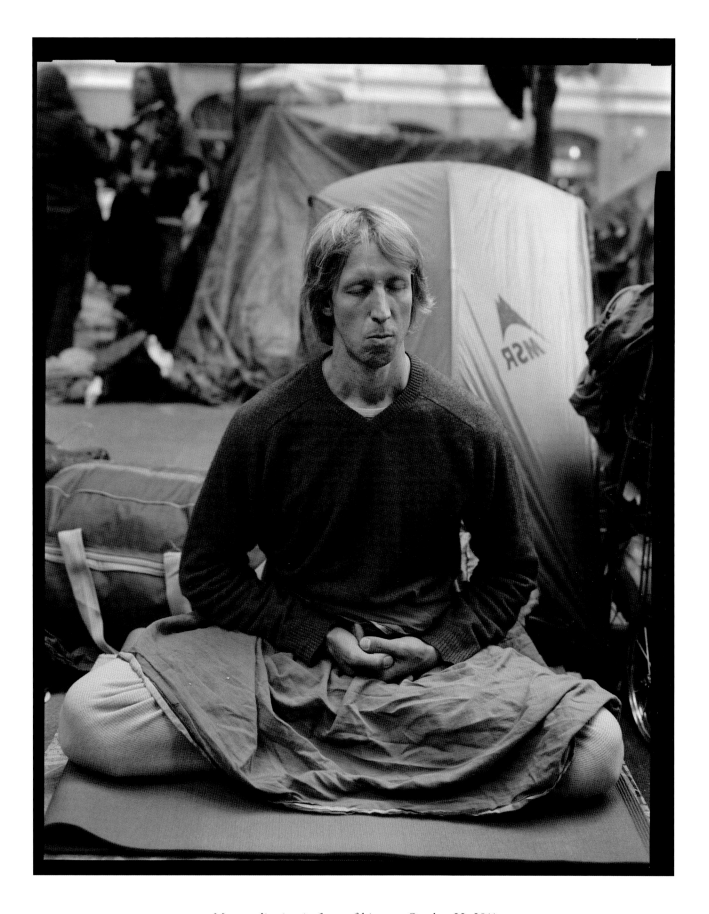

Man meditating in front of his tent, October 22, 2011

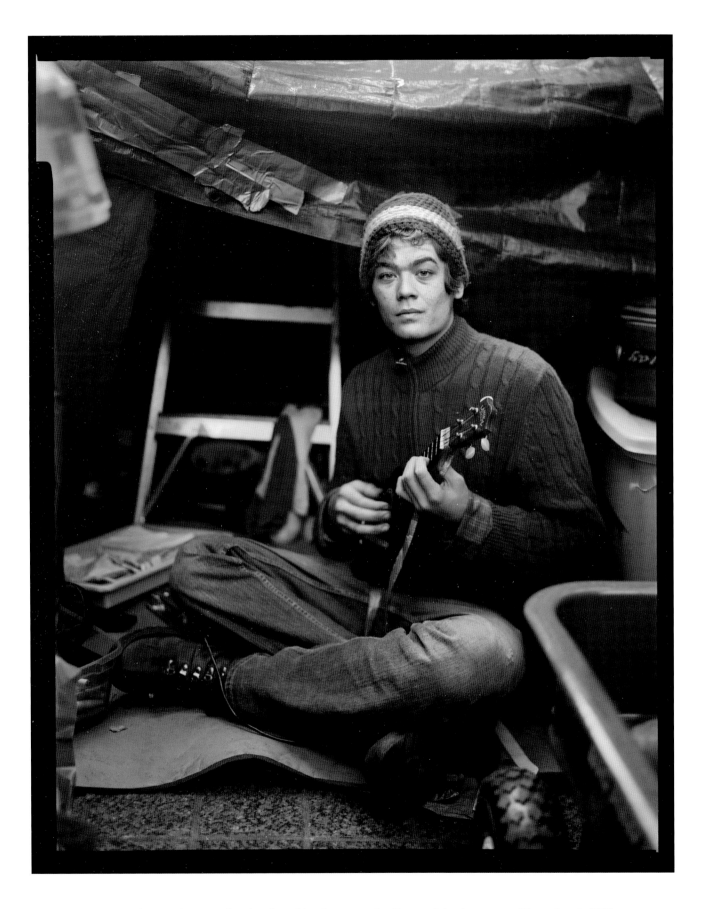

Charlie from Arkansas, who abandoned his last year of college to join the protest, November 3, 2011

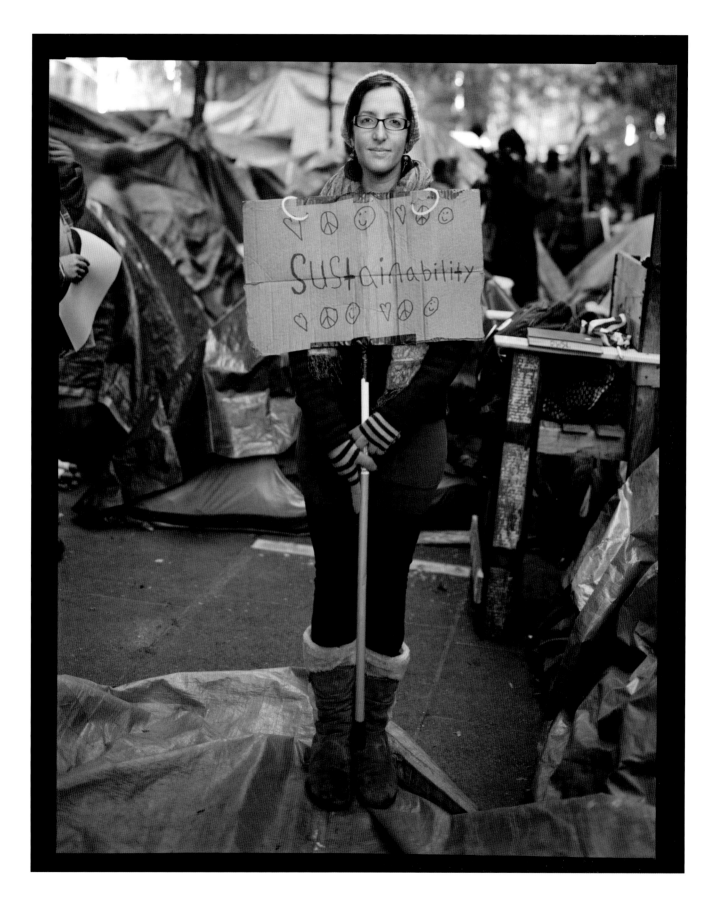

Lauren, a leader of the Sustainability Working Group on its first day in Zuccotti Park, November 5, 2011

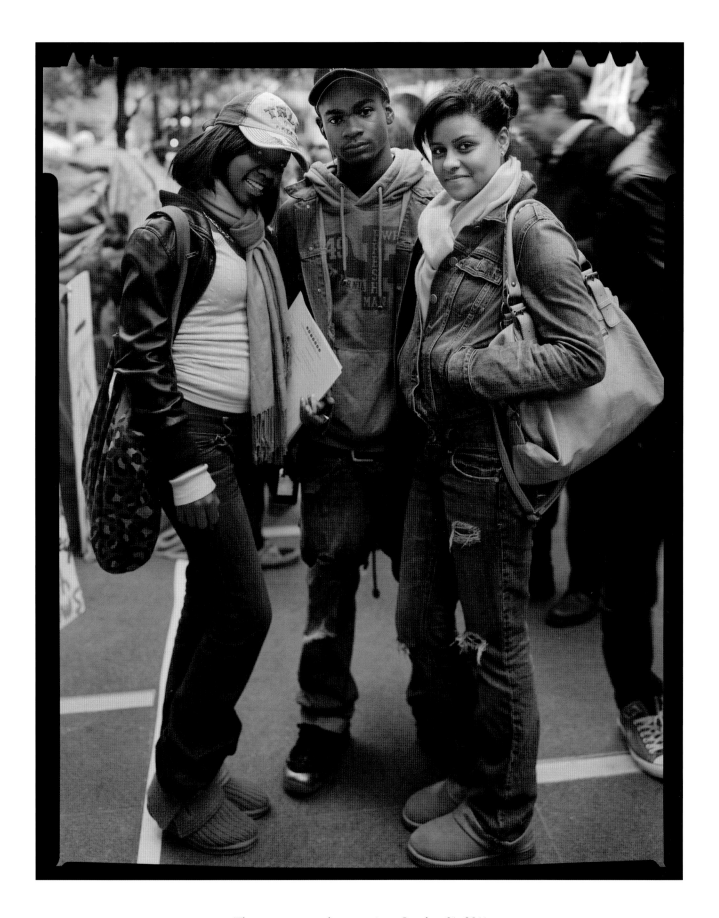

Three young people protesting, October 21, 2011

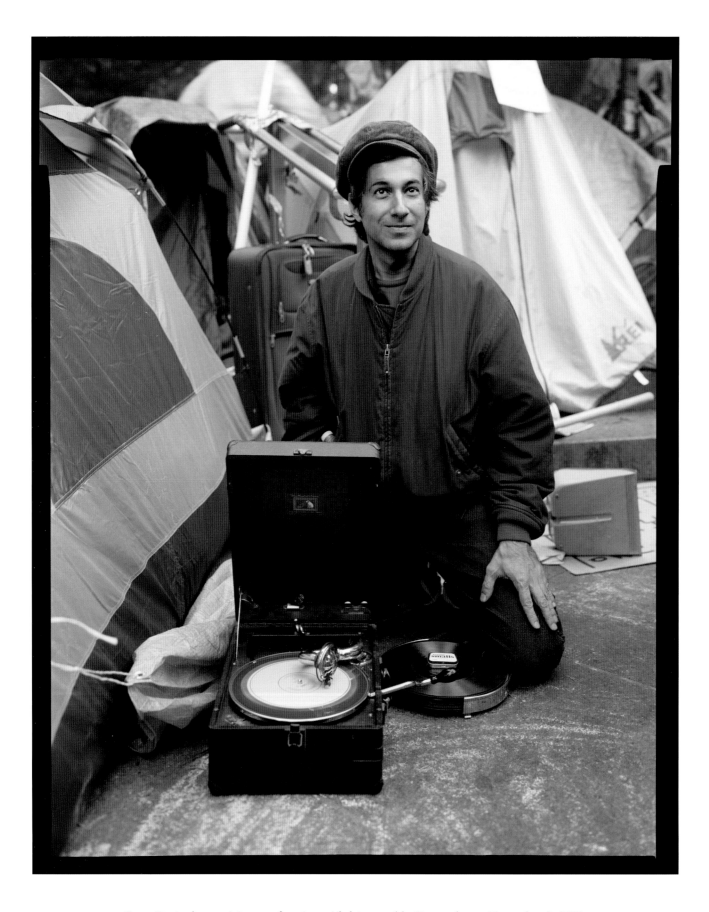

Steve Espinola, musician, performing with his portable Gramophone, November 3, 2011

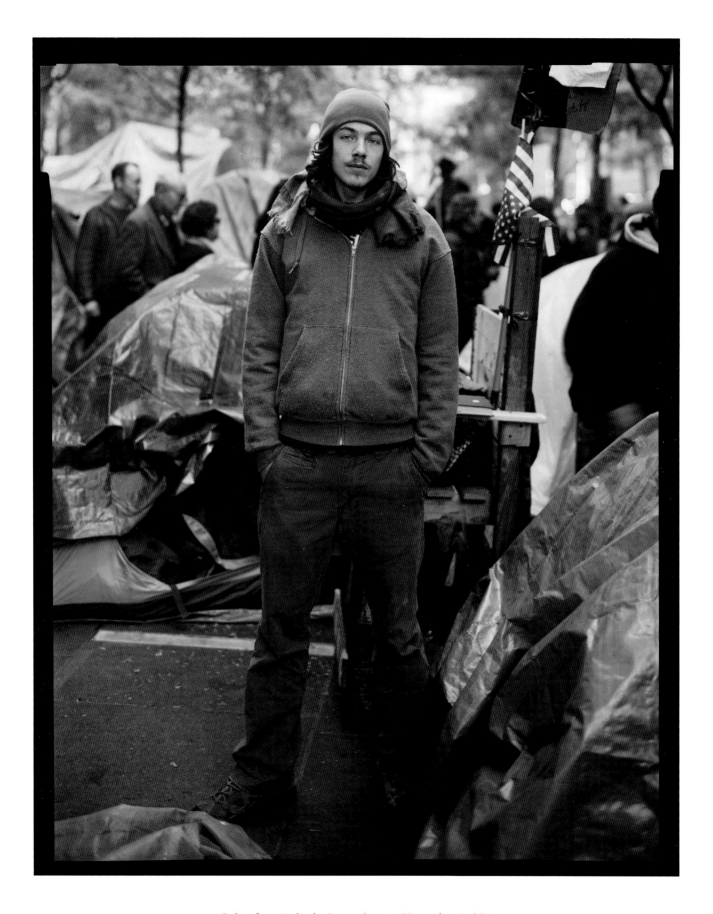

Colin from Lehigh, Pennsylvania, November 5, 2011

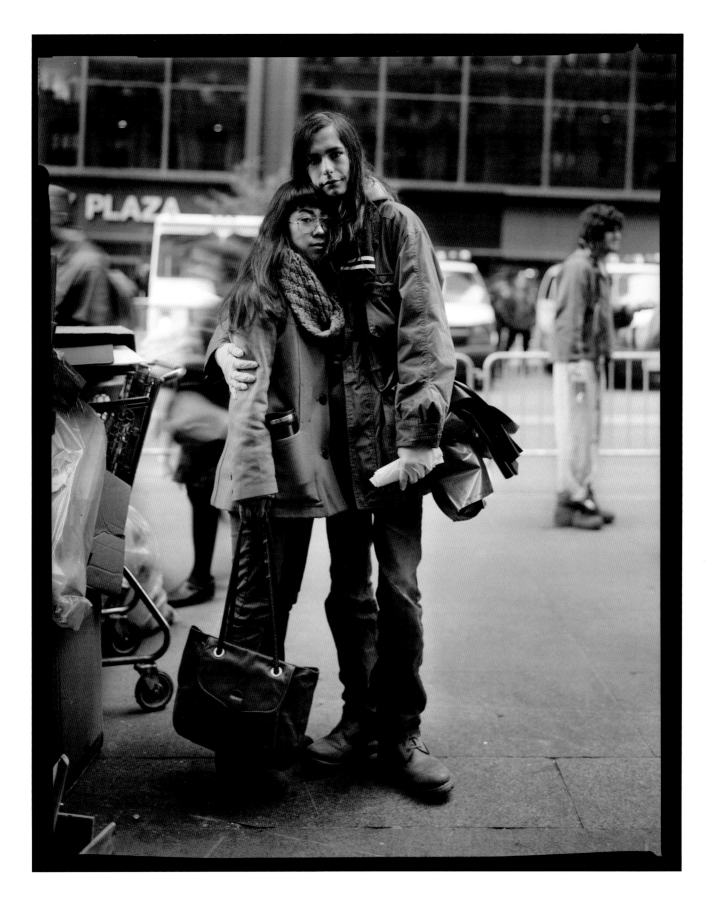

Su and Kyle who both participated from the first day, November 1, 2011

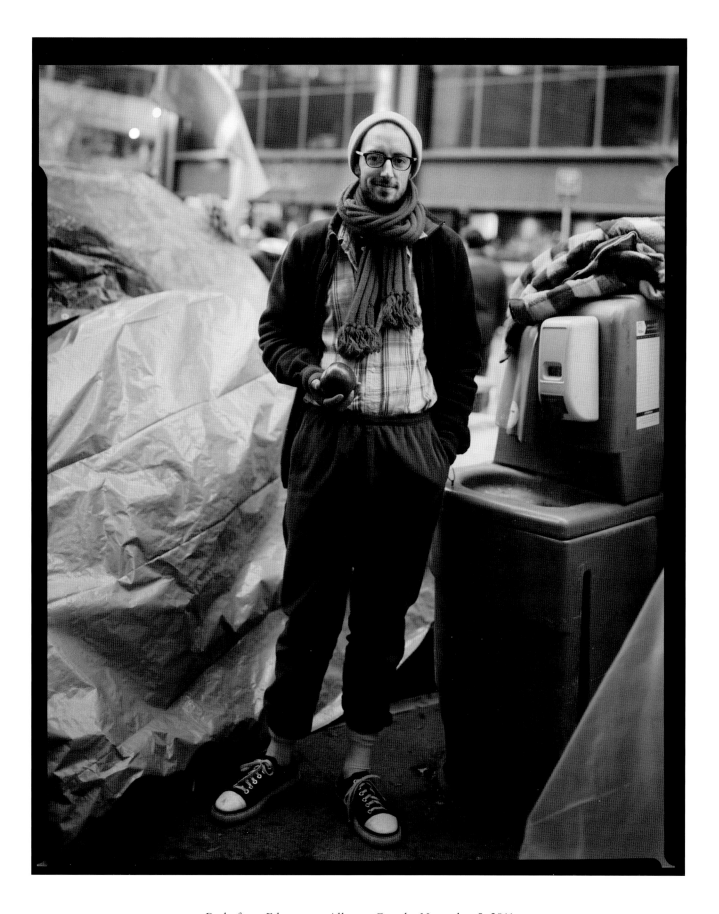

Rudy from Edmonton, Alberta, Canada, November 5, 2011

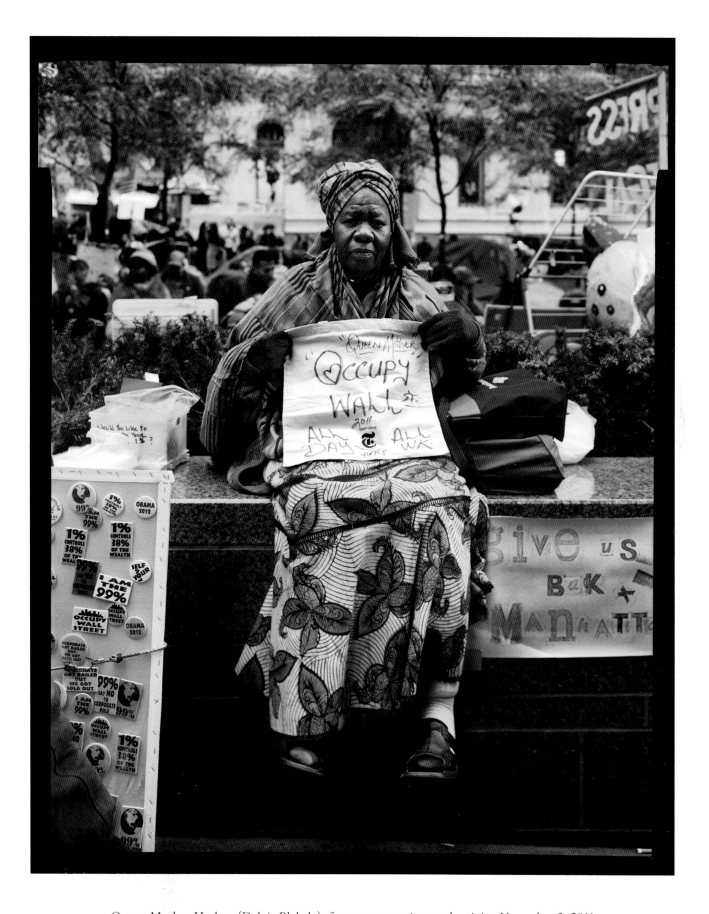

Queen Mother Harlem (Delois Blakely), former nun, writer, and activist, November 3, 2011

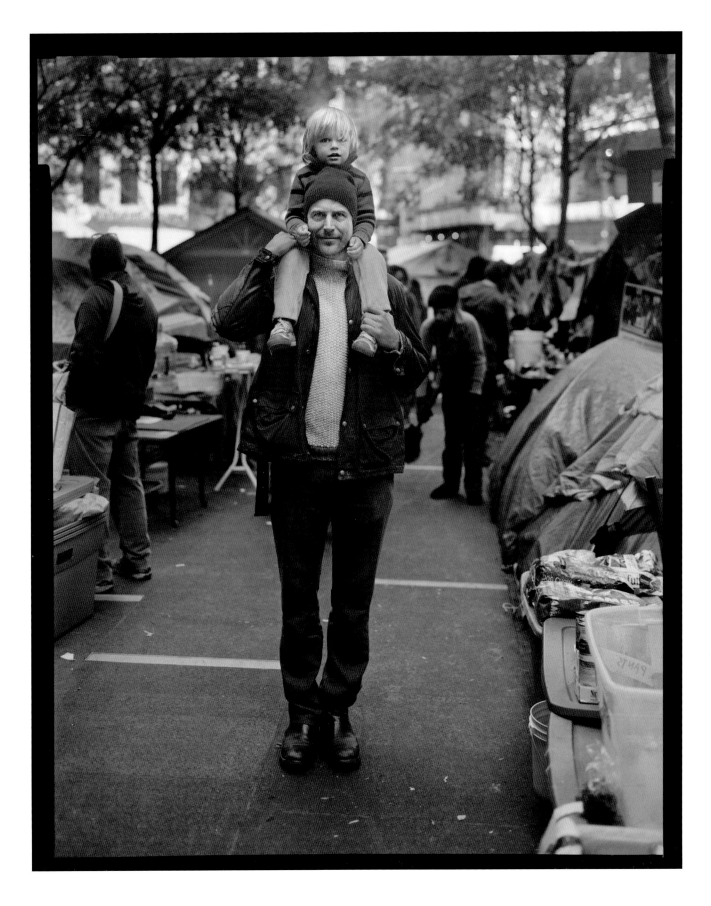

Bertie and Beckett from Brooklyn, November 7, 2011

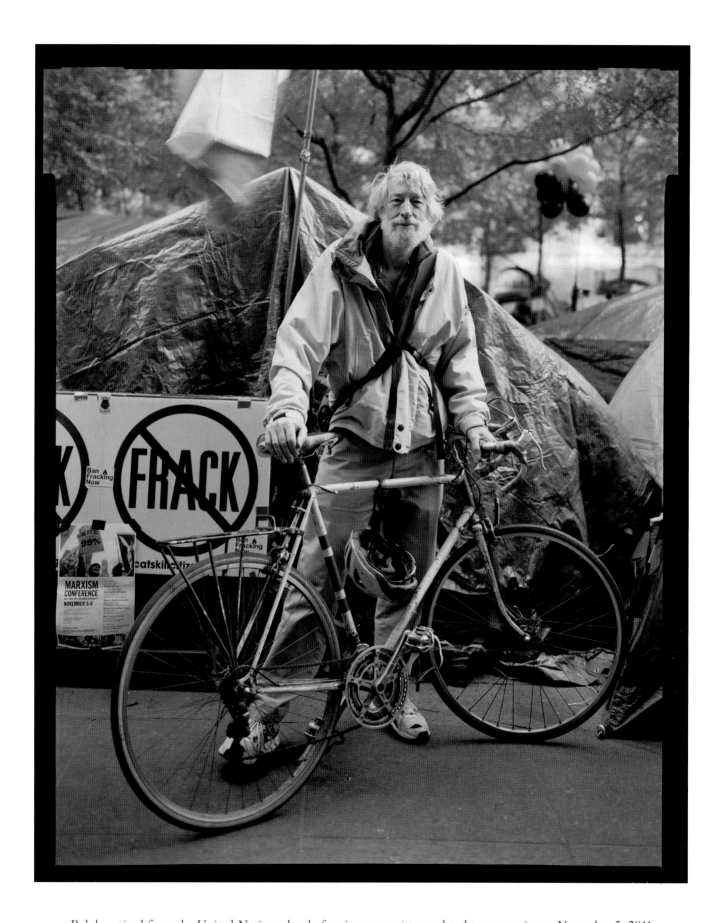

Ralph, retired from the United Nations, head of various committees related to space science, November 5, 2011

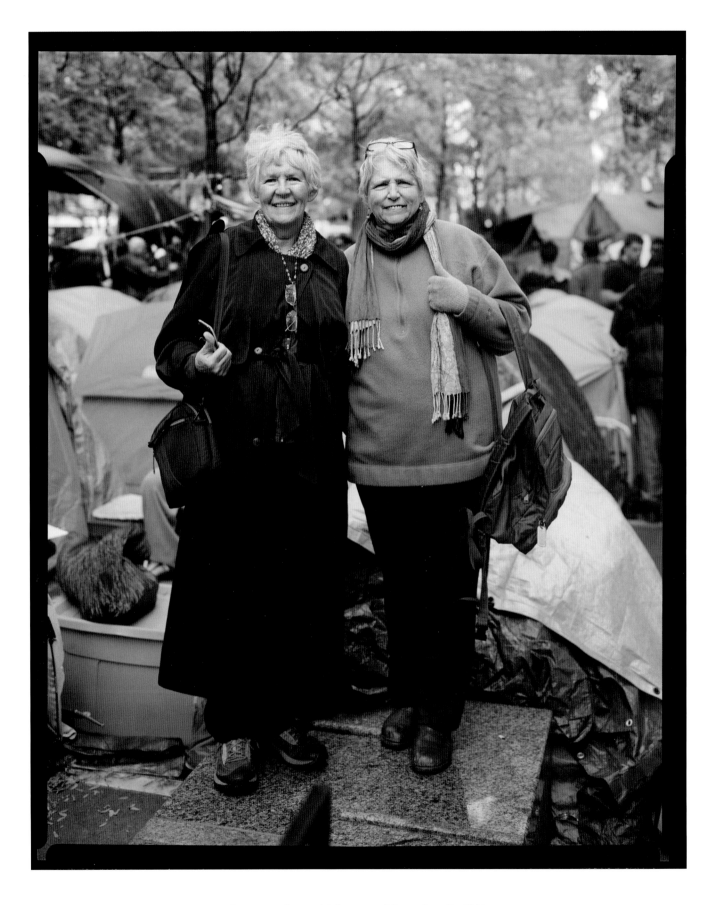

Sisters, Helen and Marianne, November 12, 2011

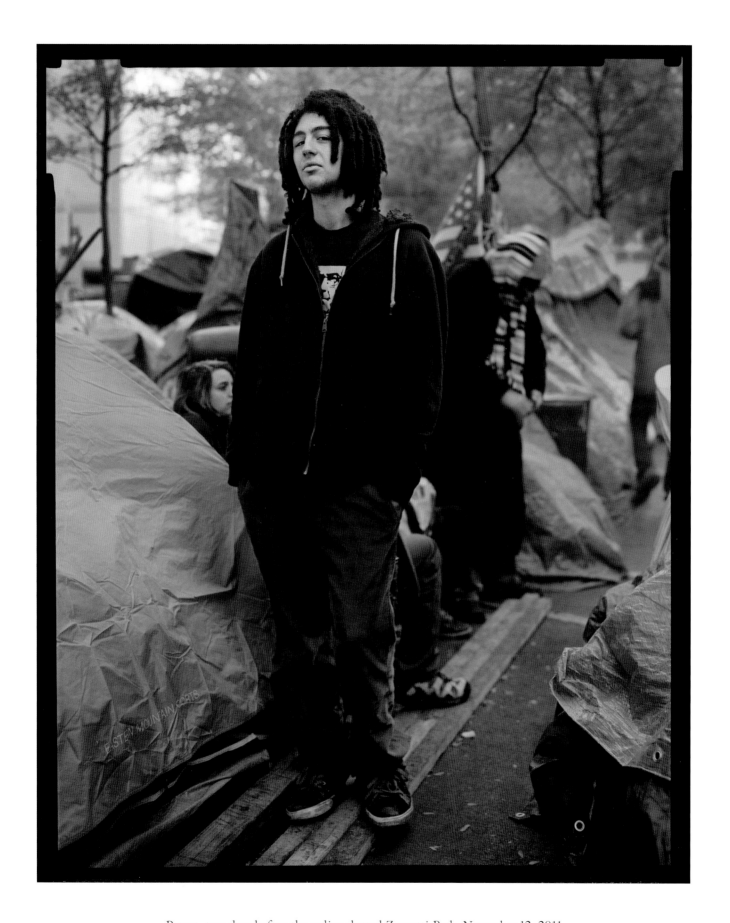

Raven, two days before the police cleared Zuccotti Park, November 12, 2011

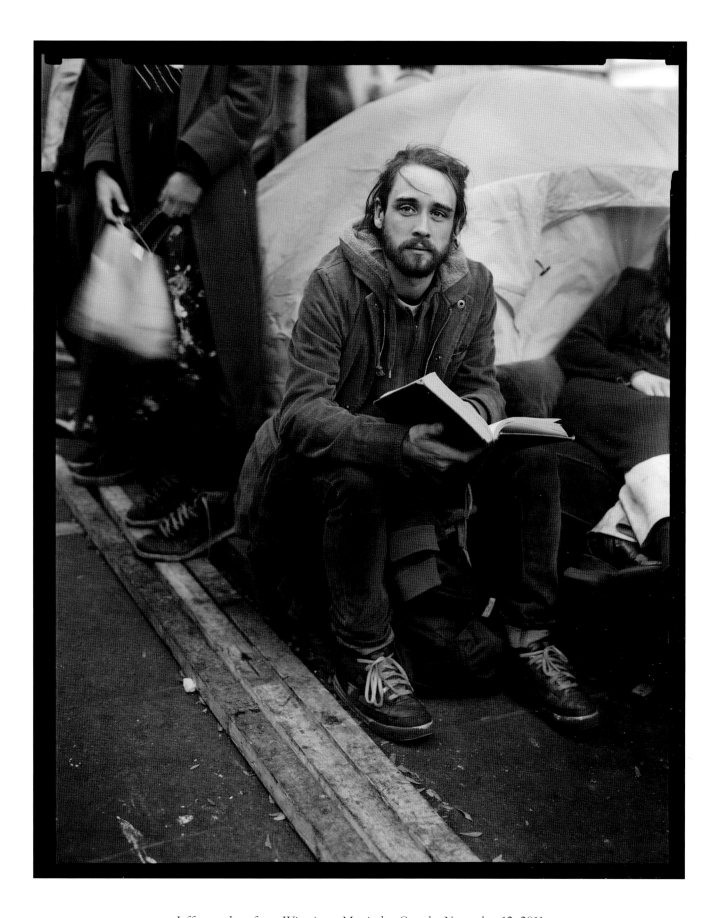

Jeff, a student from Winnipeg, Manitoba, Canada, November 12, 2011

III
99%

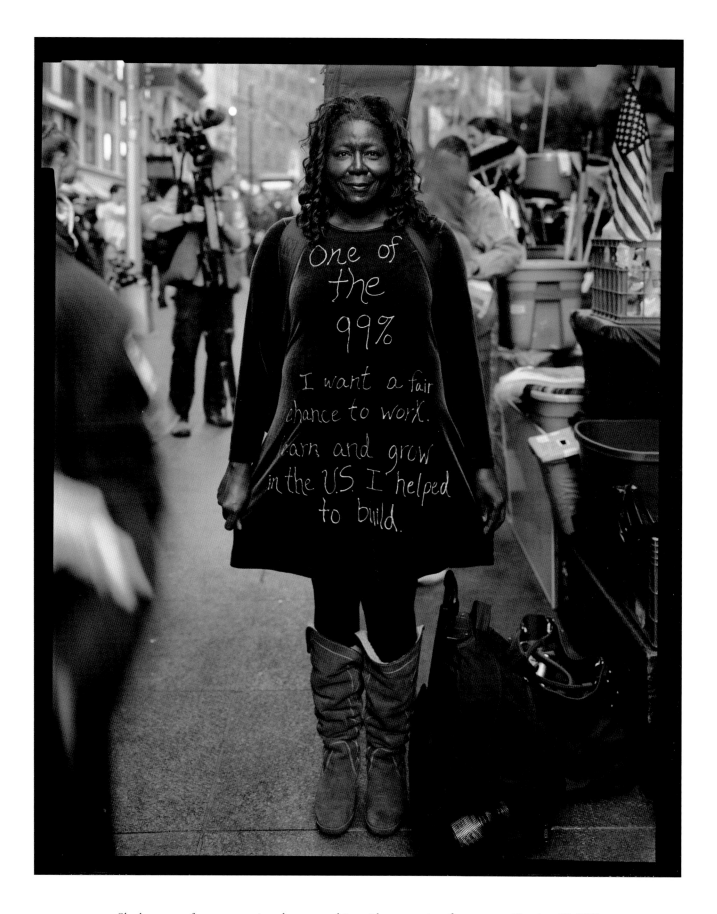

Shadow, a performance artist who was making video portraits of protesters, October 15, 2011

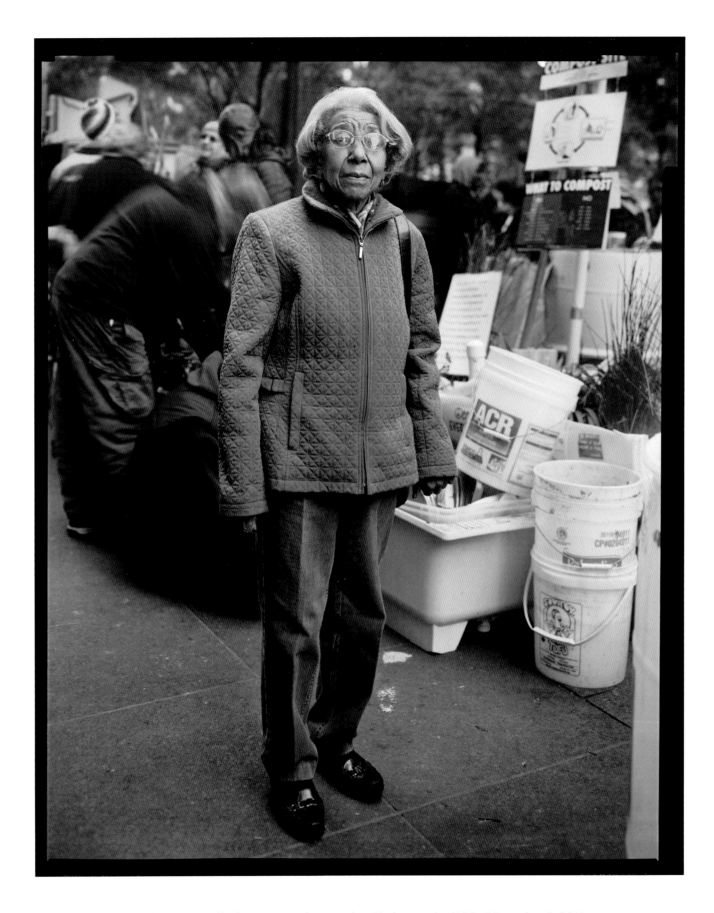

Colette, originally from Haiti, who moved to Harlem in the 1950s, November 5, 2011

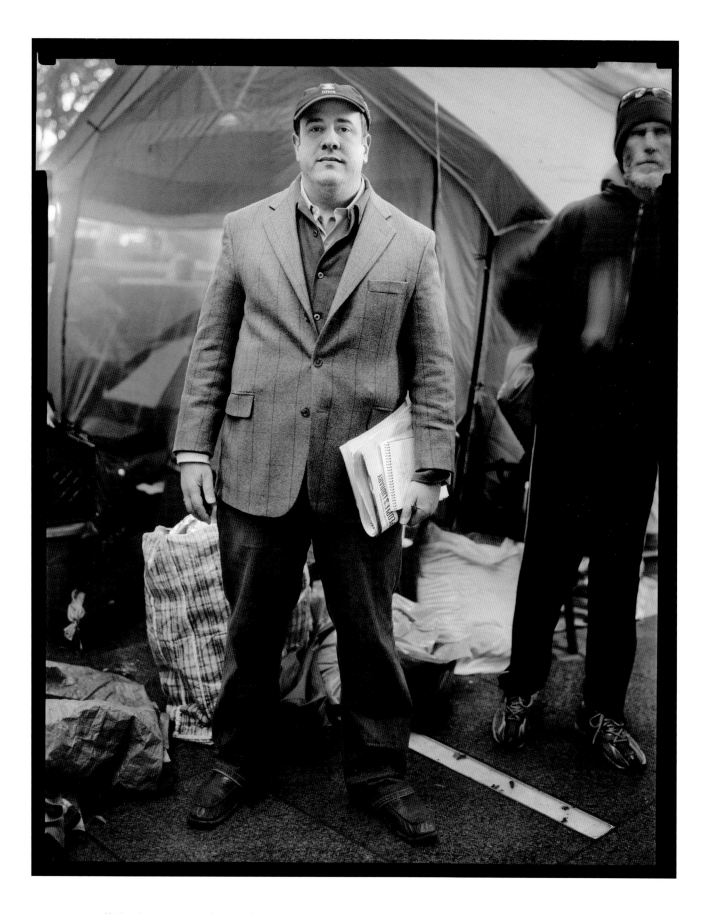

Jeff Sharlet, writer and journalist, researching a story on Occupy for *Rolling Stone*, October 30, 2011

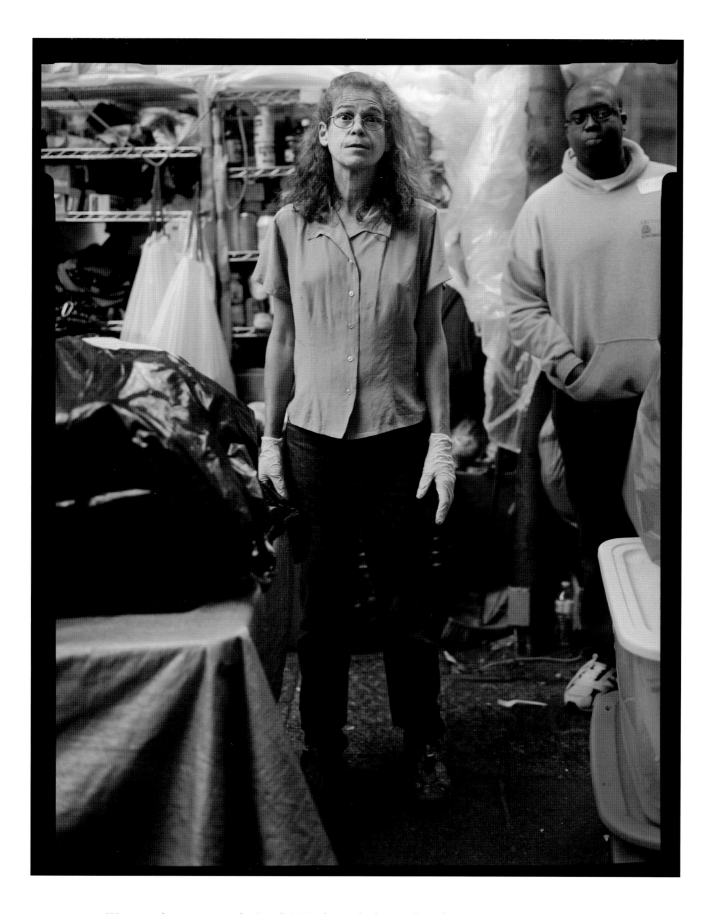

Woman volunteering in the People's Kitchen, which served meals to everyone, October 15, 2011

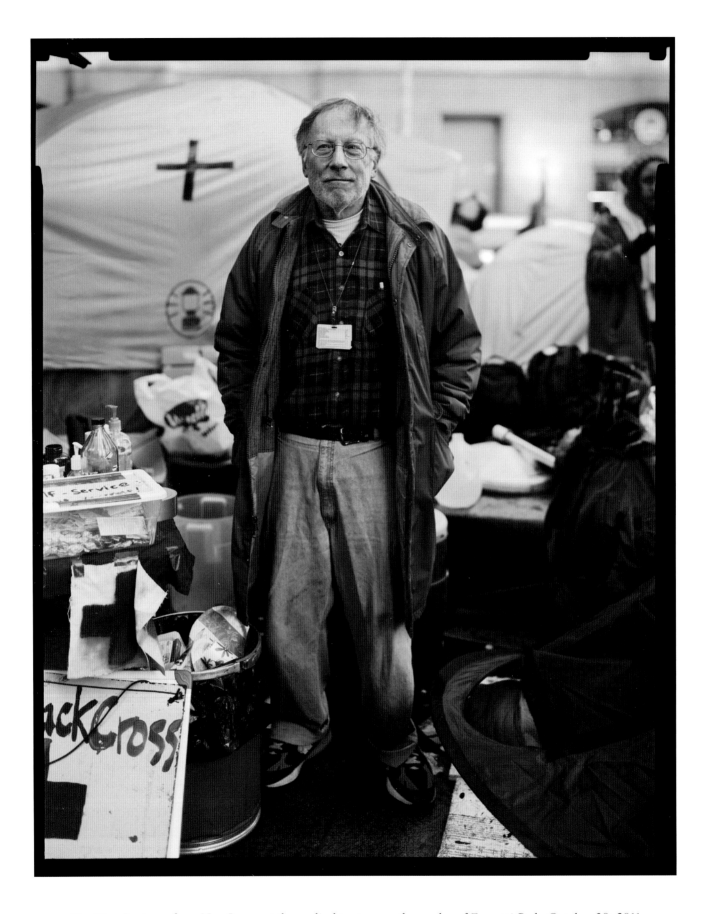

Dr. Marc Lavietes, from New Jersey, at the medical tent on southern edge of Zuccotti Park, October 30, 2011

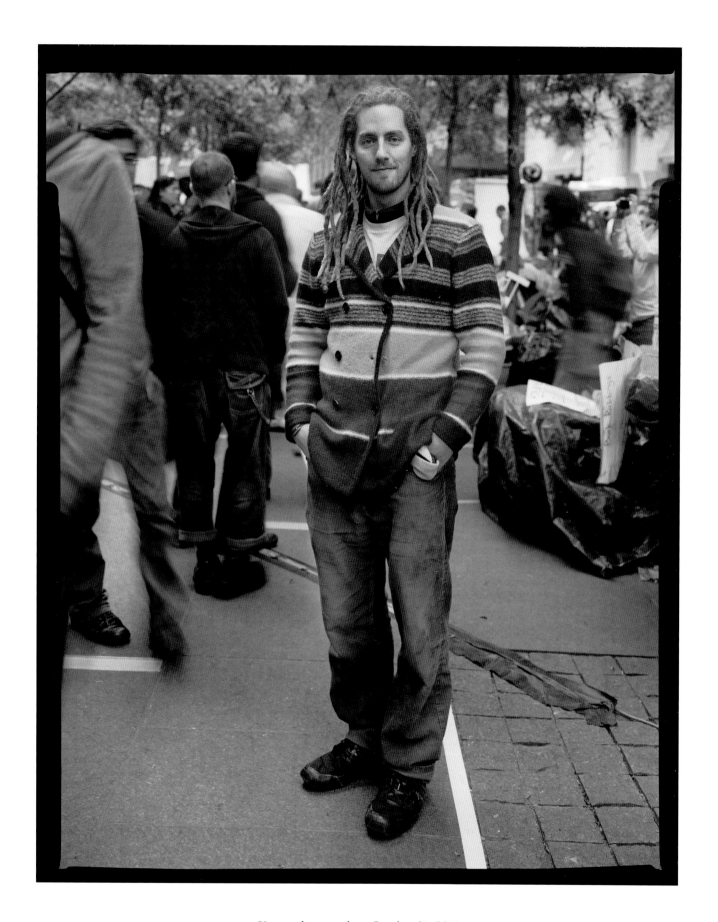

Young photographer, October 21, 2011

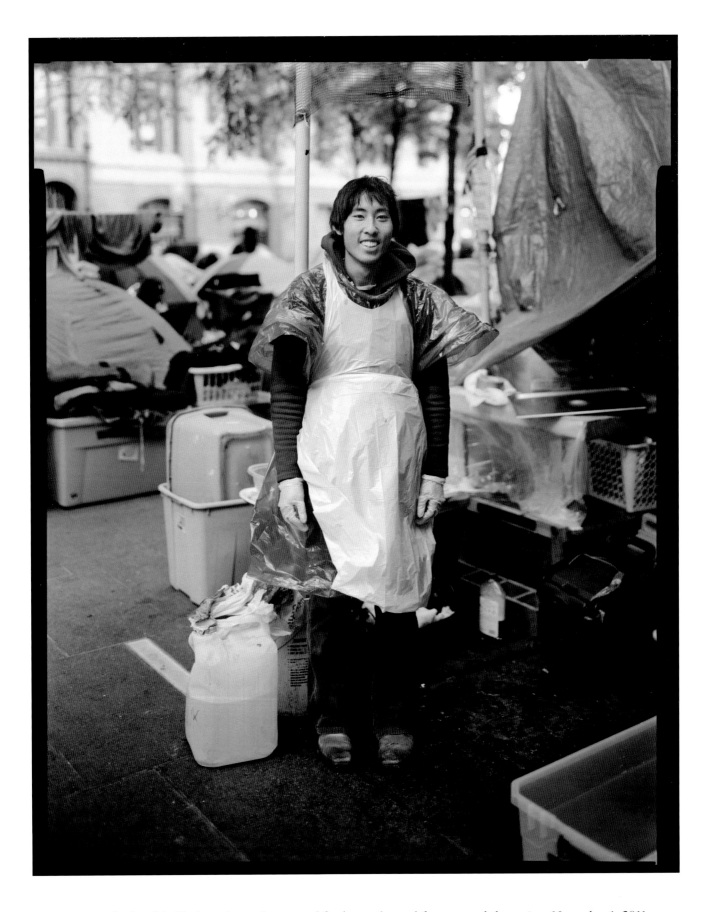

Dane in the People's Kitchen; the equipment and food were donated from around the nation, November 1, 2011

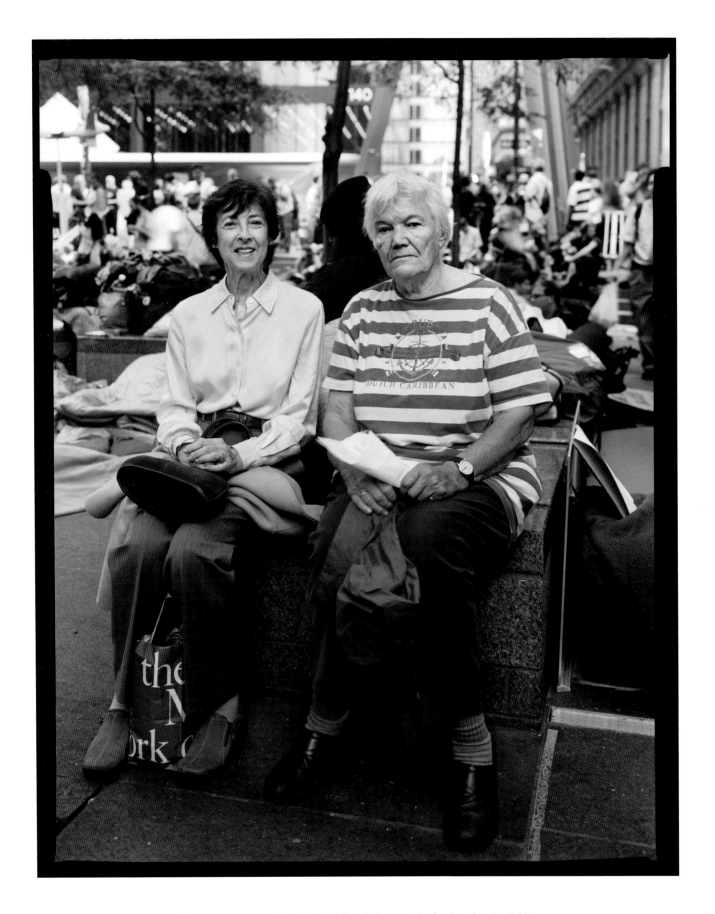

Two women seated in the middle of Zuccotti Park, October 11, 2011

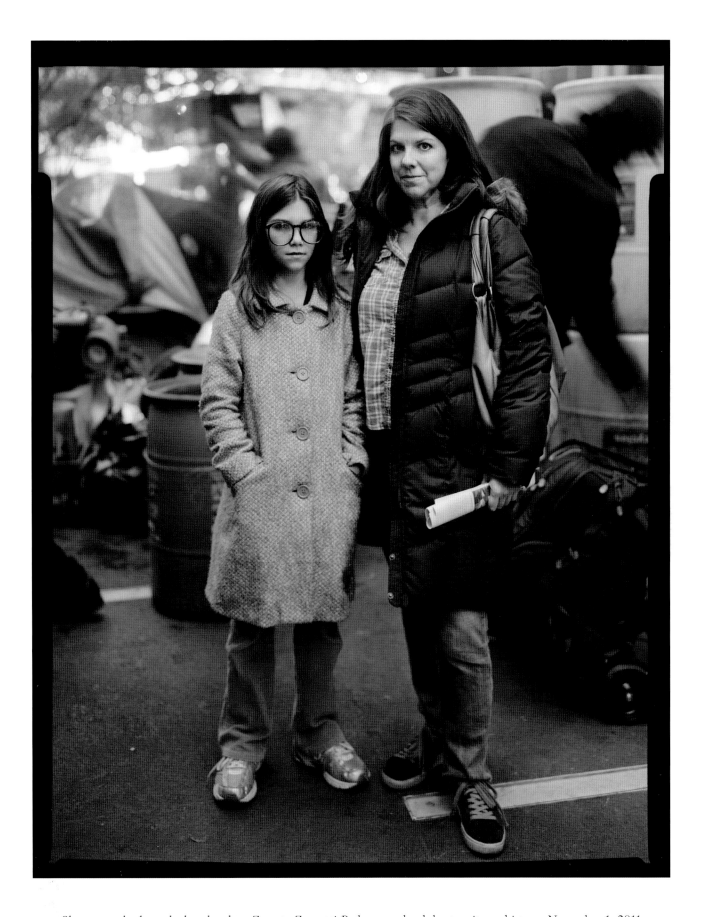

Shannon, who brought her daughter Zuzu to Zuccotti Park on a school day to witness history, November 1, 2011

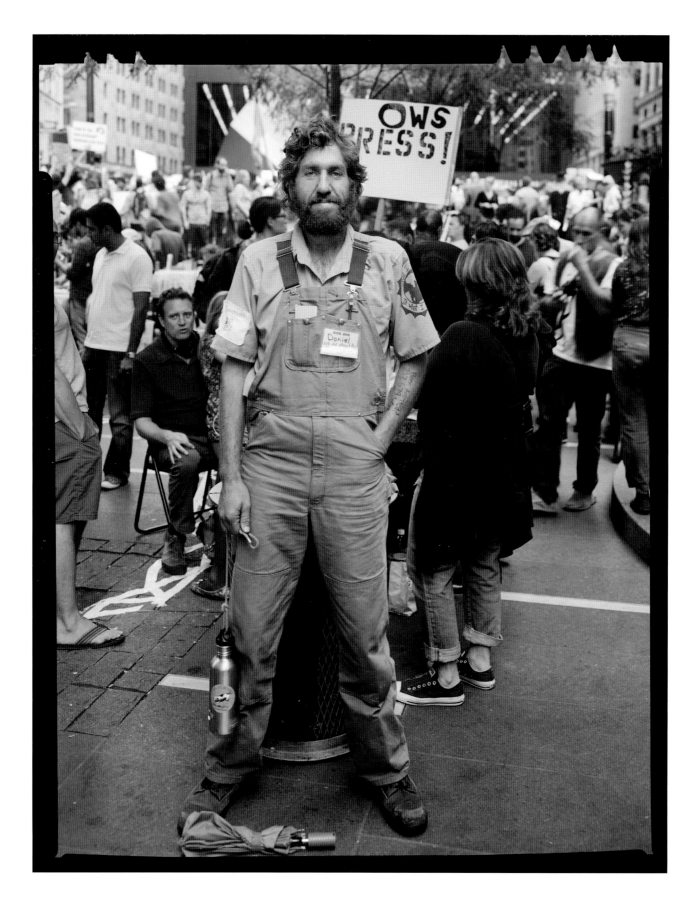

Daniel Zetah, one of the organizers of the protest, October 11, 2011

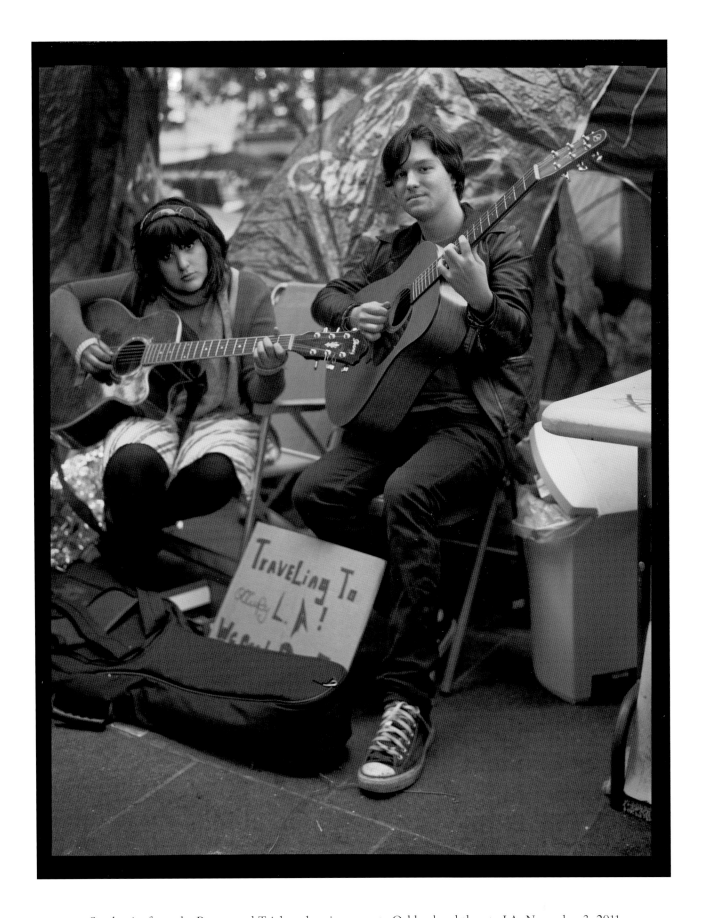

Stephanie, from the Bronx, and Tricky, planning to go to Oakland and then to LA, November 3, 2011

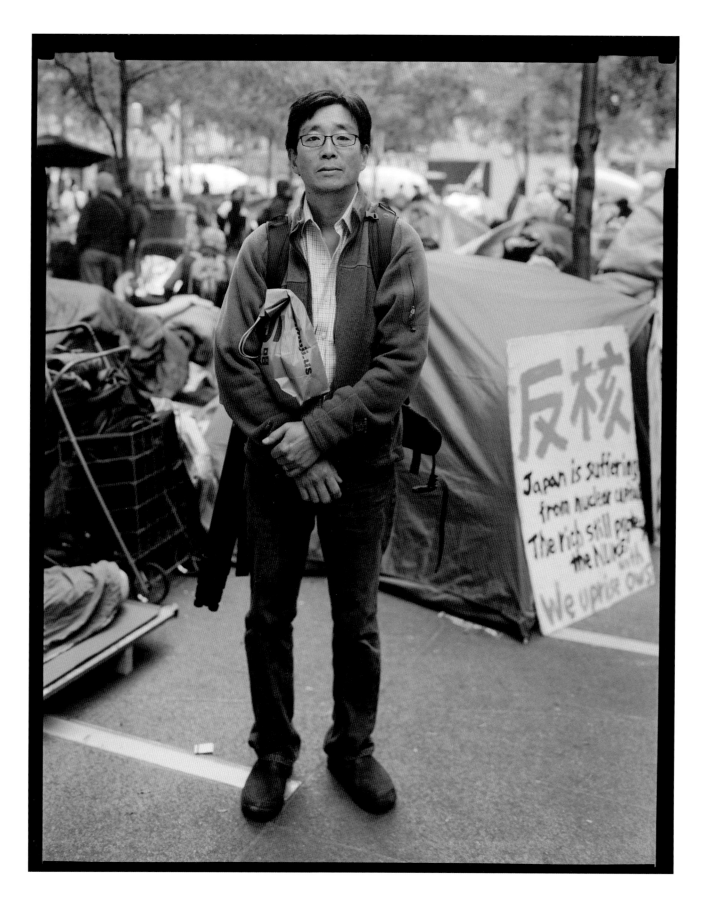

Chuck, architectural photographer from Boston, October 22, 2011

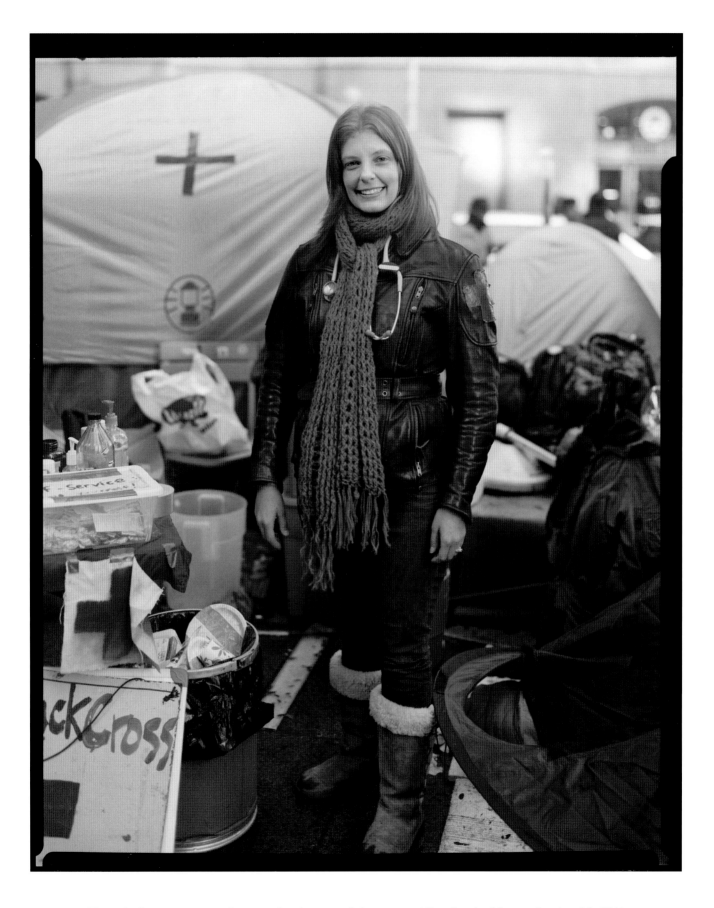

Nurse Liali, a new nurse who wanted to be part of change, providing free healthcare, October 30, 2011

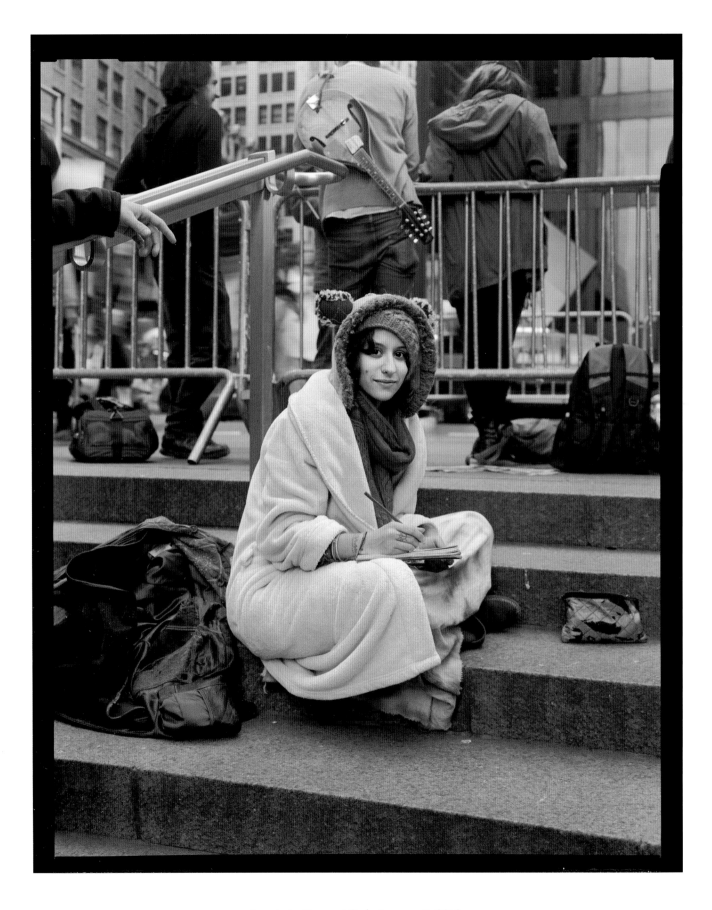

Jasmin in Zuccotti Park, January 7, 2012

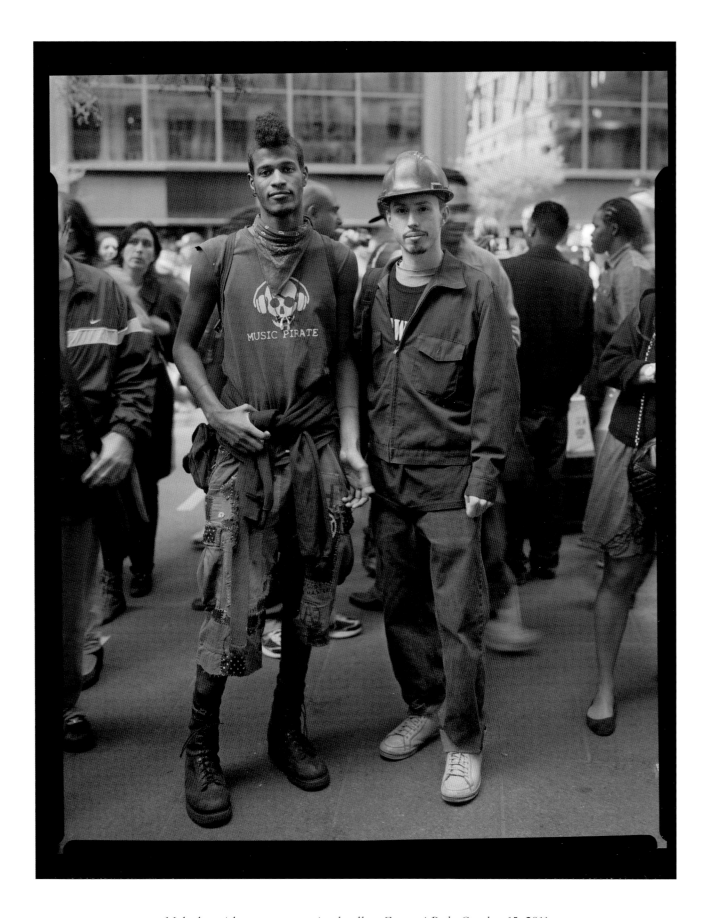

Malcolm with protester wearing hardhat, Zuccotti Park, October 15, 2011

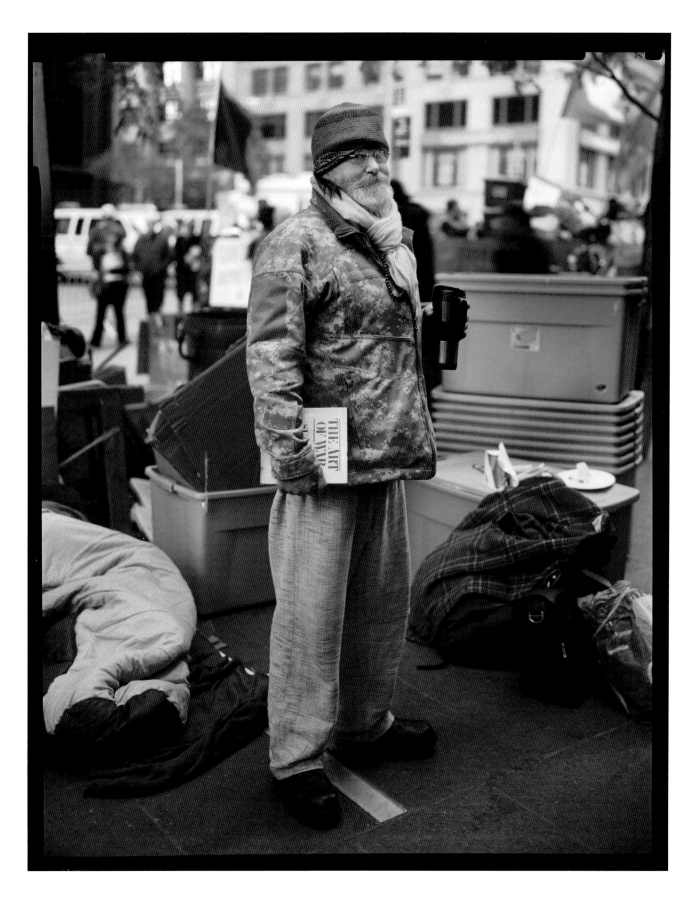

A community organizer based in India, October 21, 2011

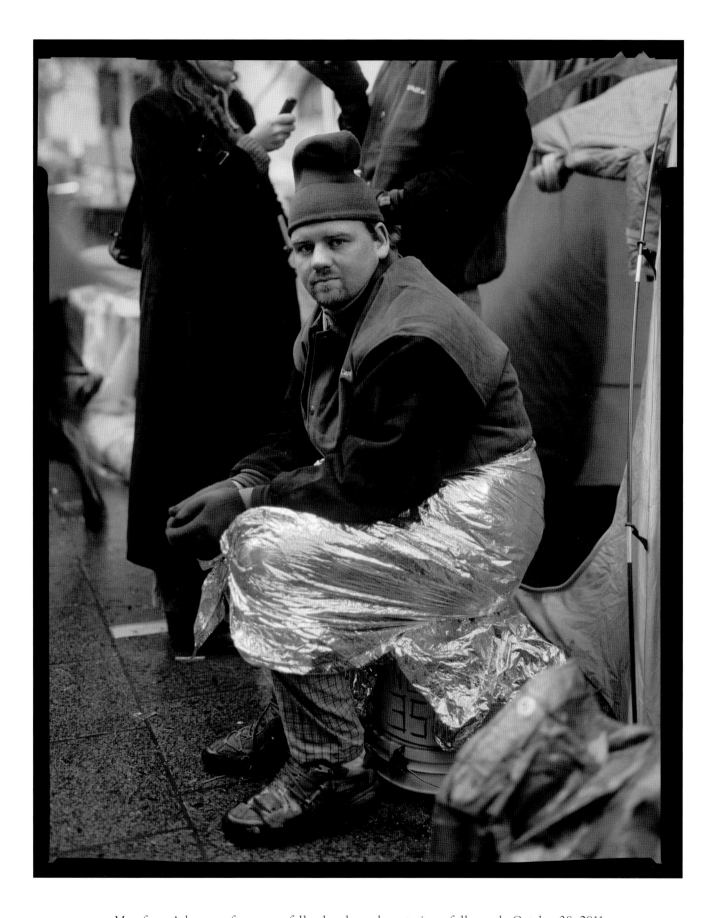

Man from Arkansas, after a snowfall, who planned on staying a full month, October 30, 2011

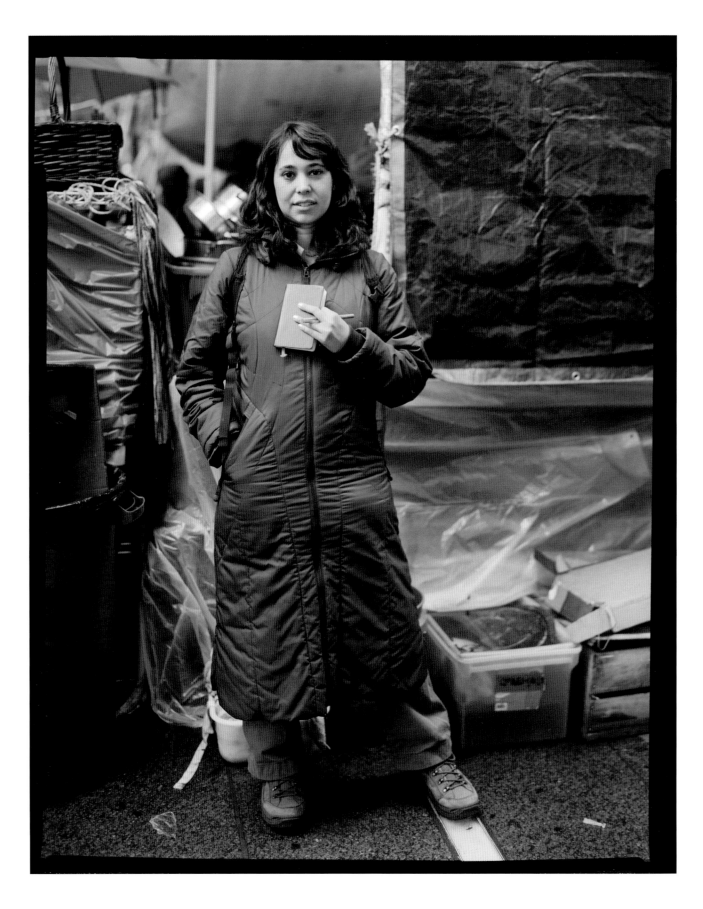

Anjali Sachdeva, writer and Director, Creative Nonfiction Foundation, researching Occupy, October 30, 2011

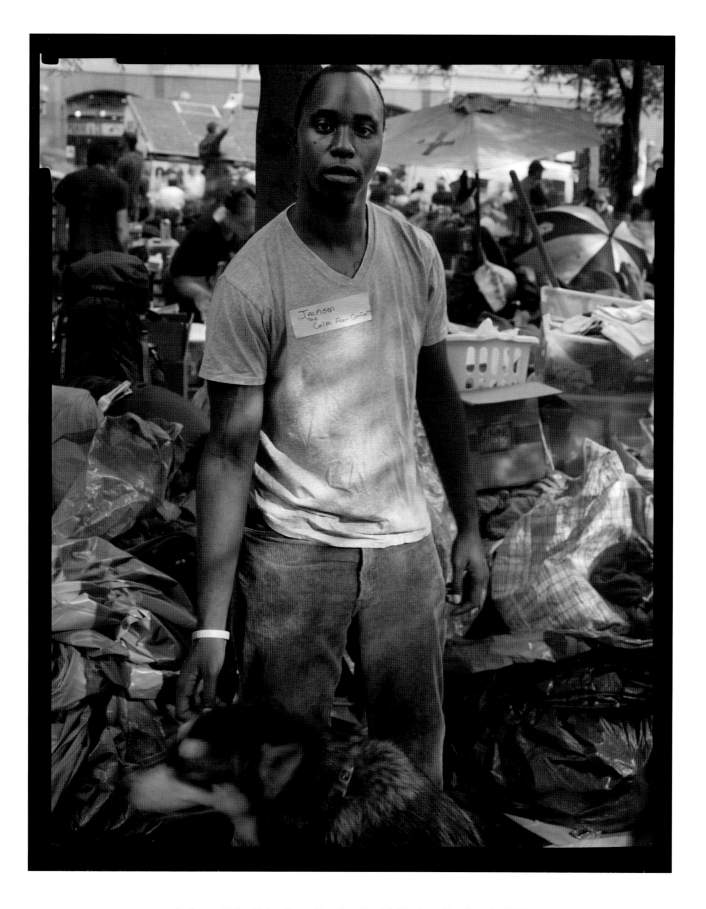

Jackson, "The Calm from Comfort," with his dog, October 9, 2011

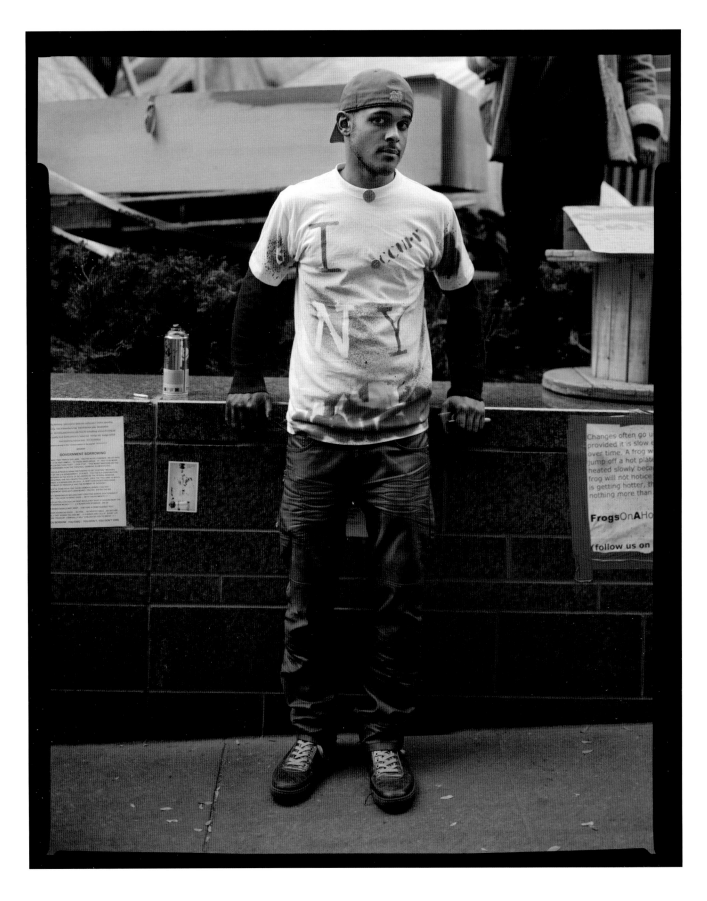

Hairo, formerly in the military, November 12, 2011

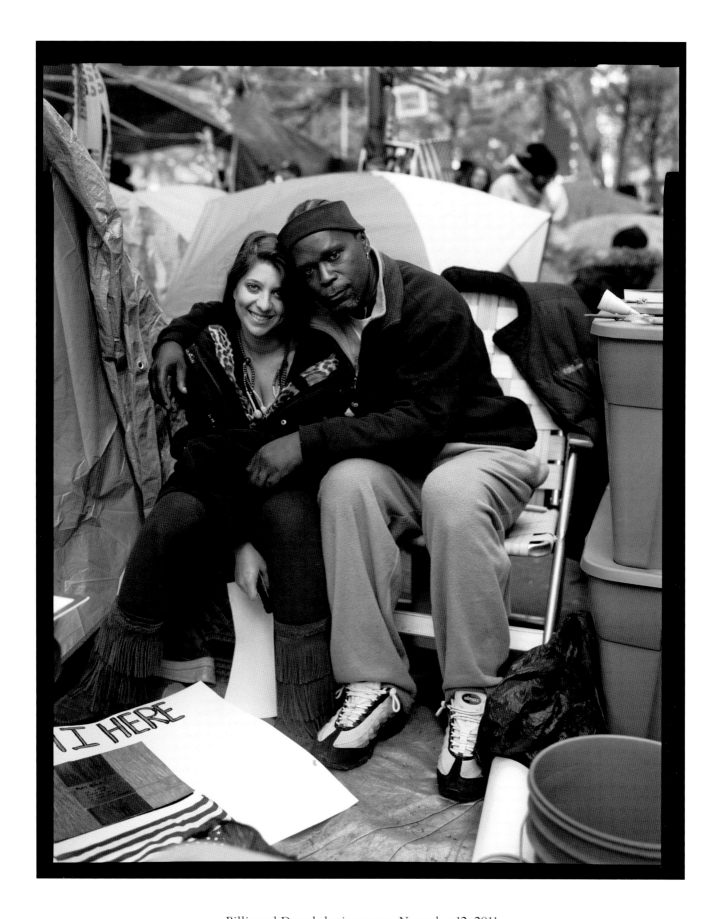

Billie and Darryl sharing a tent, November 12, 2011

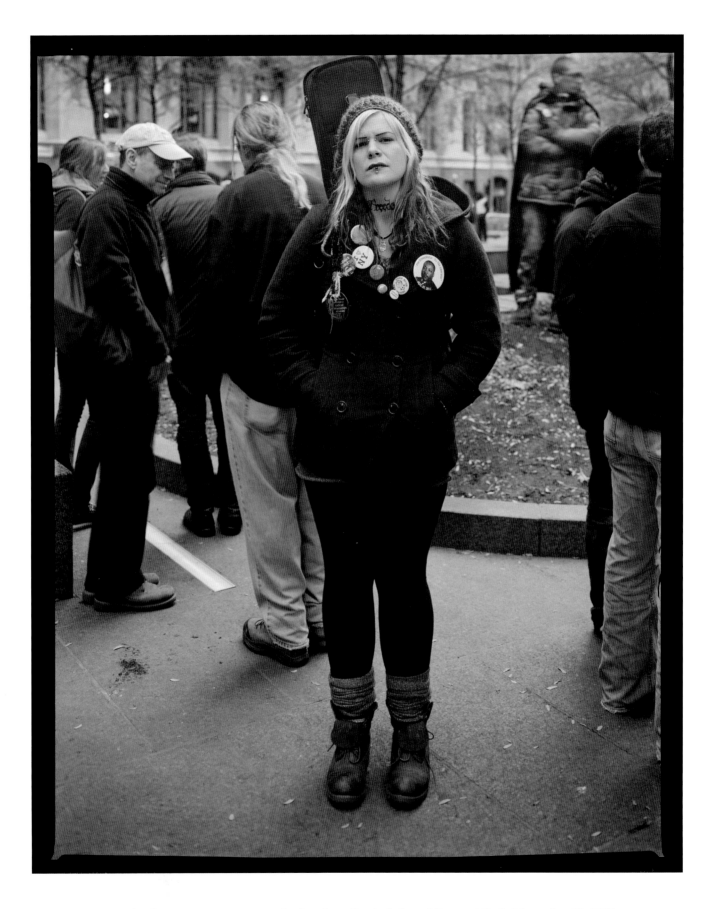

Kanaska Carter, musician, one week after the police had cleared Zuccotti Park, November 21, 2011

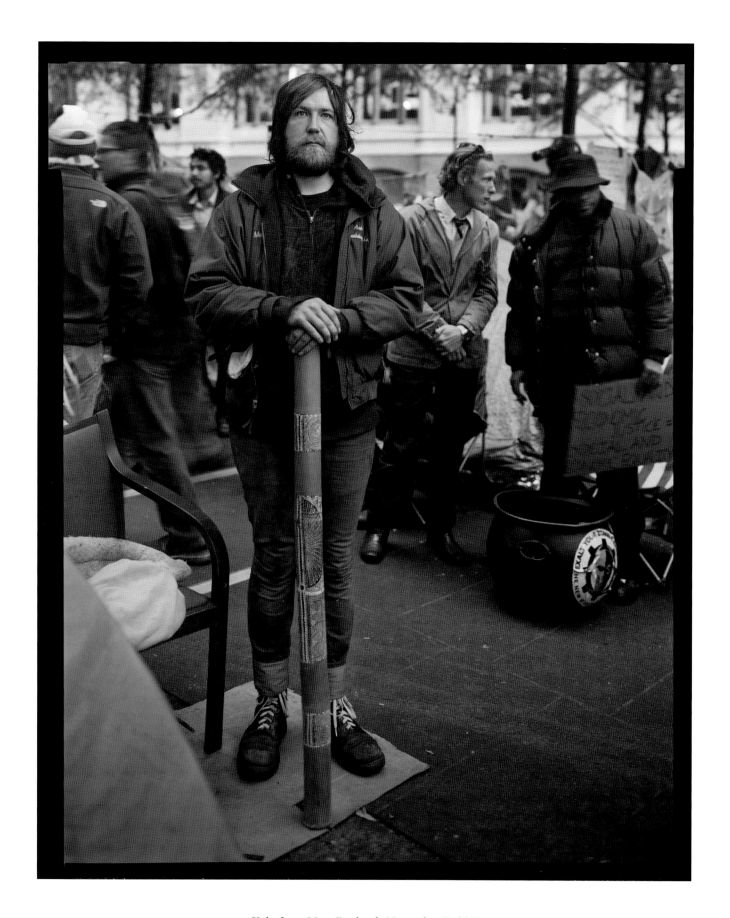

Kyle from New England, November 7, 2011

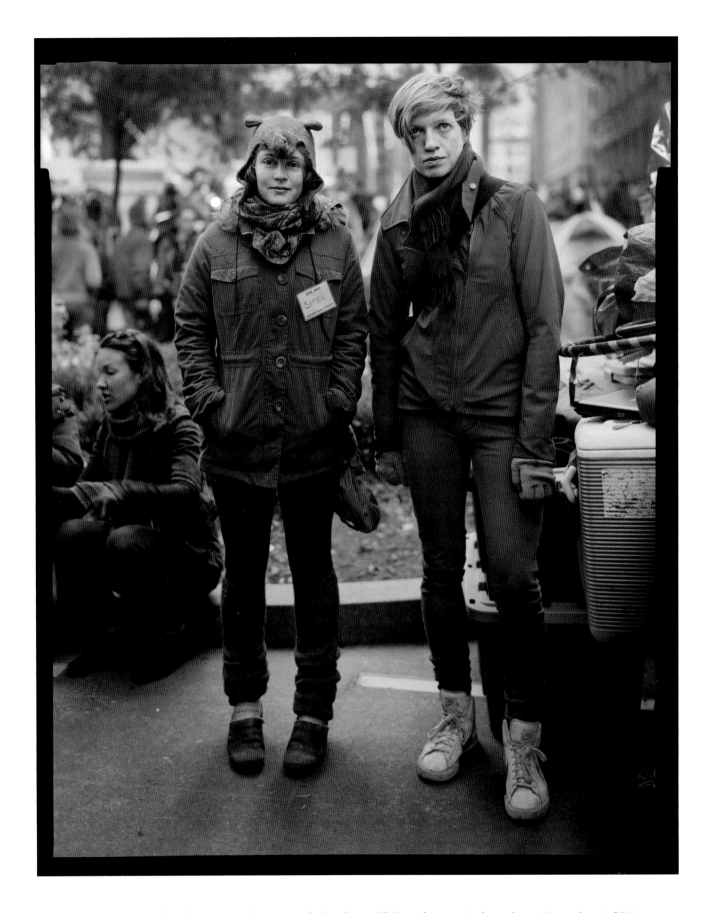

Sophie cycling from Vermont to Georgia with Caroline a PhD student in Anthropology, November 1, 2011

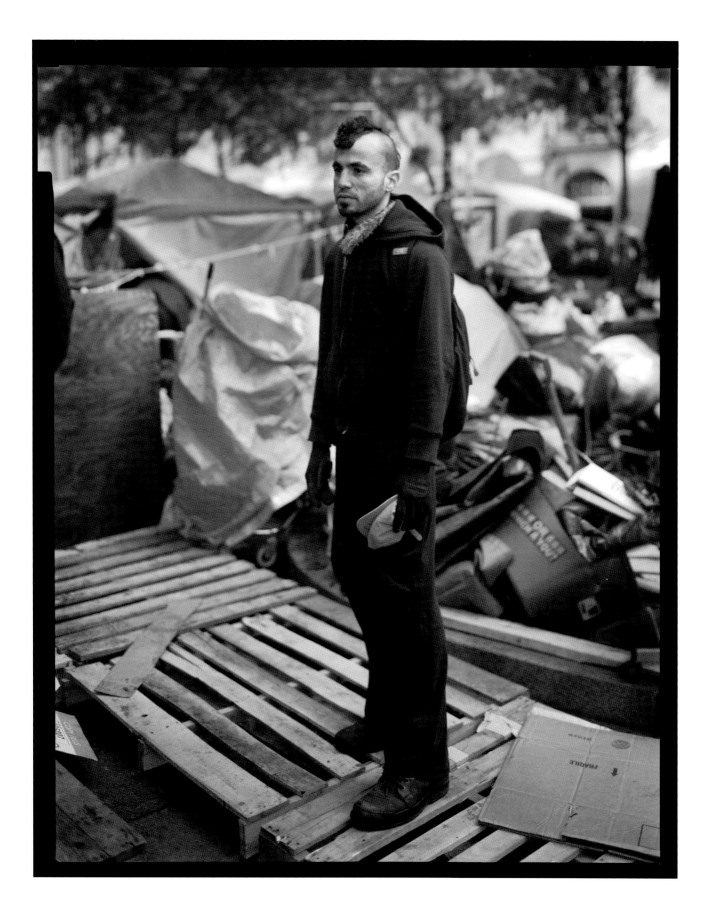

At the protest since the first day, October 28, 2011

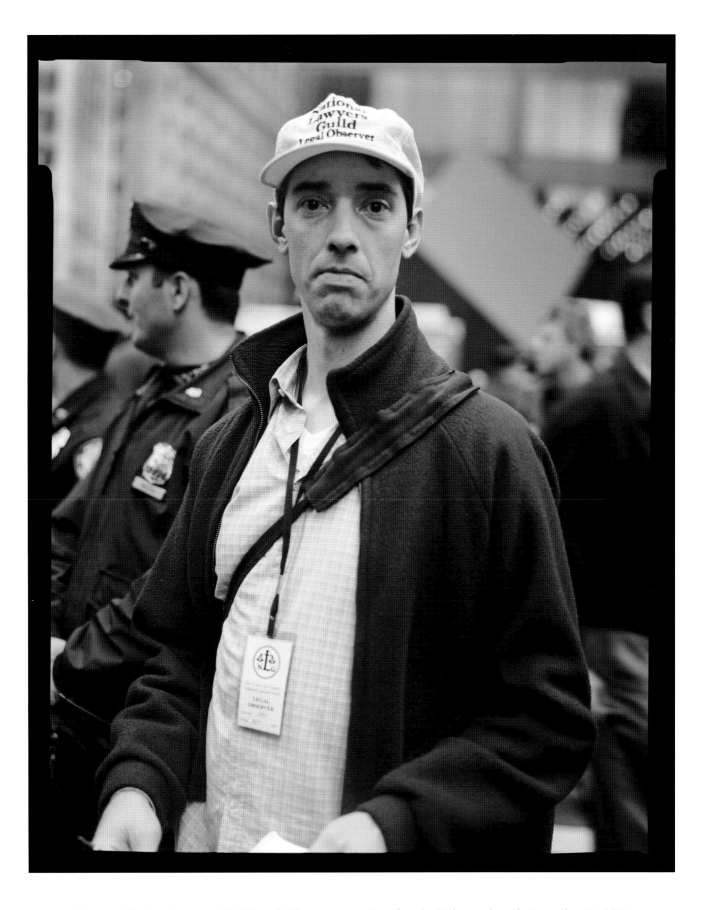

Damien, National Lawyers Guild Legal Observer, morning after the Park was cleared, November 15, 2011

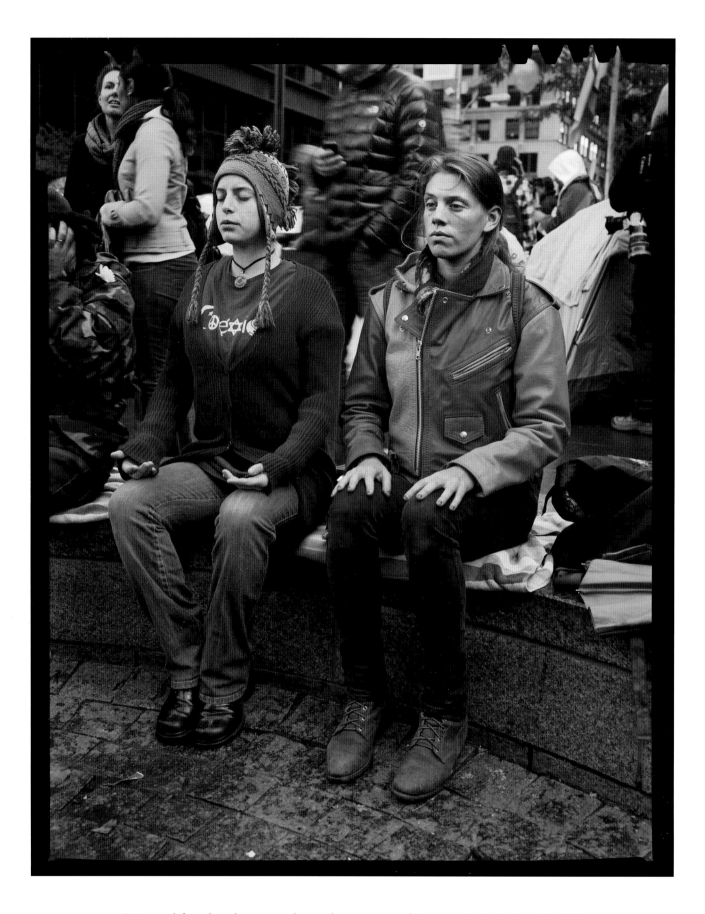

Reina and friend meditating in the northwest corner of Zuccotti Park, October 30, 2011

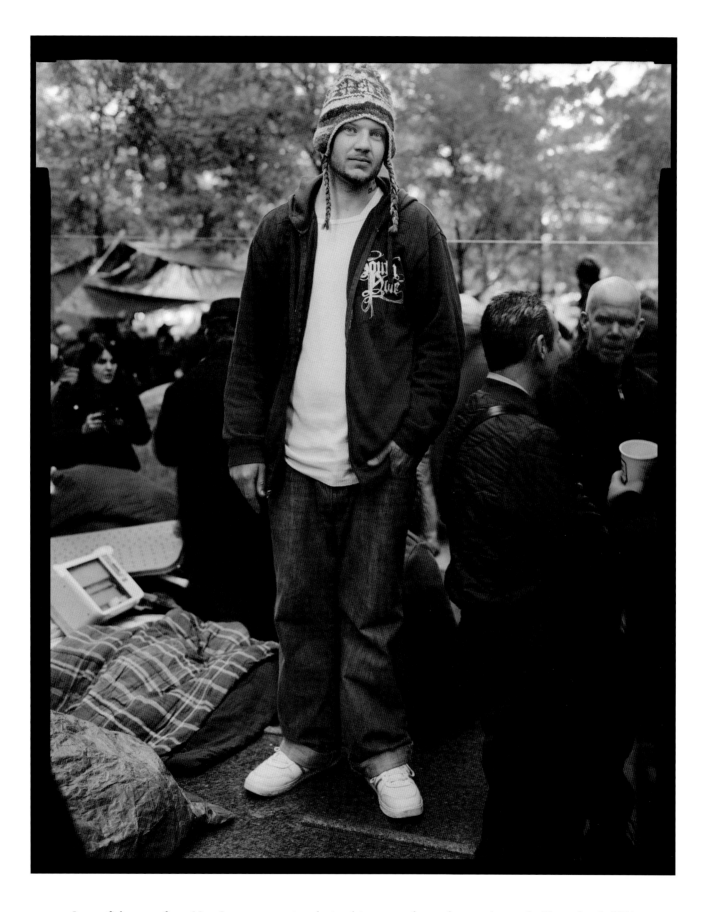

Jason, fisherman from New Jersey, protesting during his two weeks on shore each month, November 1, 2011

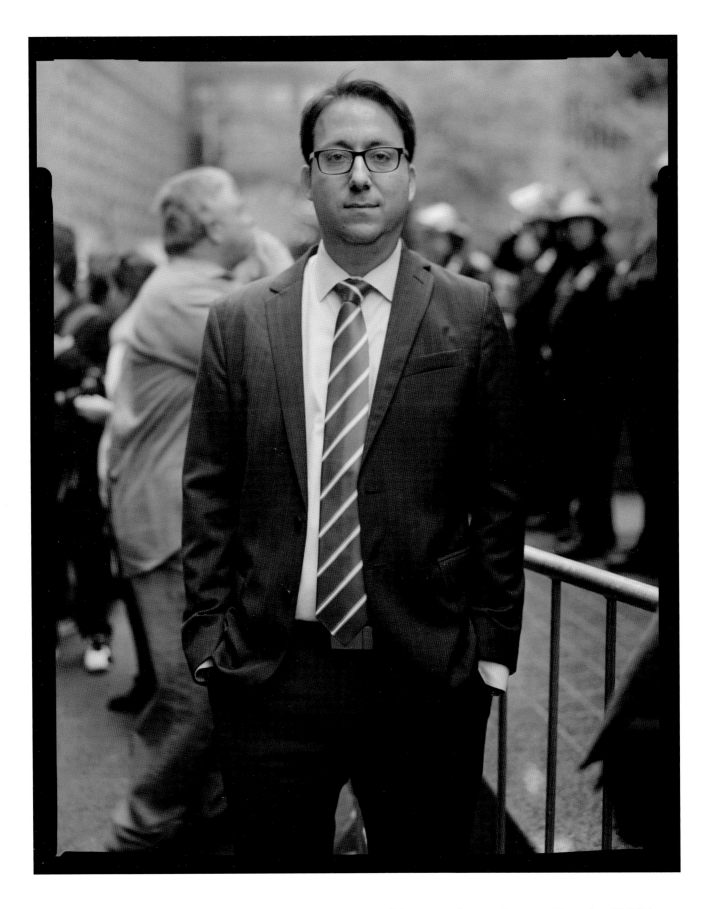

Udi Ofer, then head of the New Jersey ACLU, now Director of the National Justice Division, November 15, 2011

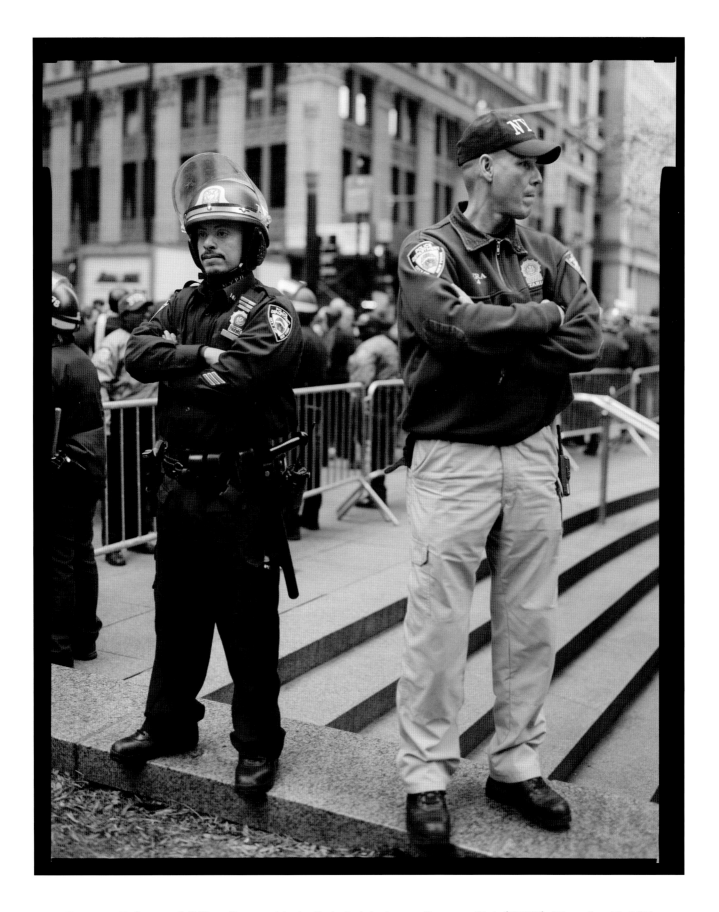

Detective DeJesus and Officer Rivera with the Technical Assistance Response Unit (TARU), November 15, 2011

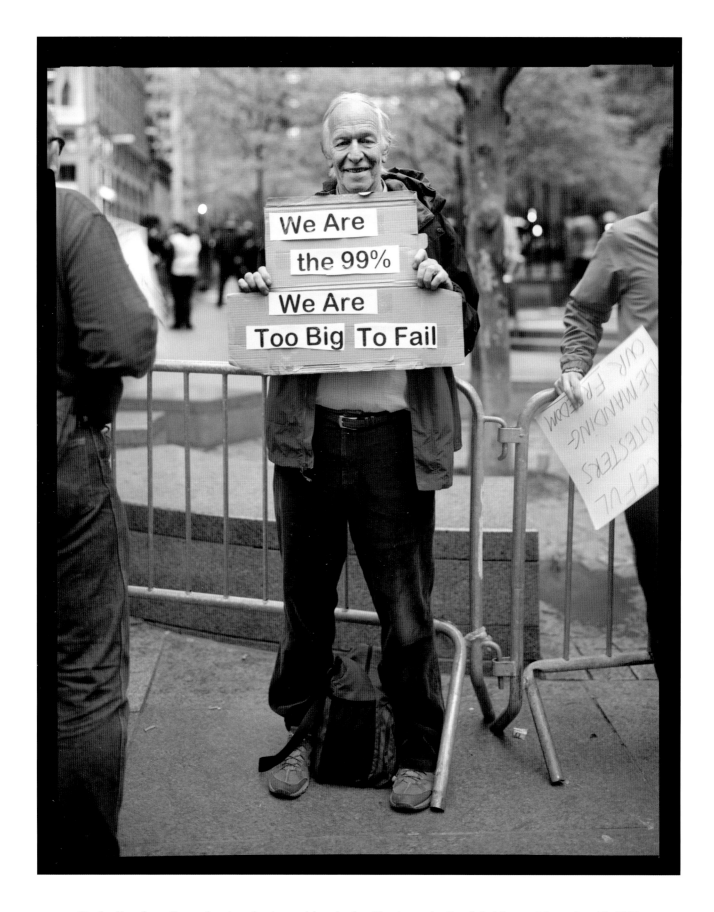

Bookseller, from Pennsylvania, who donated hundreds of books to the People's Library, November 15, 2011

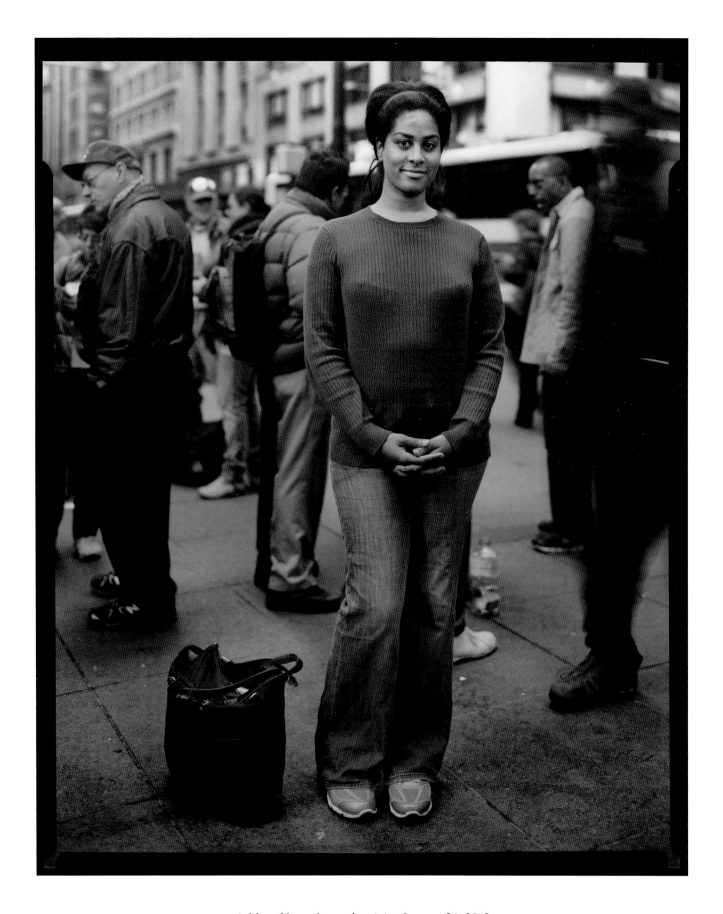

Ashley, filmmaker and activist, January 24, 2012

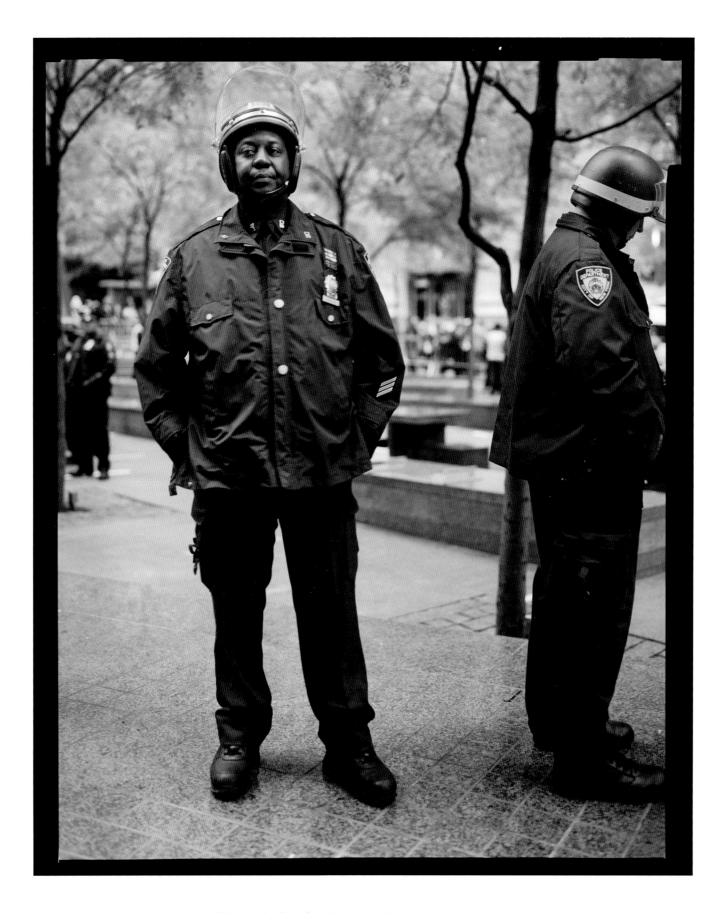

Detective Alleyne, the day after Zuccotti Park was cleared, November 15, 2011

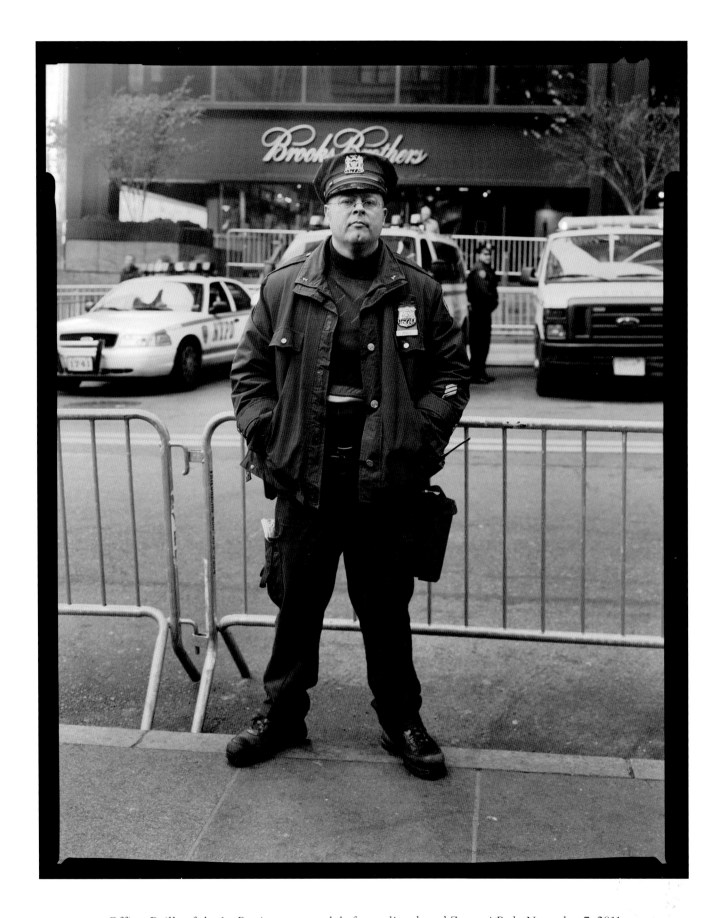

Officer Reilly of the 1st Precinct, one week before police cleared Zuccotti Park, November 7, 2011

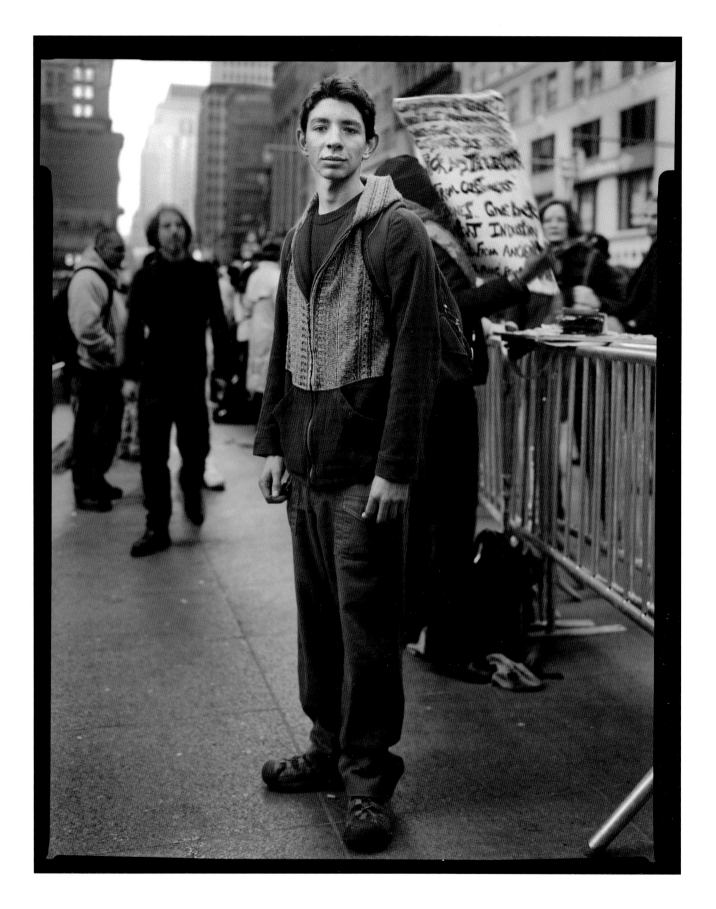

Eli Weinburd, Zuccotti Park, January 7, 2012

IV

winter of discontent

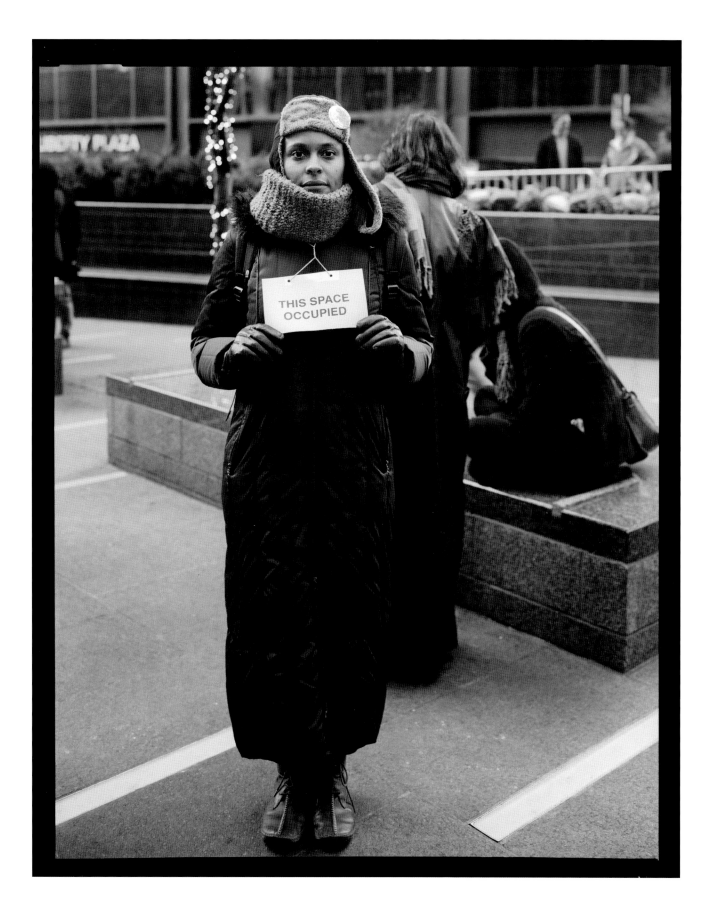

Stacey, office worker, protesting on her lunch break, December 3, 2011

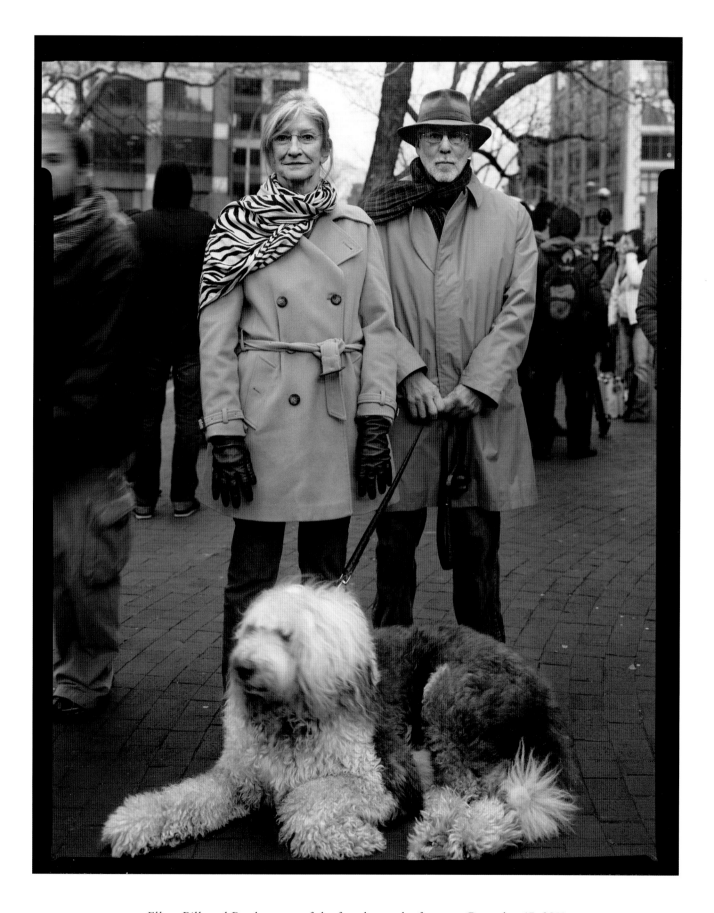

Ellen, Bill, and Bambu, start of the fourth month of protest, December 17, 2011

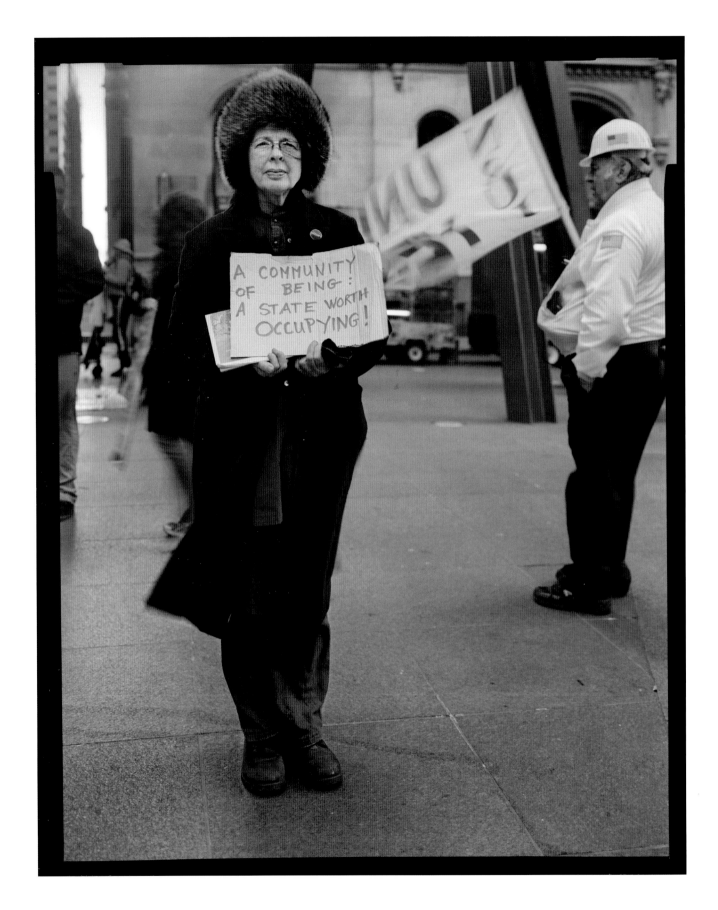

Mary from New York City protesting in Zuccotti Park, January 31, 2012

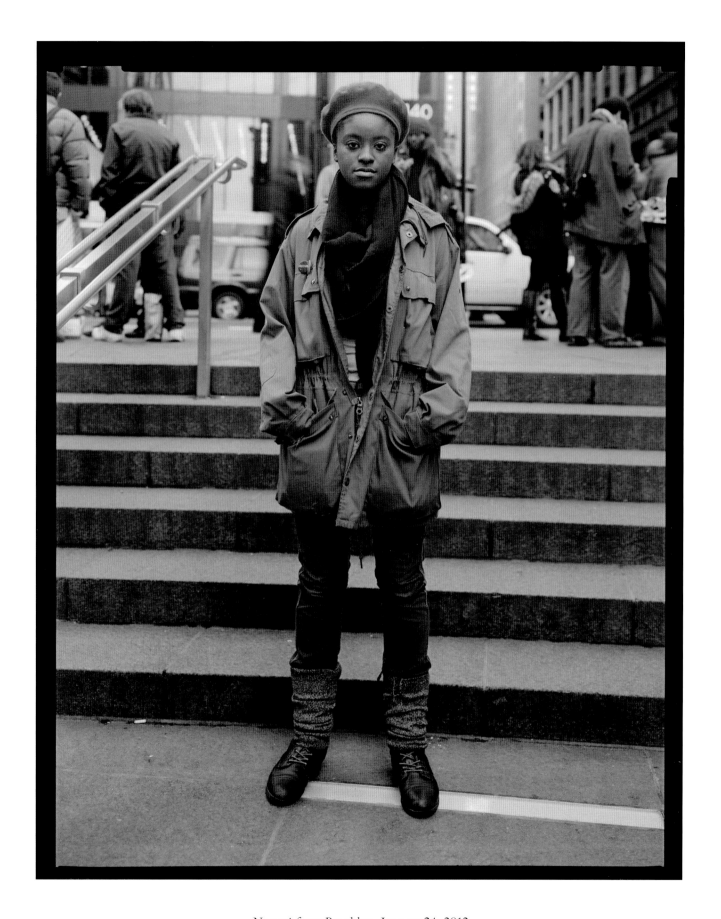

Negesti from Brooklyn, January 24, 2012

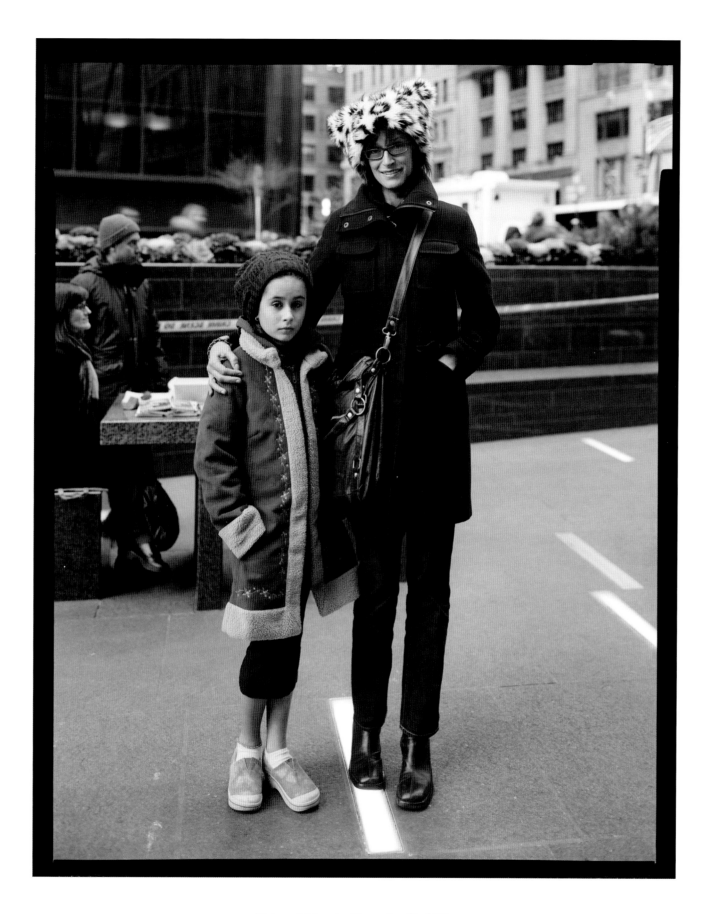

Zola and Maggie, December 11, 2011

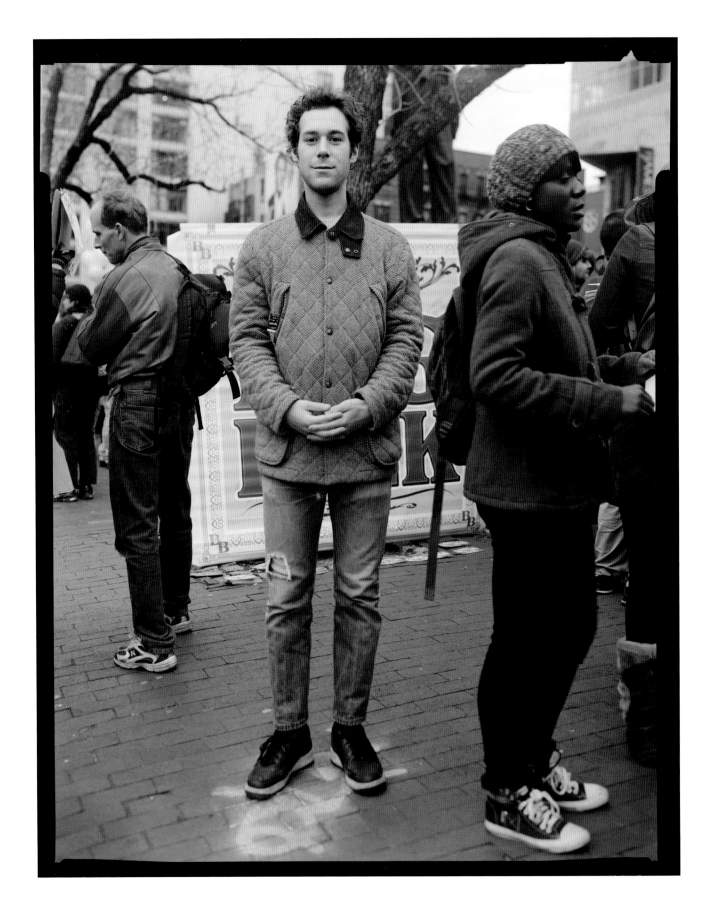

Jett, Duarte Square, December 17, 2011

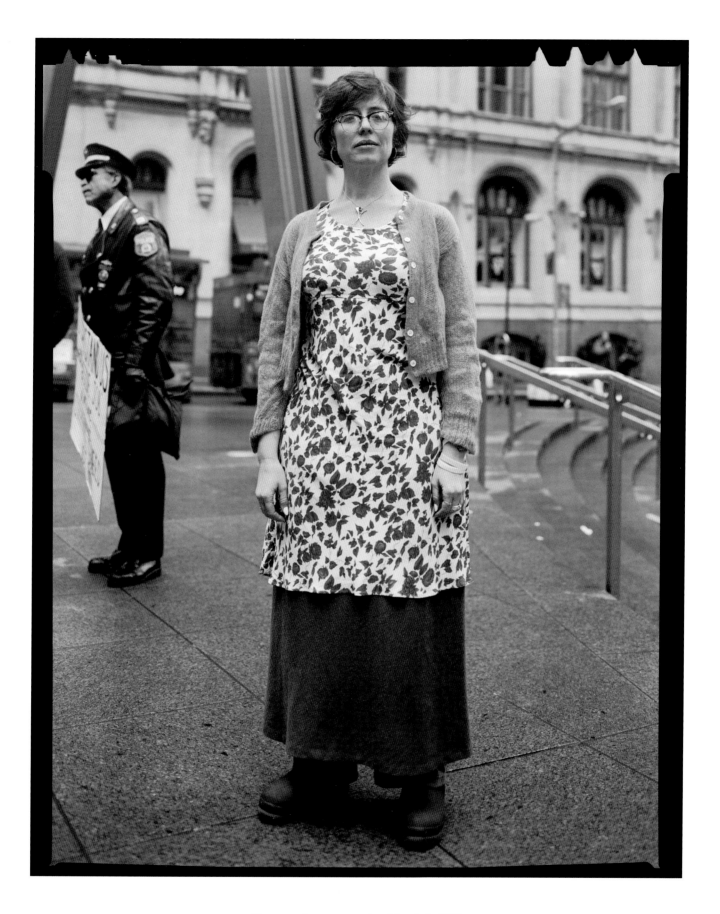

Yana, performance artist, March 1, 2012

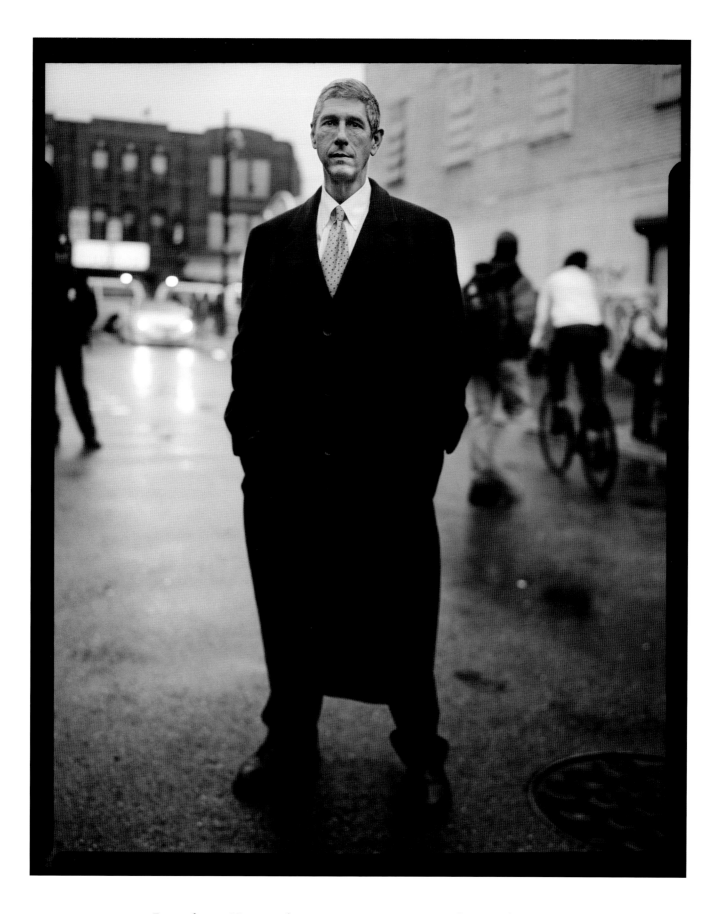

Fetzer, former Navy translator, protesting in East New York, December 6, 2011

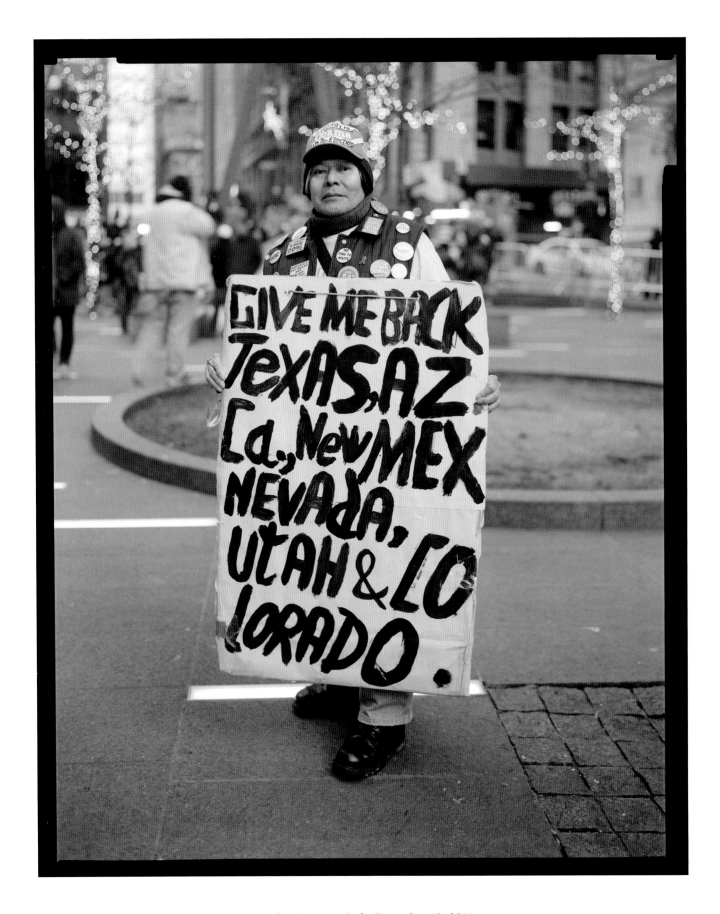

Israel in Zuccotti Park, December 18, 2011

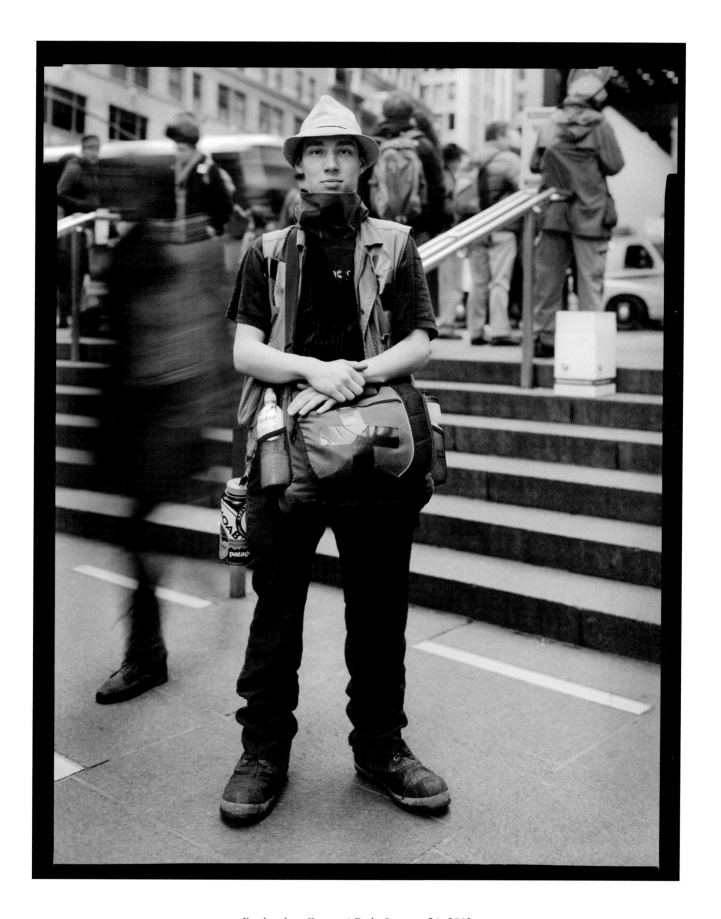

Feather-hat, Zuccotti Park, January 24, 2012

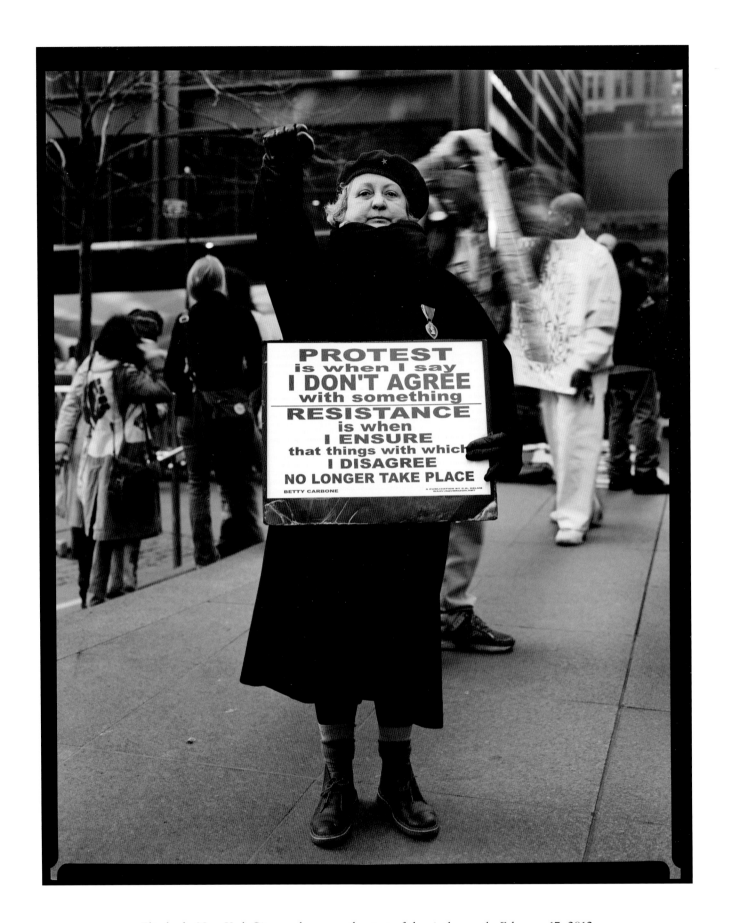

Elizabeth, New York City employee, on the start of the sixth month, February 17, 2012

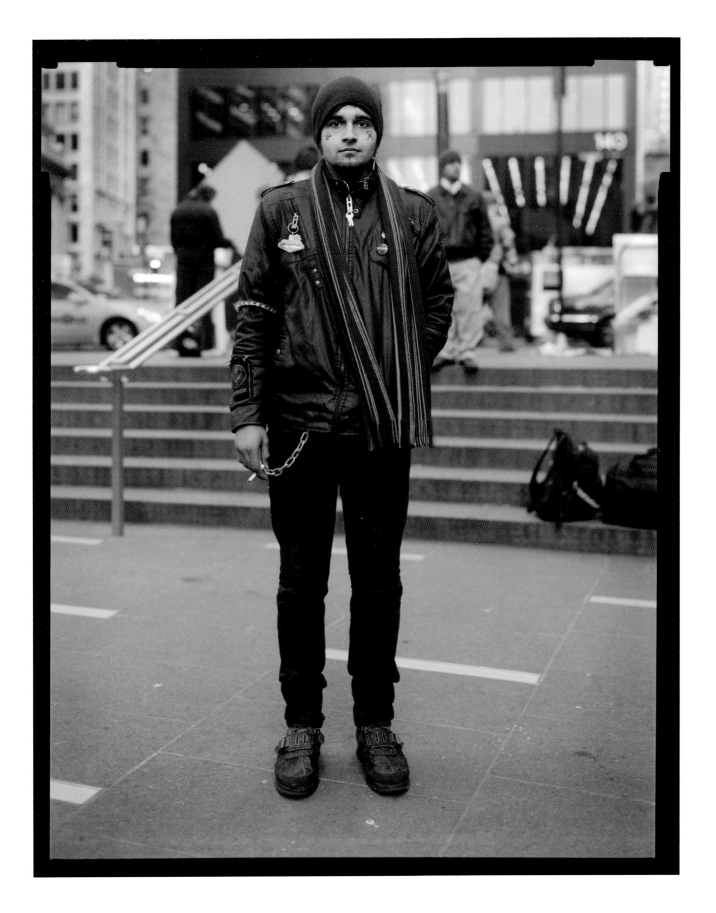

Zion from Florida, January 31, 2012

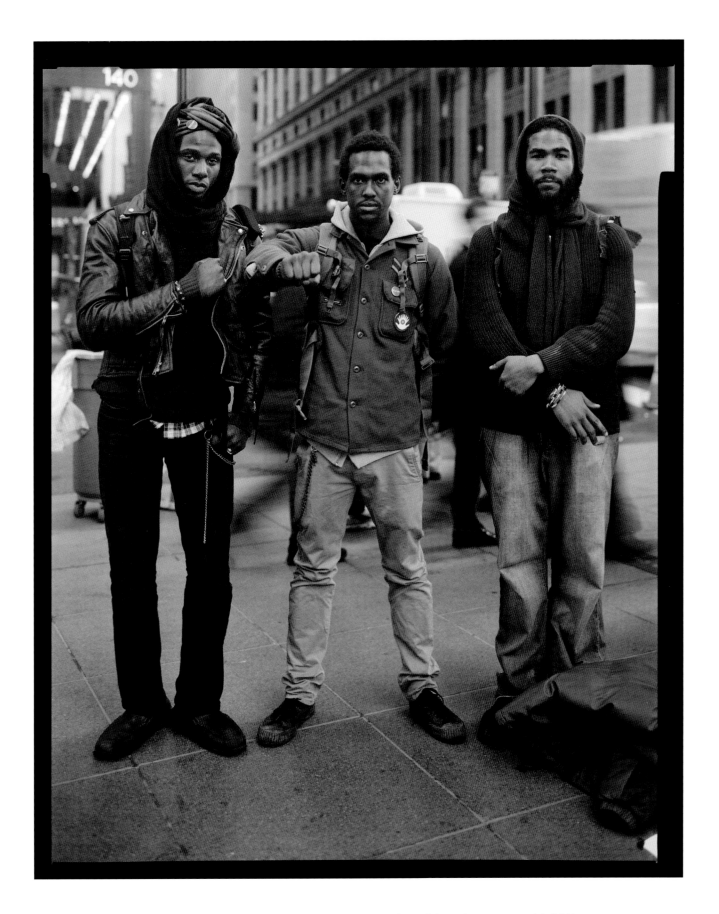

Three Black men, who requested anonymity for fear of the police, January 24, 2012

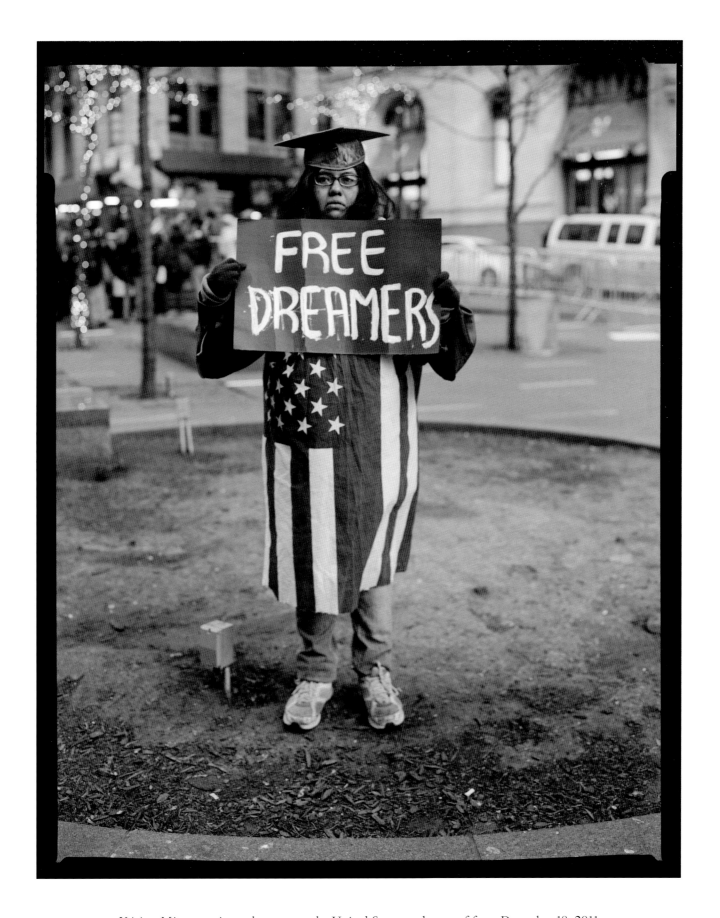

Yajaira, Mixtec nation, who came to the United States at the age of four, December 18, 2011

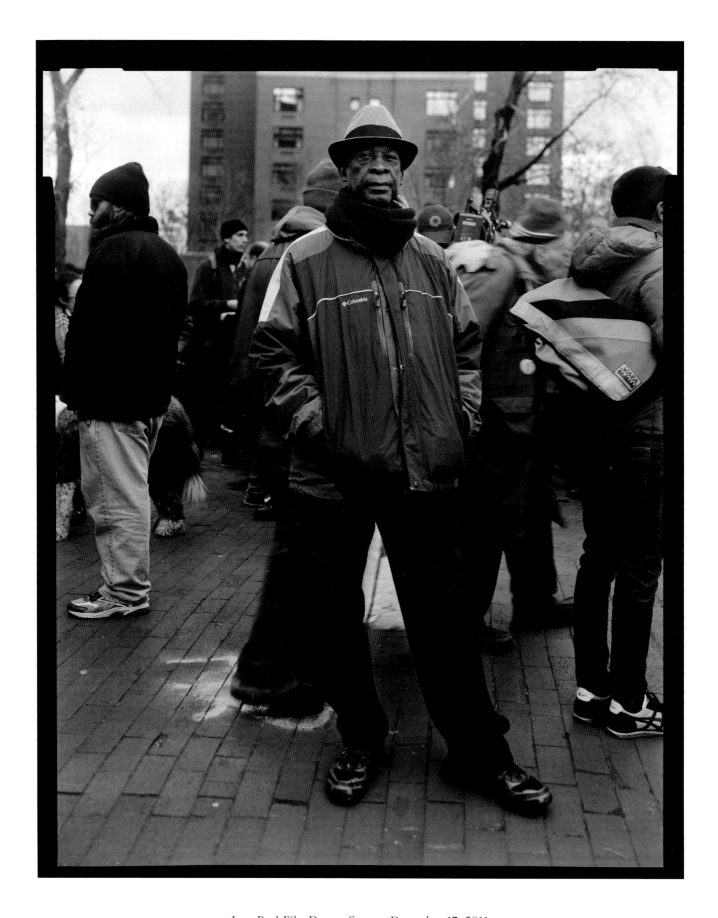

Jean-Paul Fils, Duarte Square, December 17, 2011

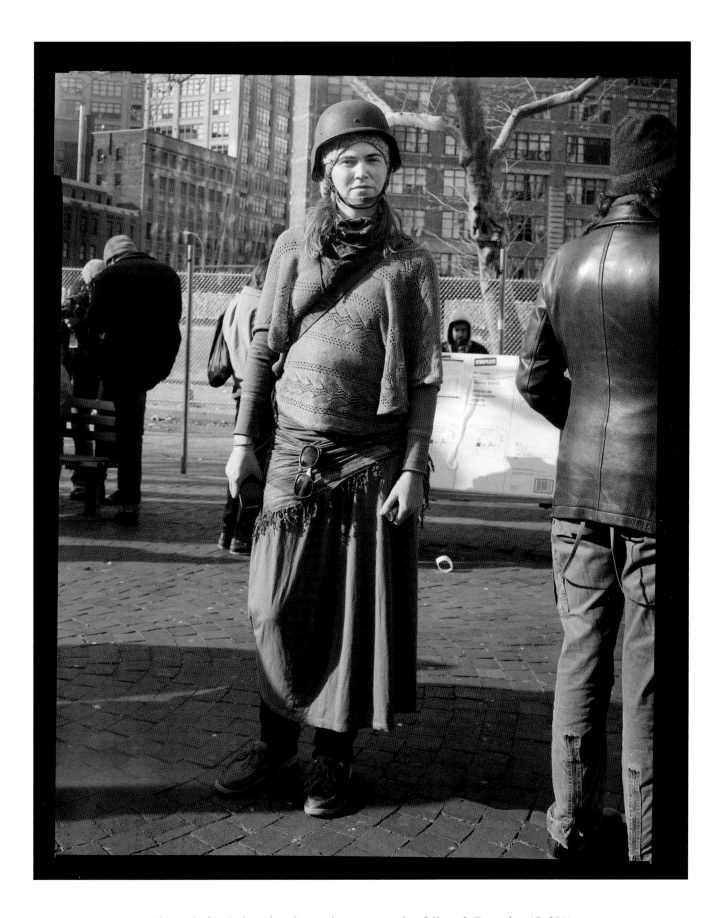

Eli, ready for clash with police and mass arrest that followed, December 17, 2011

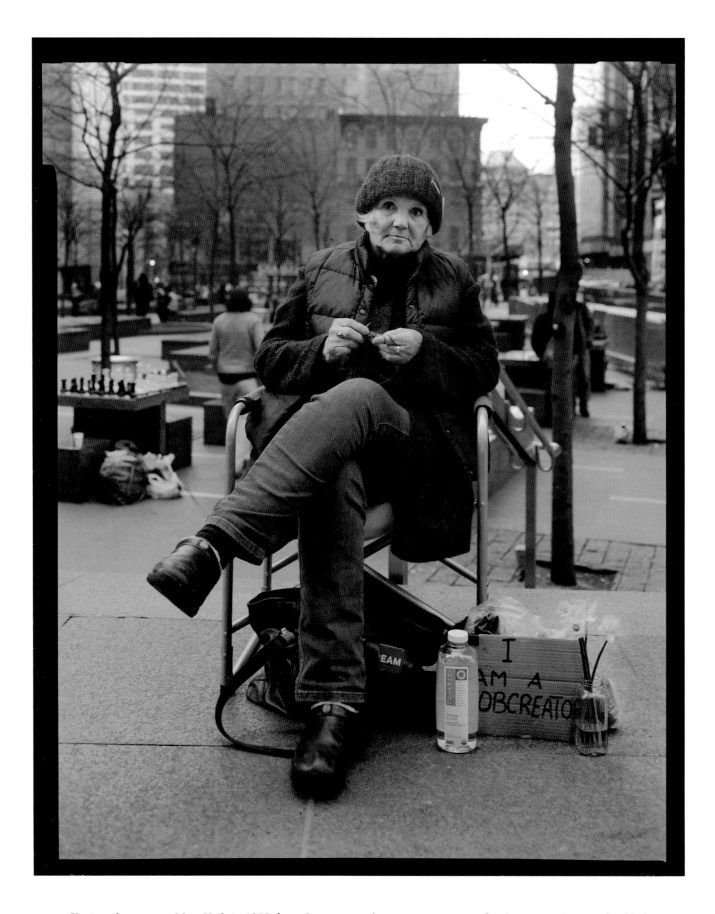

Karin, who came to New York in 1950 from Germany, making warm garments for Occupiers, January 31, 2012

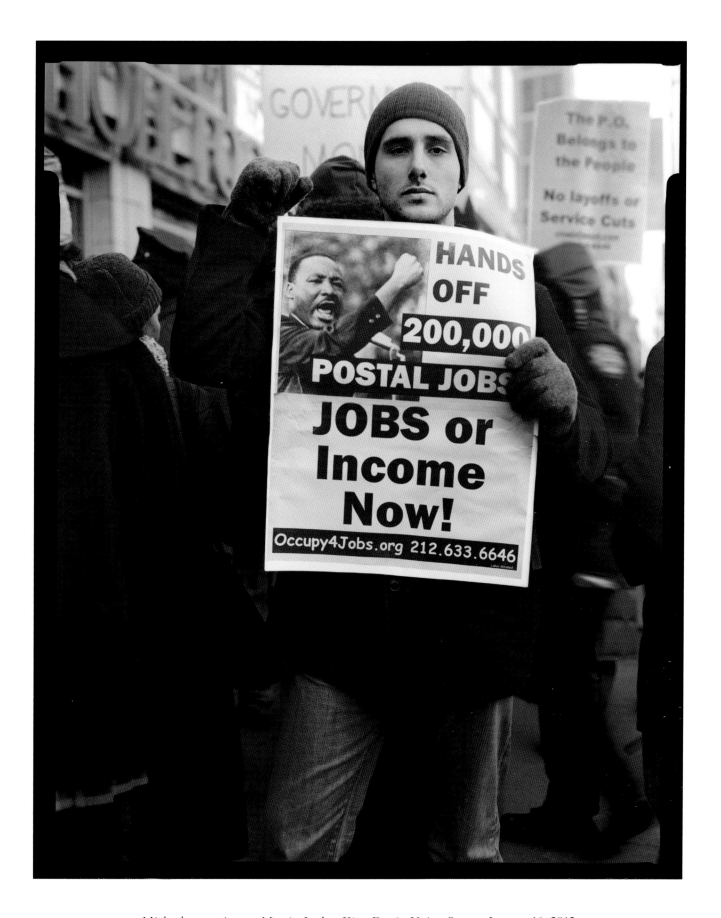

Michael protesting on Martin Luther King Day in Union Square, January 16, 2012

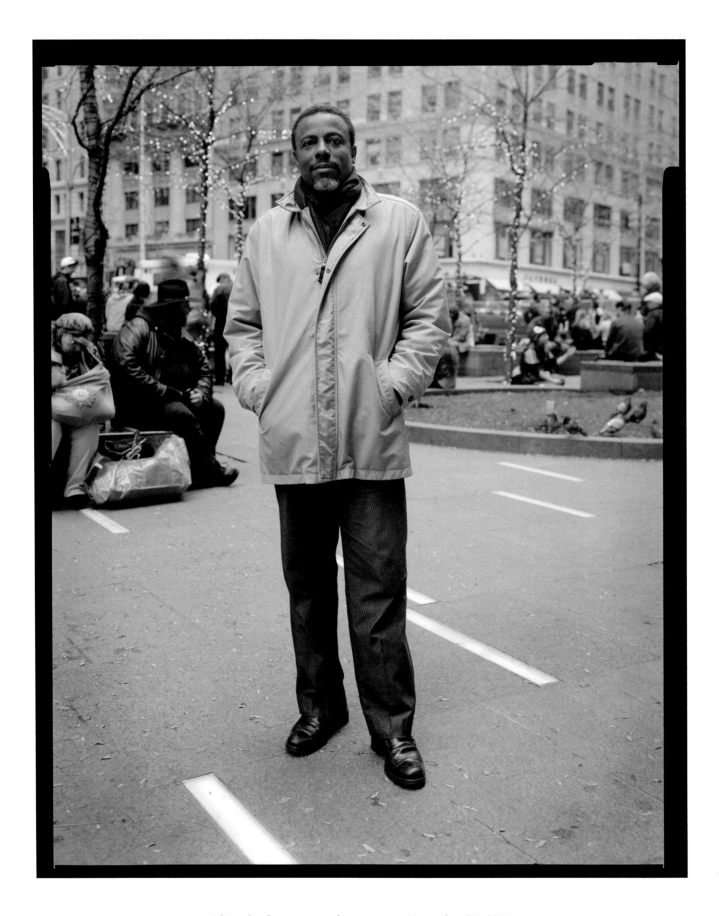

Aliy, a banker, visiting the protest on November 29, 2011

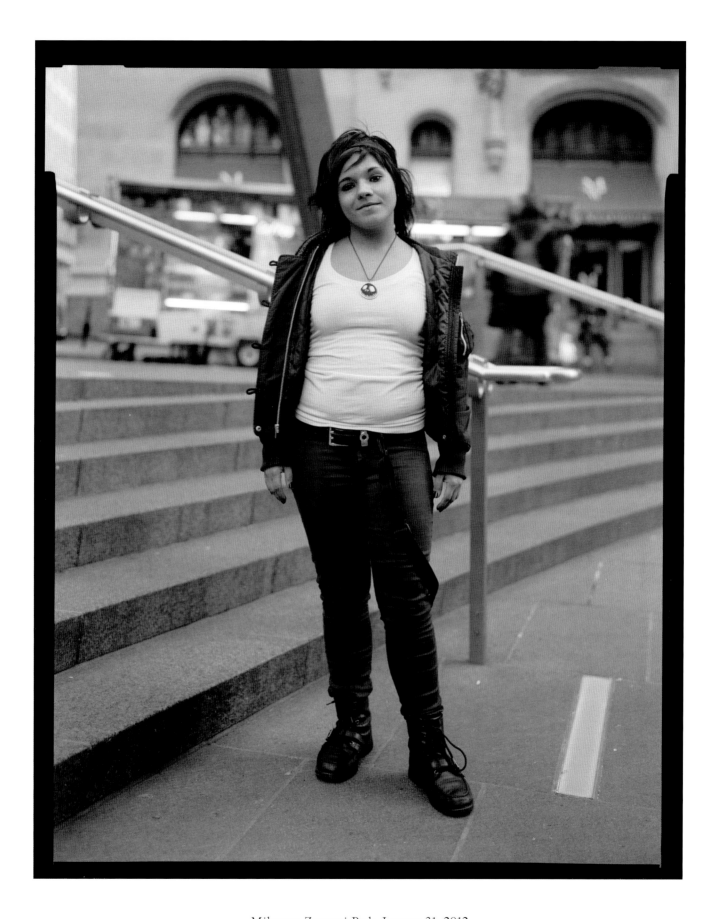

Milagros, Zuccotti Park, January 31, 2012

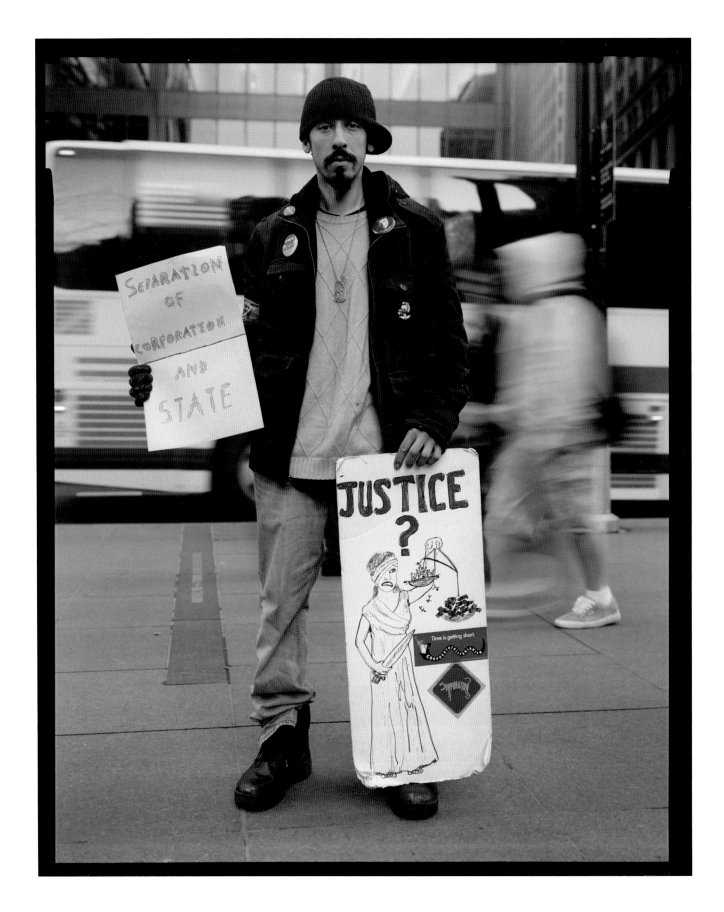

Jose, from Brooklyn, protesting in Zuccotti Park on February 17, 2012

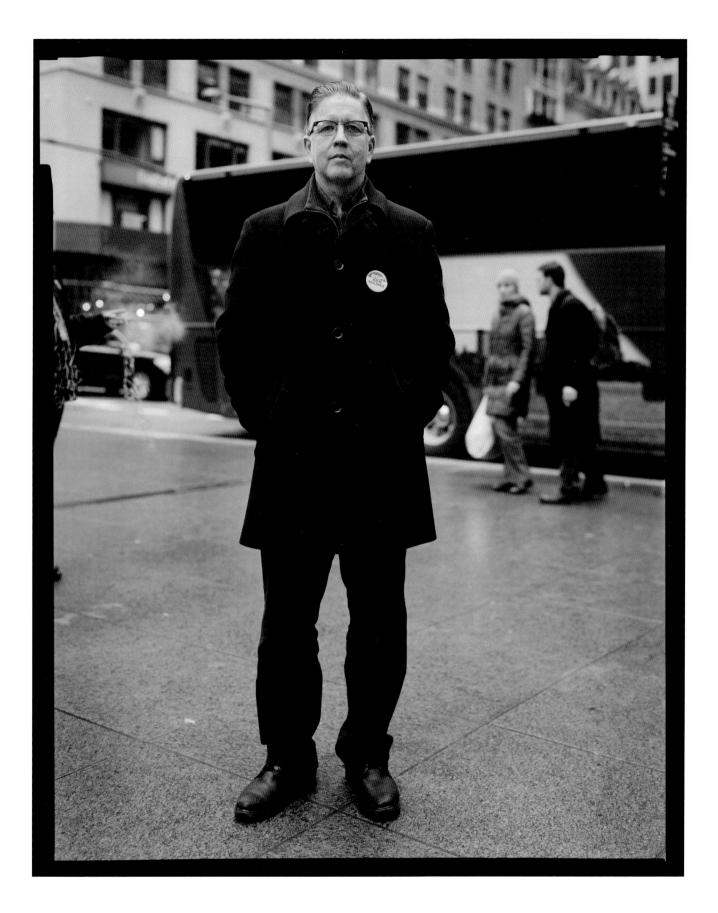

Kevin Bud Jones, musician, protesting in Zuccotti Park on March 1, 2012

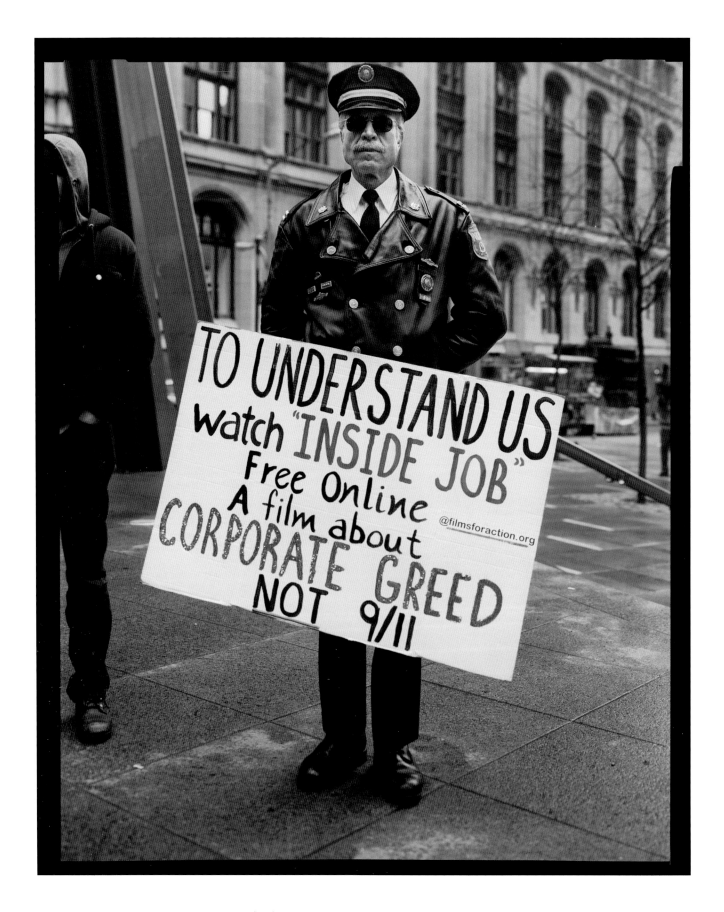

Captain Ray Lewis (ret.), Philadelphia Police officer, protesting on March 1, 2012

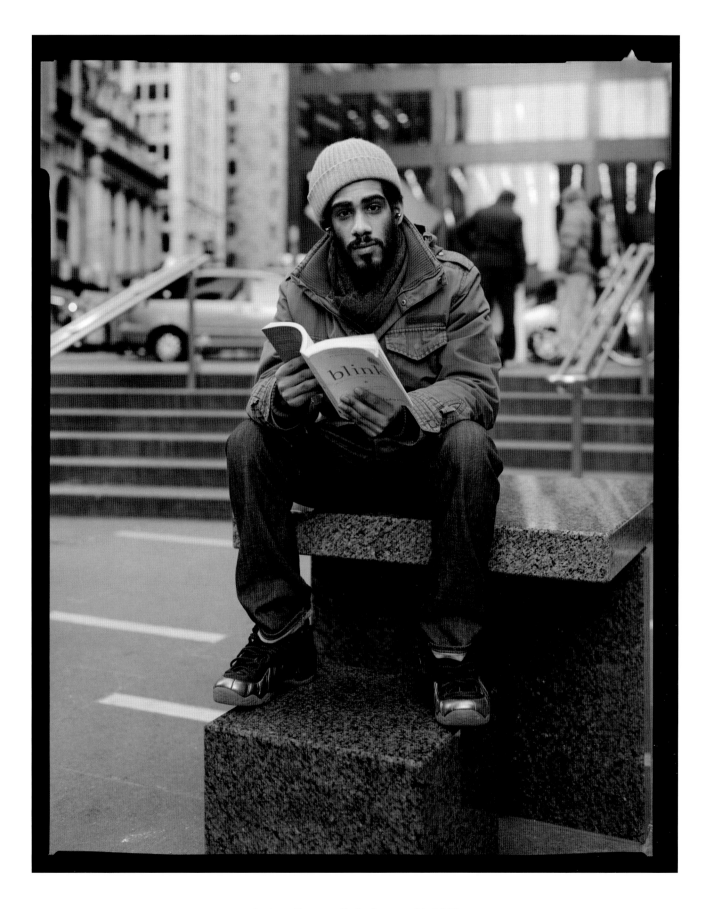

Luis in Zuccotti Park, January 31, 2012

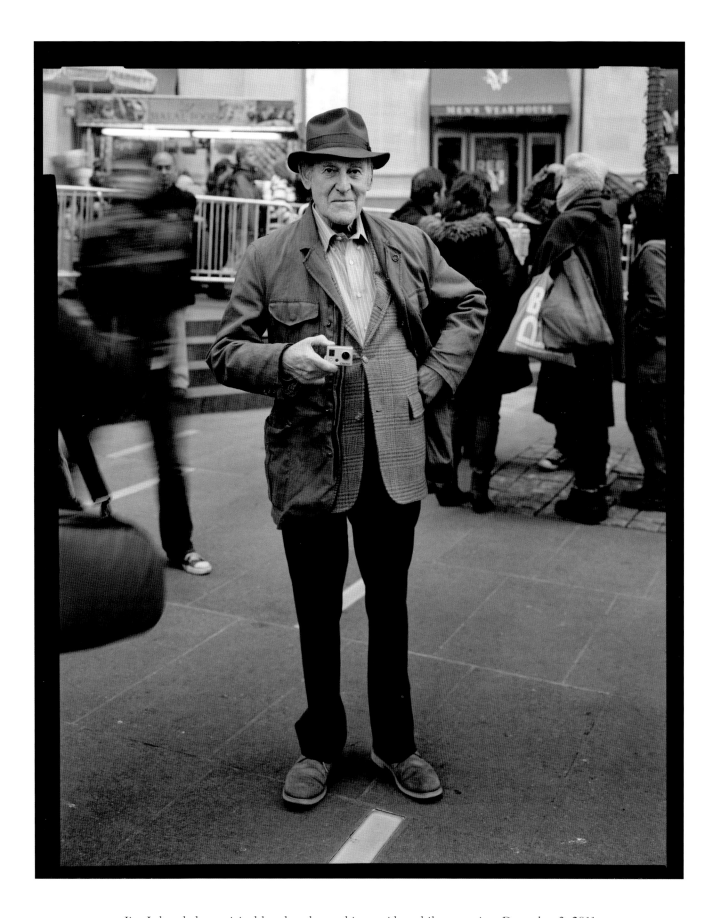

Jim Lebenthal, municipal bond trader, making a video while protesting, December 3, 2011

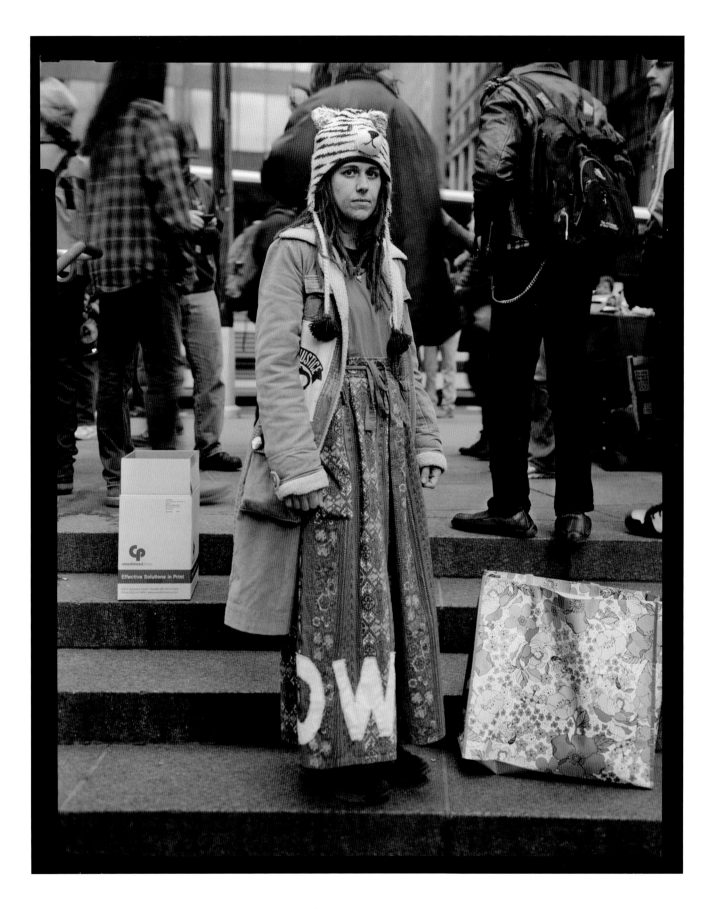

Stacey from Florida, Zuccotti Park, January 24, 2012

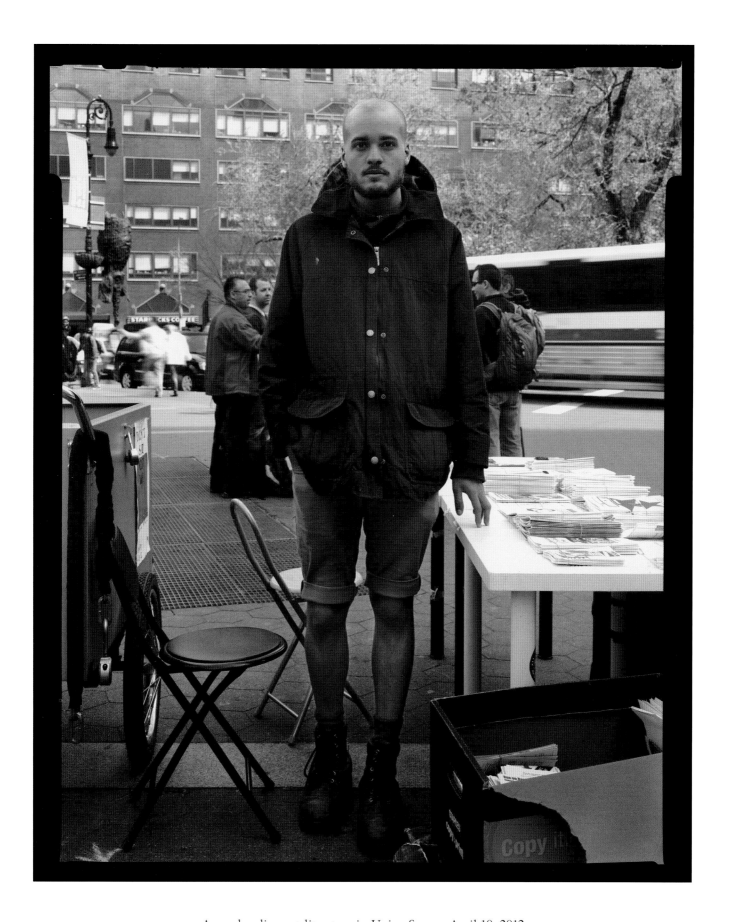

Aaron handing out literature in Union Square, April 10, 2012

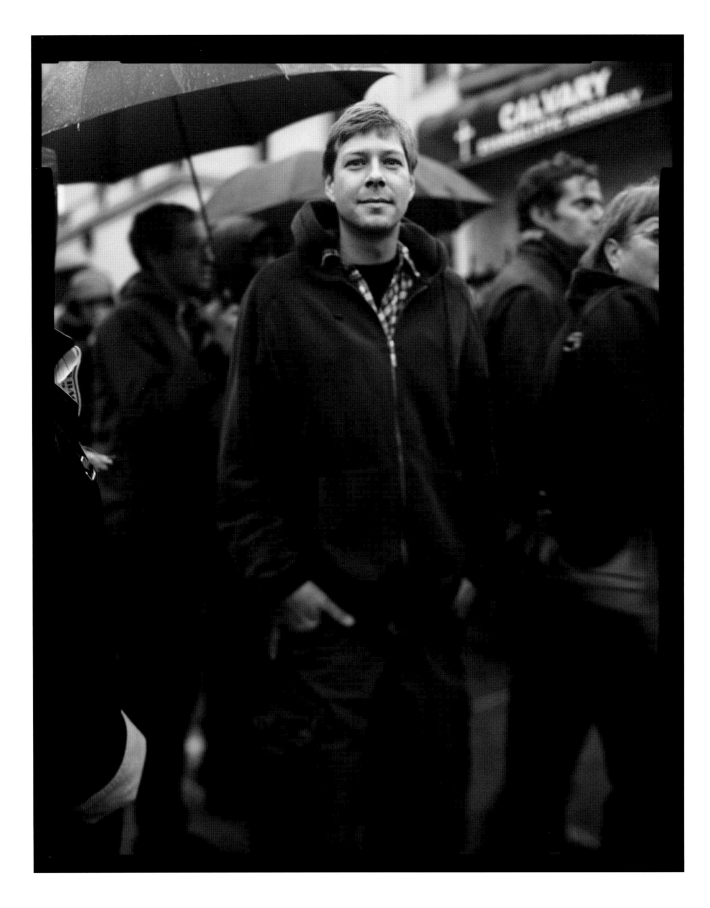

Rob, union electrician, protesting for fair housing in East New York on December 6, 2011

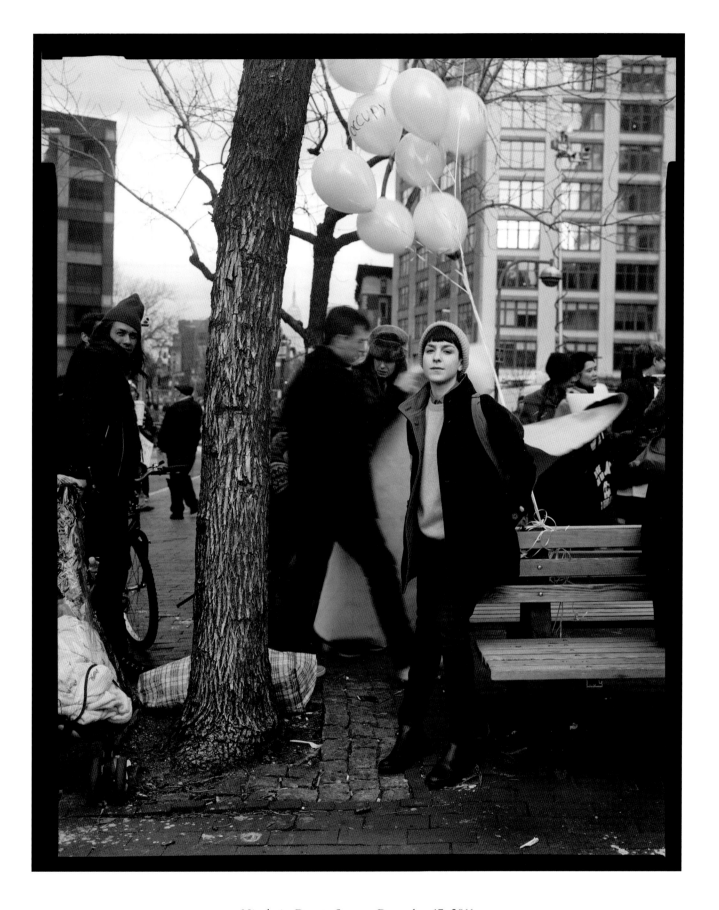

Nicole in Duarte Square, December 17, 2011

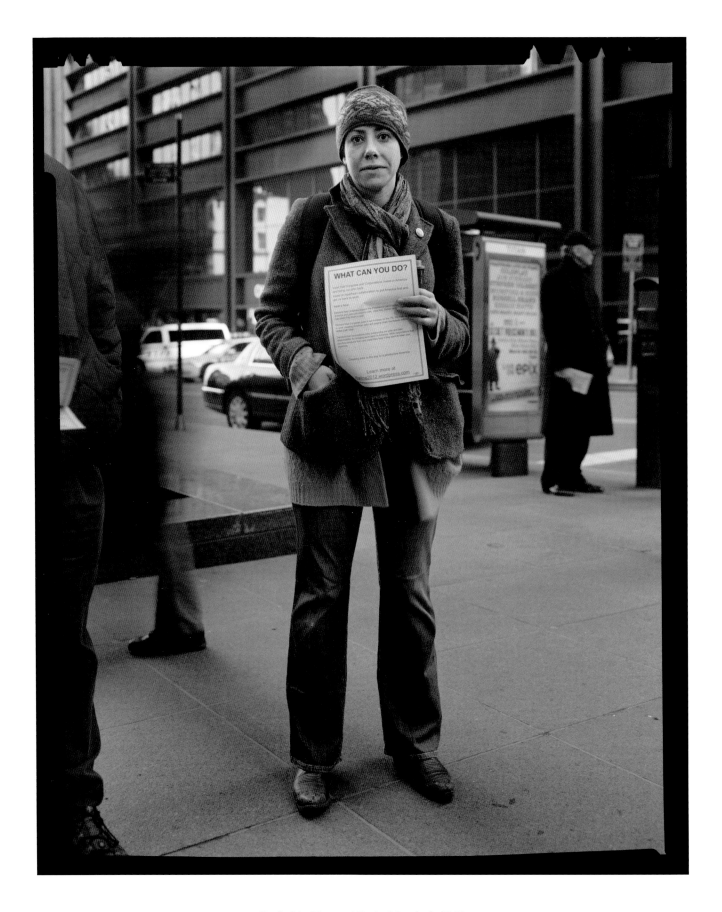

Rachel in Zuccotti Park, March 6, 2012

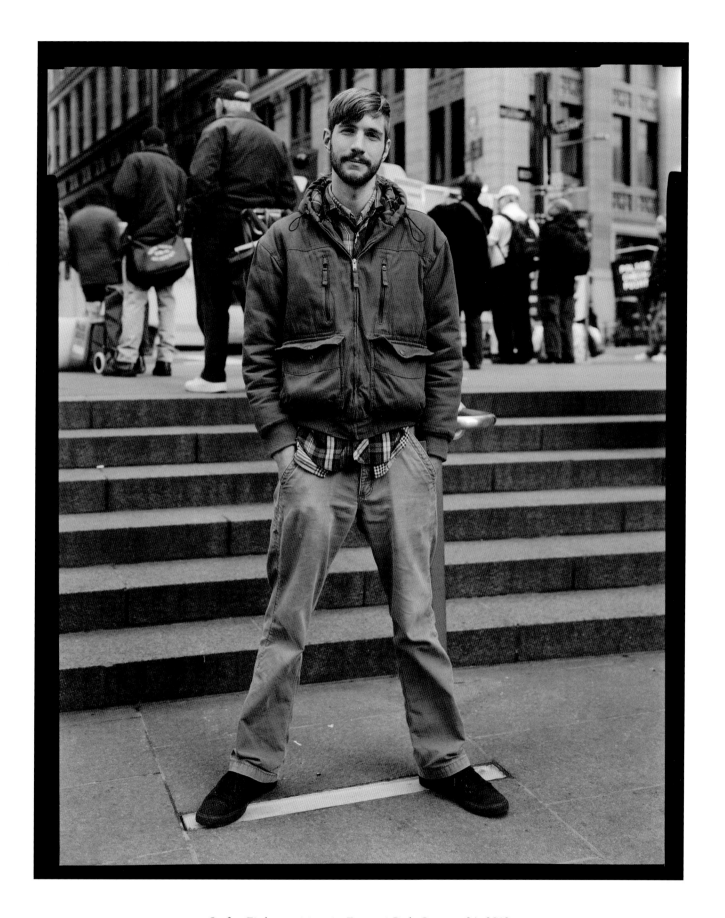

Stefan Fink, musician, in Zuccotti Park, January 24, 2012

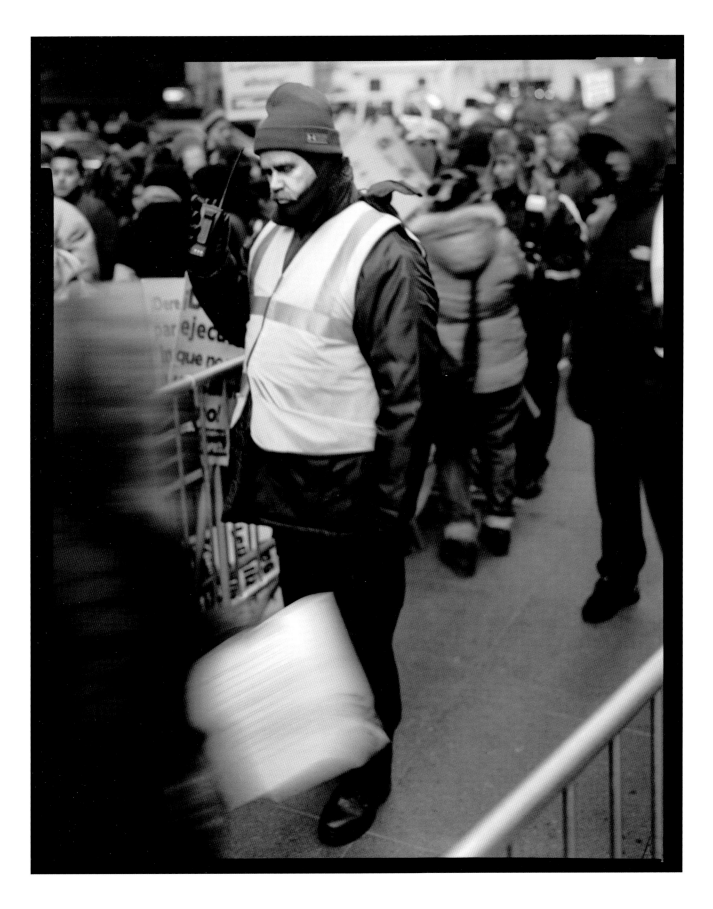

Guard keeping protesters out of Zuccotti Park, December 18, 2011

V

a new season

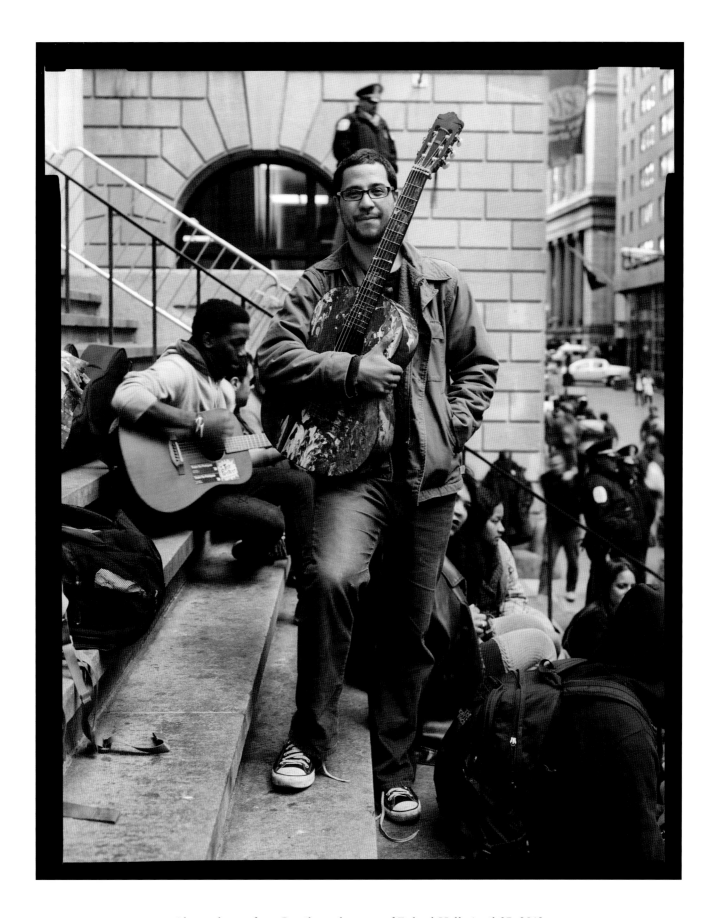

Alex, a doctor from Brazil, on the steps of Federal Hall, April 27, 2012

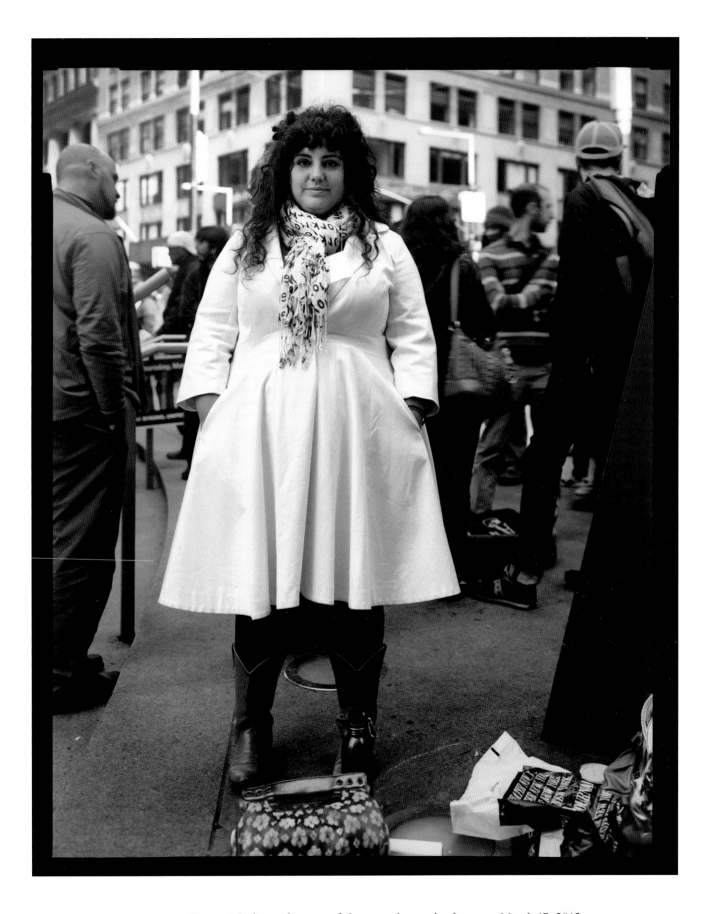

Lauren, in Zuccotti Park, on the start of the seventh month of protest, March 17, 2012

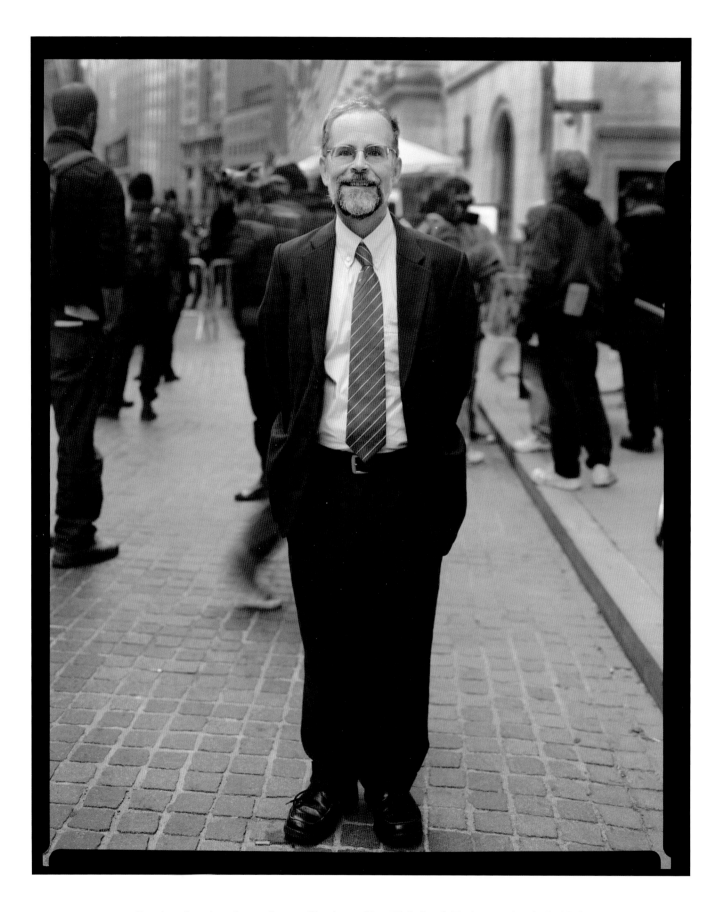

Jim Angel, university professor of business, New York Stock Exchange, April 13, 2012

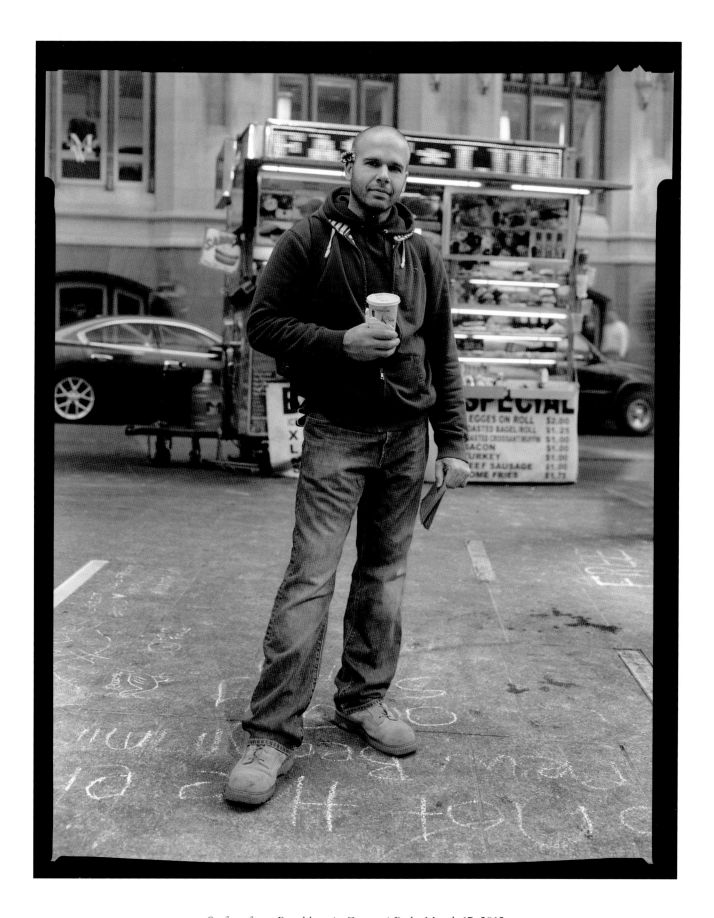

Stefan, from Brooklyn, in Zuccotti Park, March 17, 2012

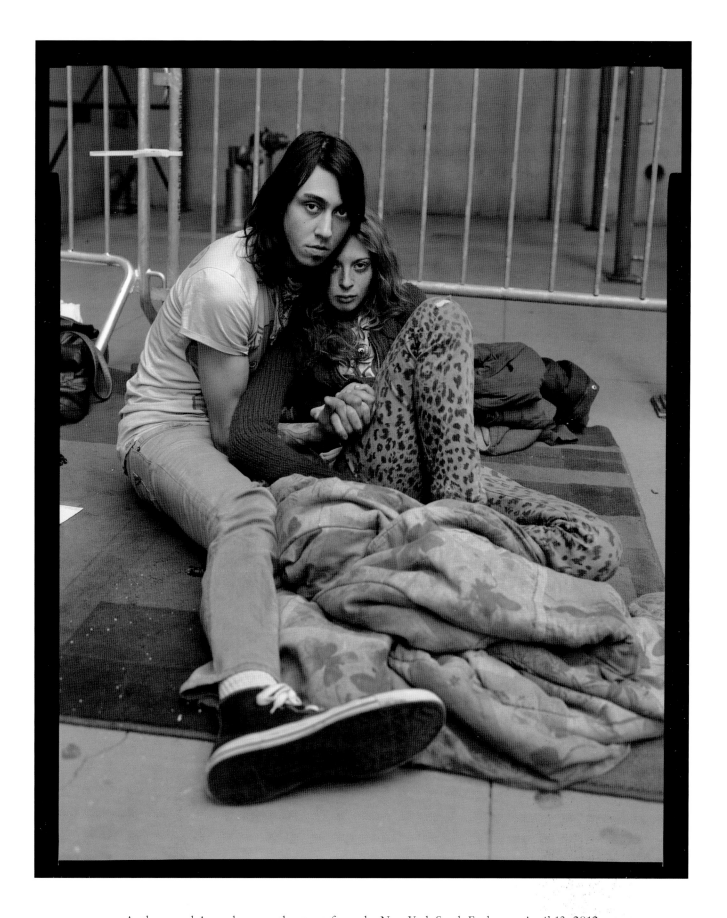

Anthony and Amanda across the street from the New York Stock Exchange, April 13, 2012

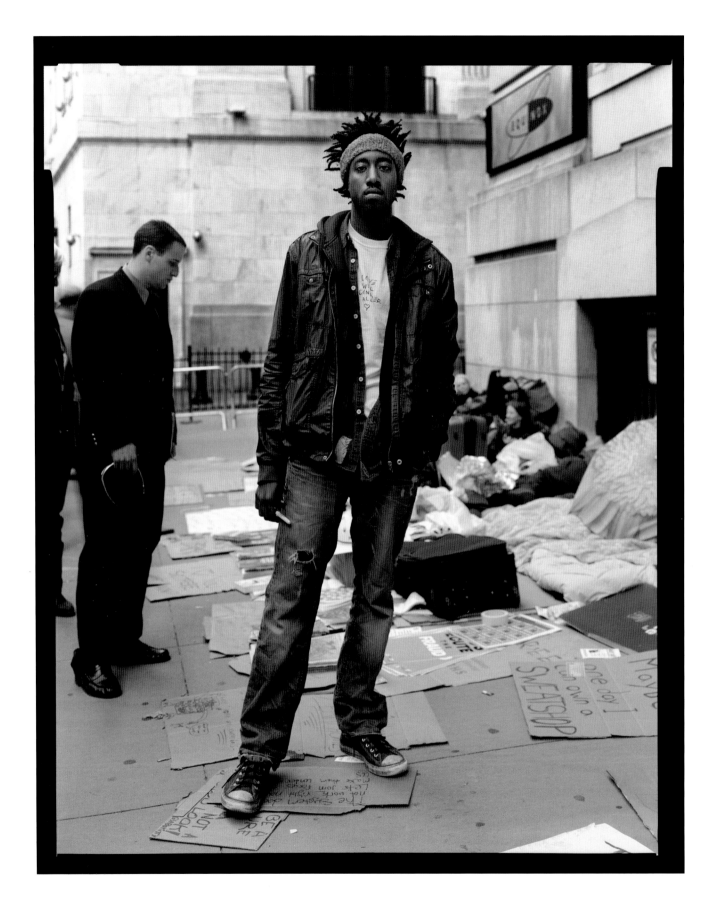

Terence by the New York Stock Exchange, April 13, 2012

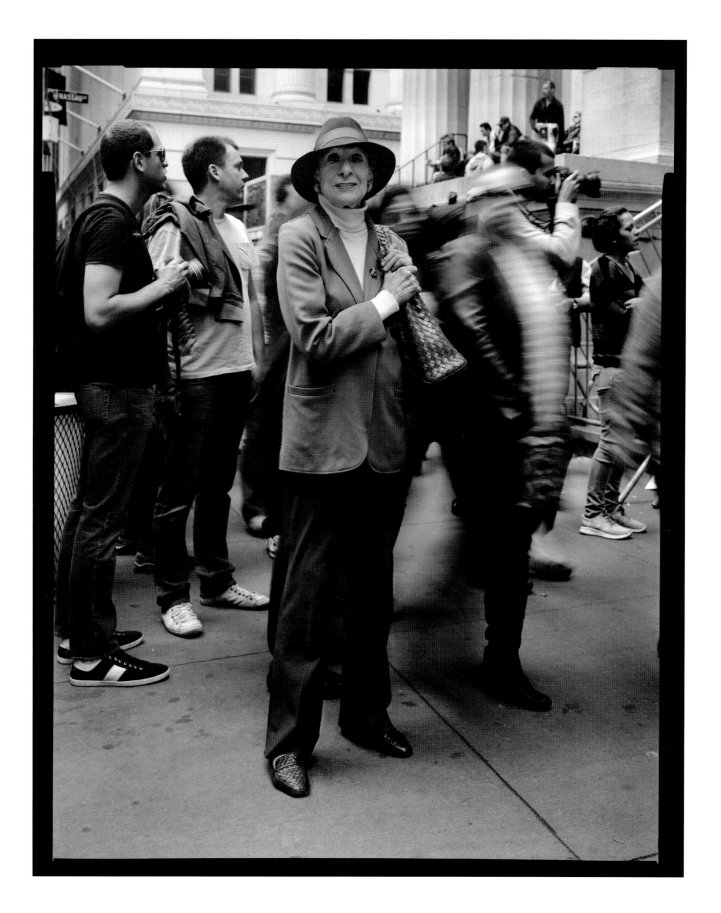

Barbara, originally from Iowa, in front of Federal Hall, April 20, 2012

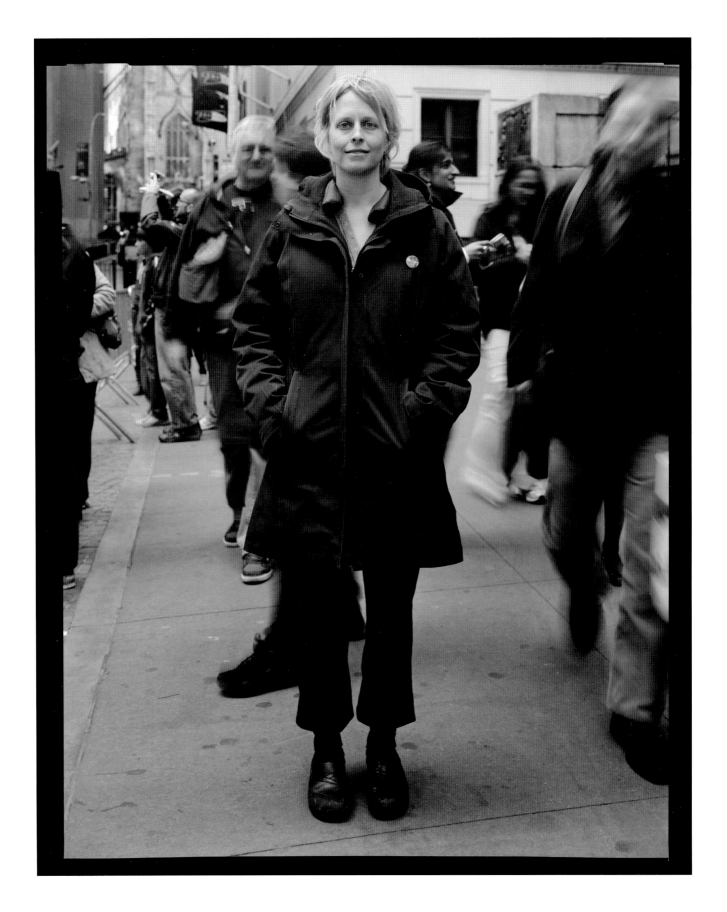

Cristina, graduate student, by Federal Hall, April 27, 2012

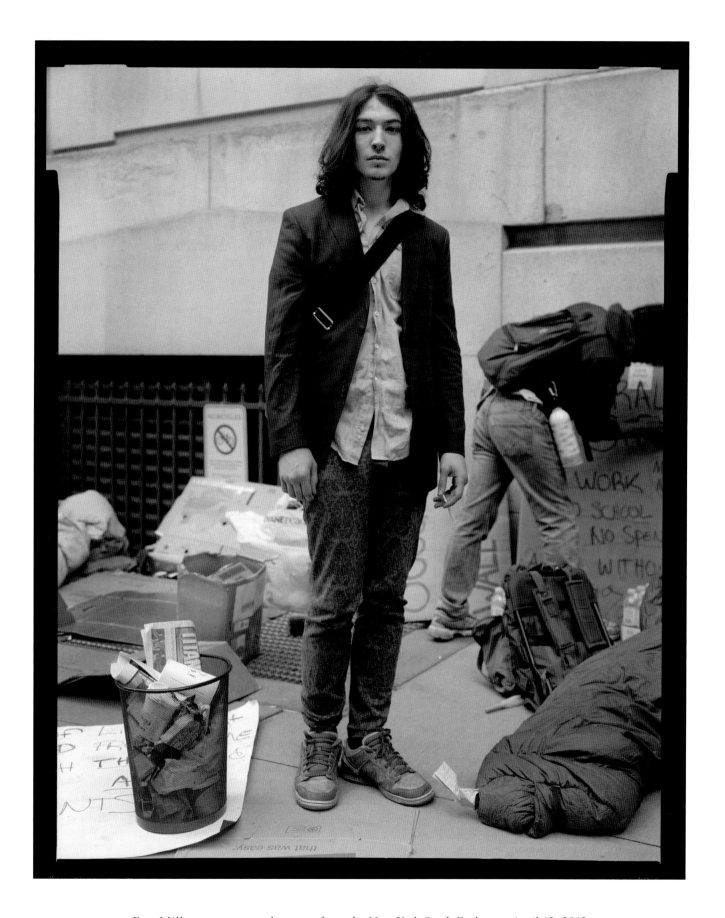

Ezra Miller, actor, across the street from the New York Stock Exchange, April 13, 2012

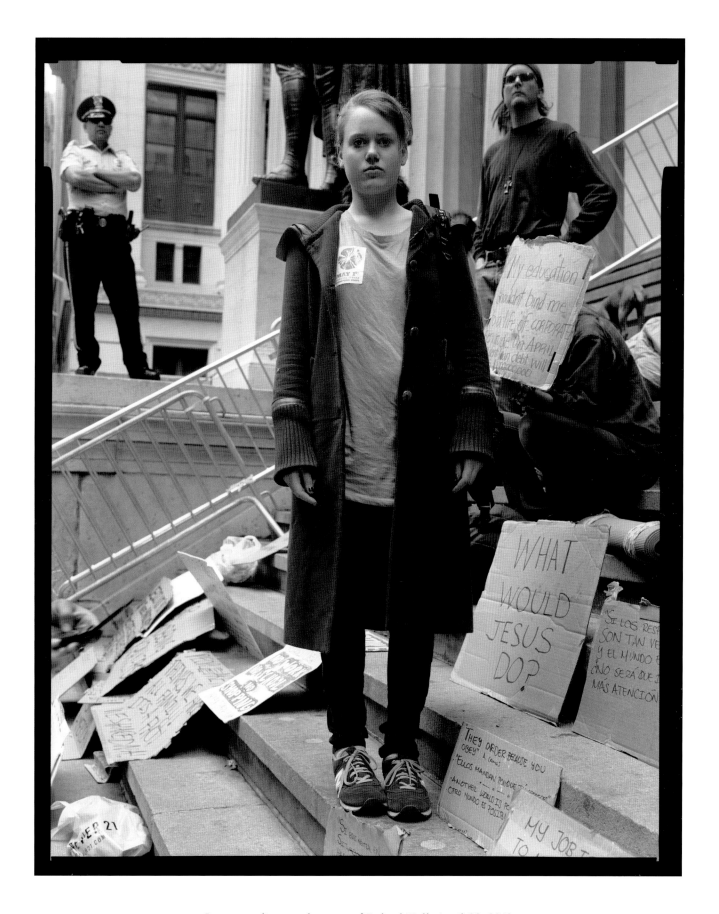

Laura standing on the steps of Federal Hall, April 20, 2012

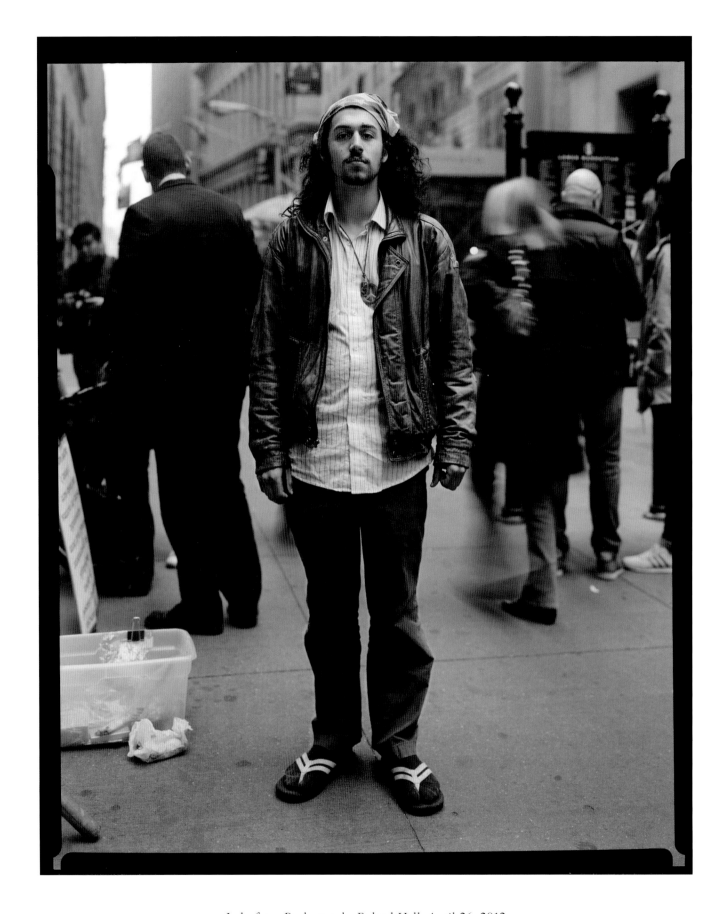

Josh, from Rochester, by Federal Hall, April 26, 2012

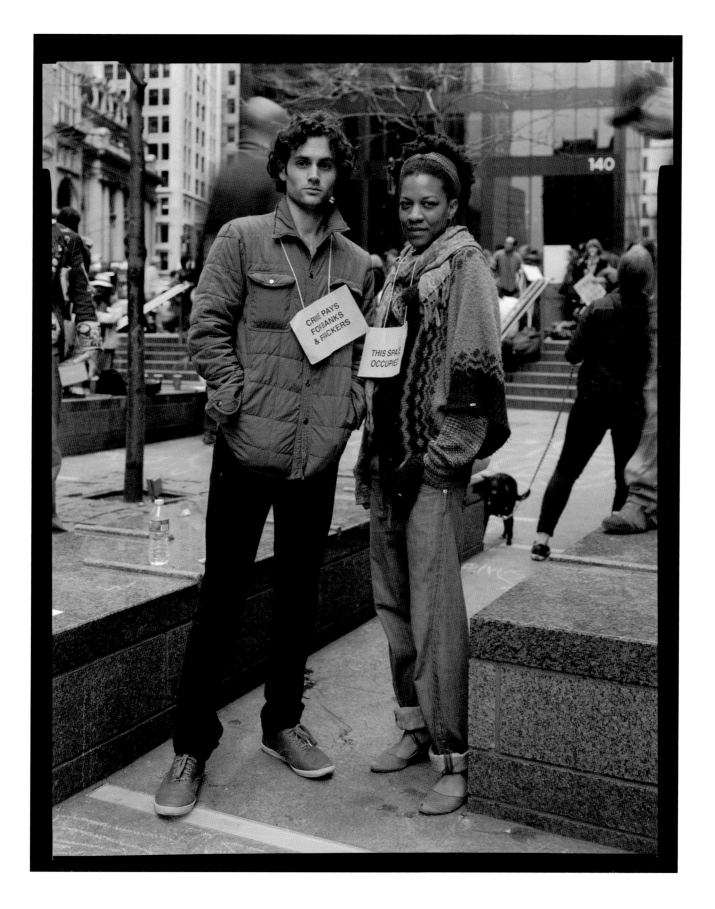

Penn and Booker in Zuccotti Park on March 17, 2012

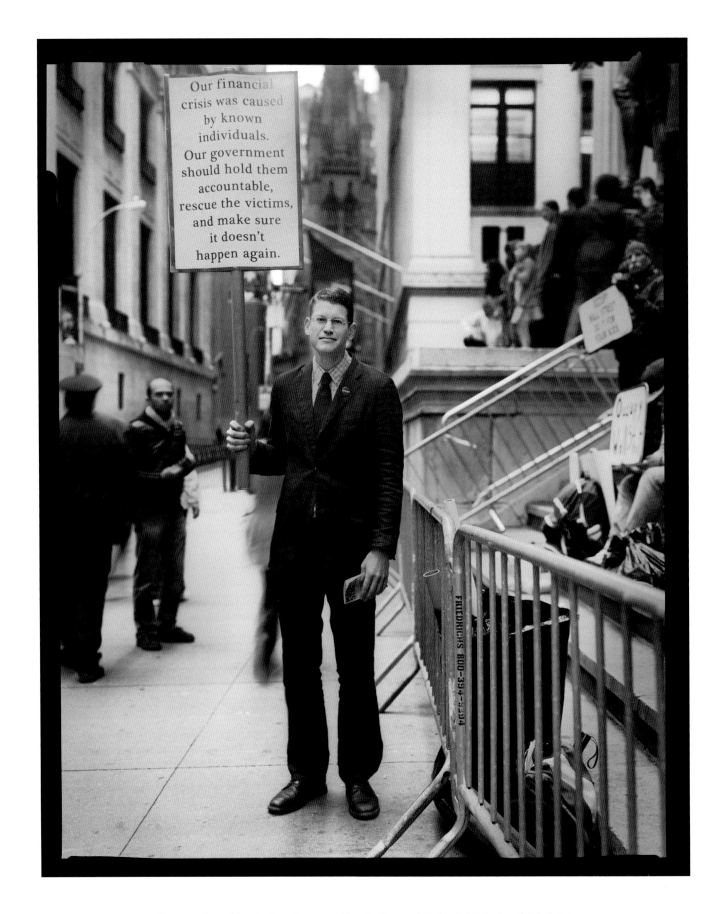

Lauren, from North Carolina, standing in front of Federal Hall, April 26, 2012

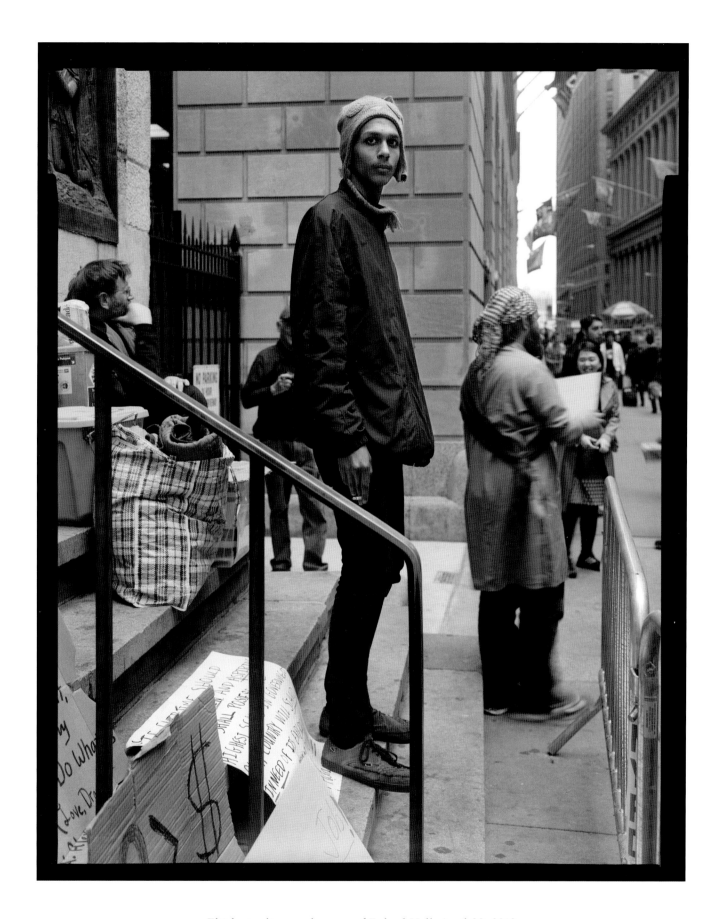

Elijah standing on the steps of Federal Hall, April 20, 2012

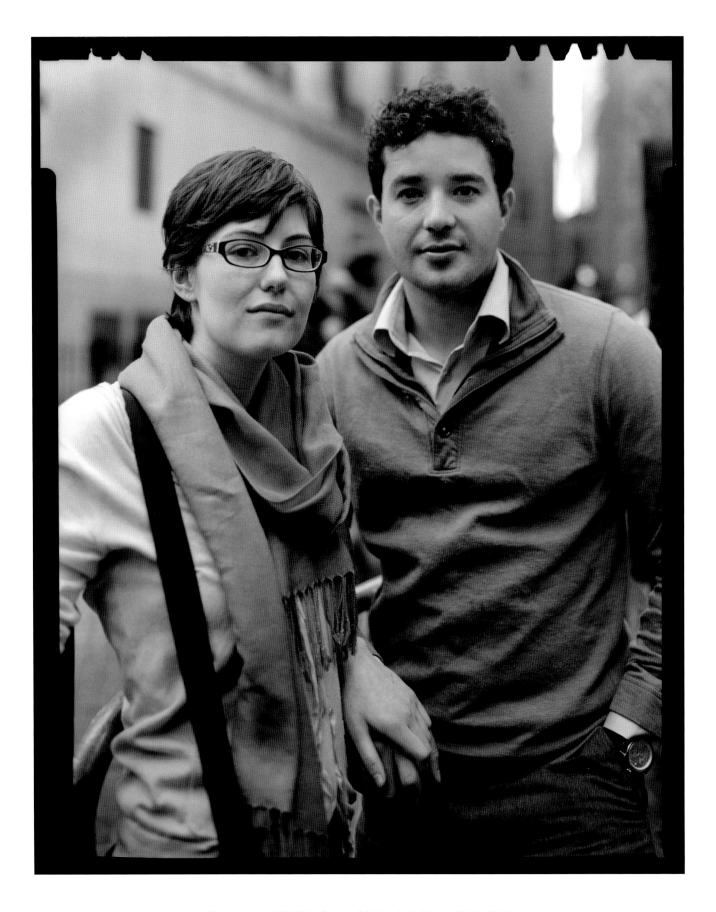

Cameron and Will in front of Federal Hall, April 13, 2012

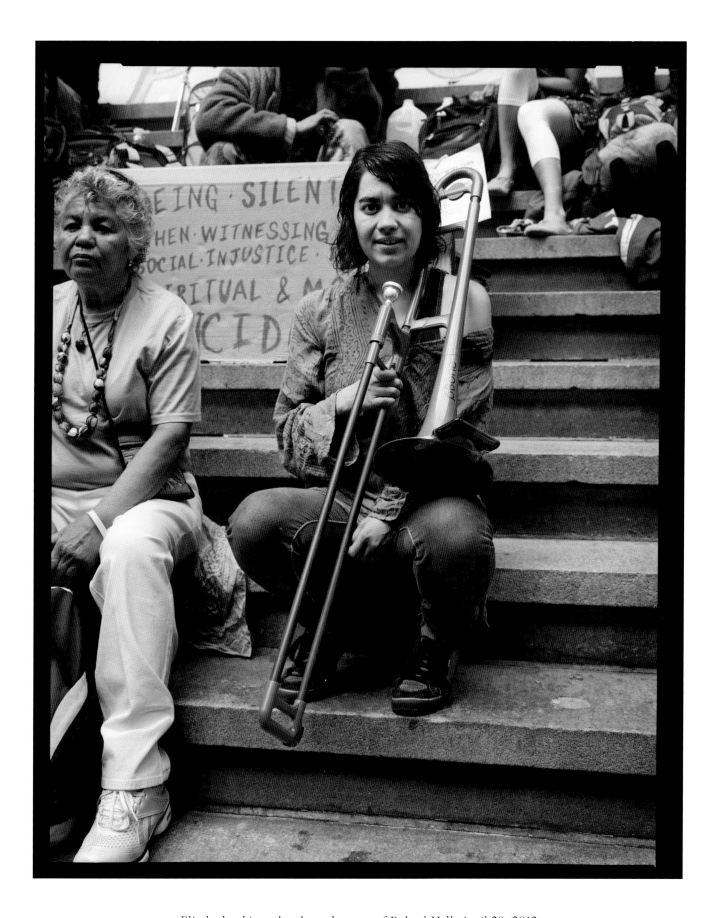

Elizabeth taking a break on the steps of Federal Hall, April 20, 2012

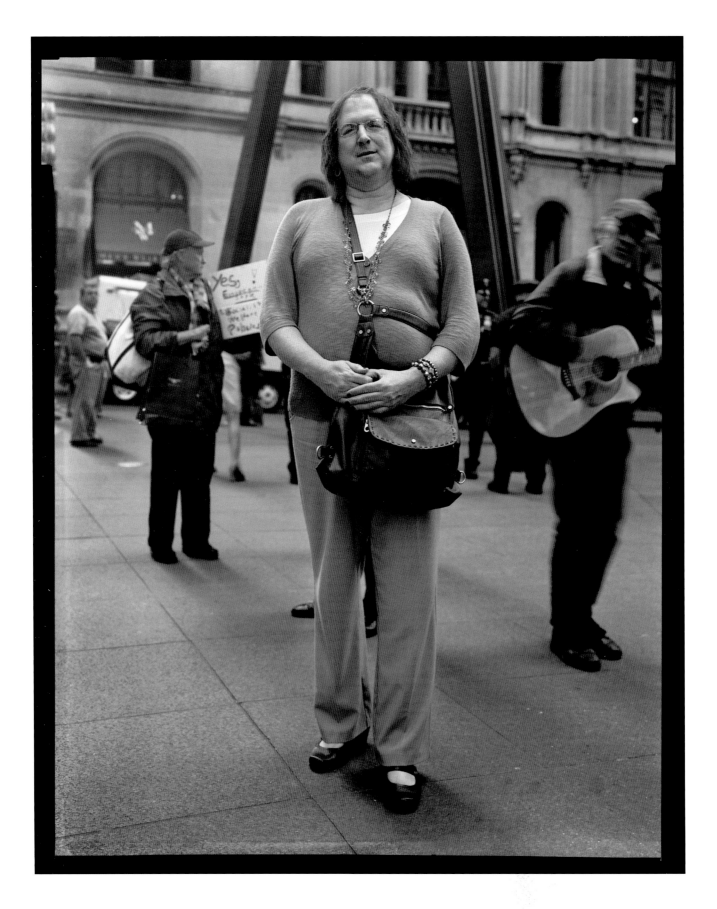

Jennifer in Zuccotti Park, May 11, 2012

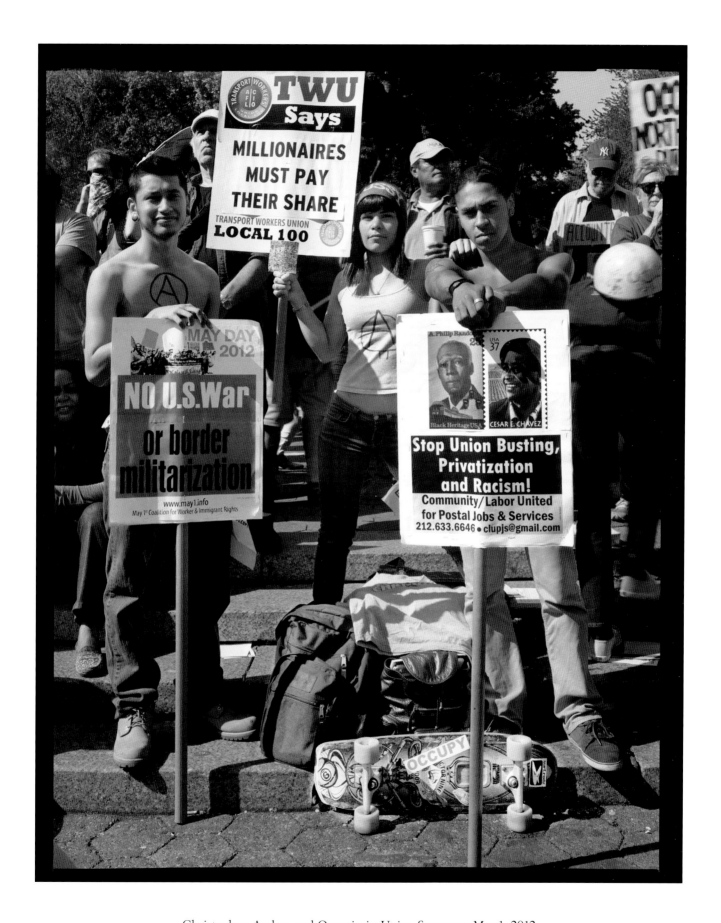

Christopher, Amber, and Quentin in Union Square on May 1, 2012

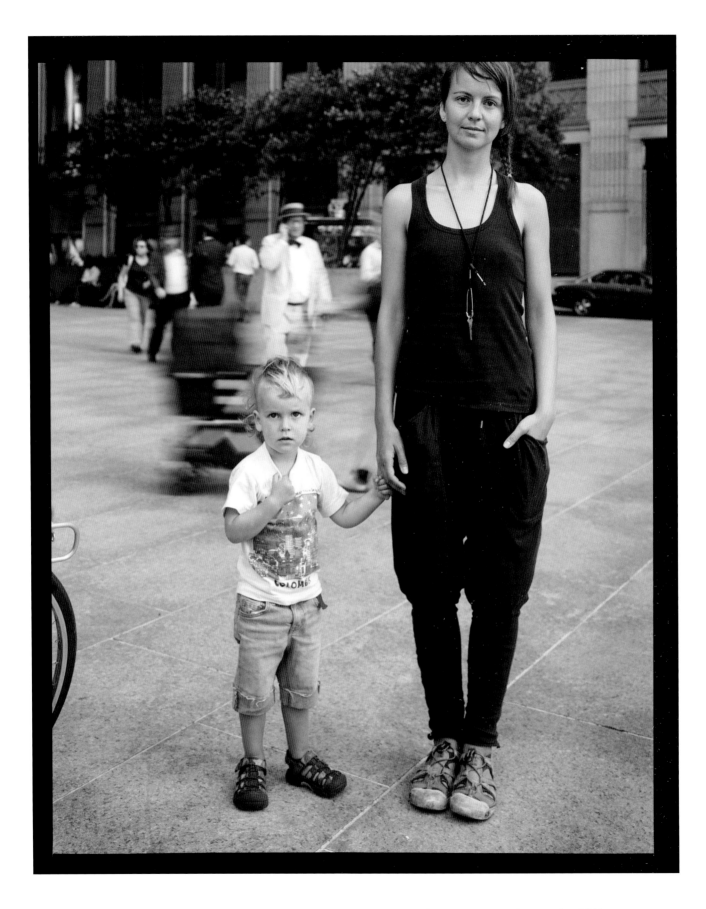

Teo and Maria in front of Brown Brothers Harriman, across from Zuccotti Park, June 27, 2012

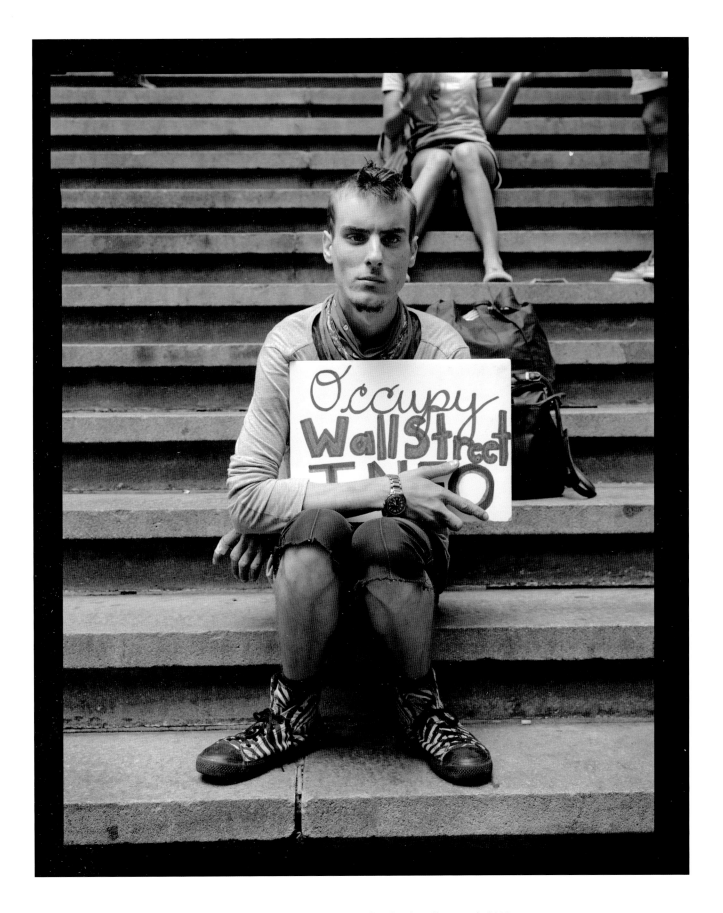

Connor sitting on the steps of Federal Hall, June 6, 2012

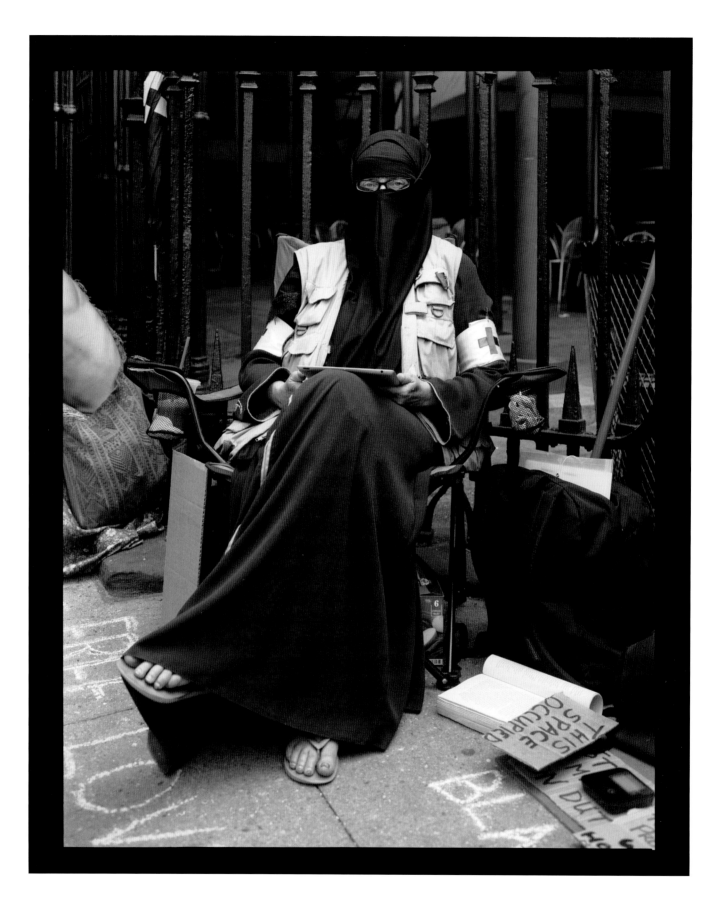

Fathema sitting in front of Trinity Church, a block from Zuccotti Park, July 28, 2012

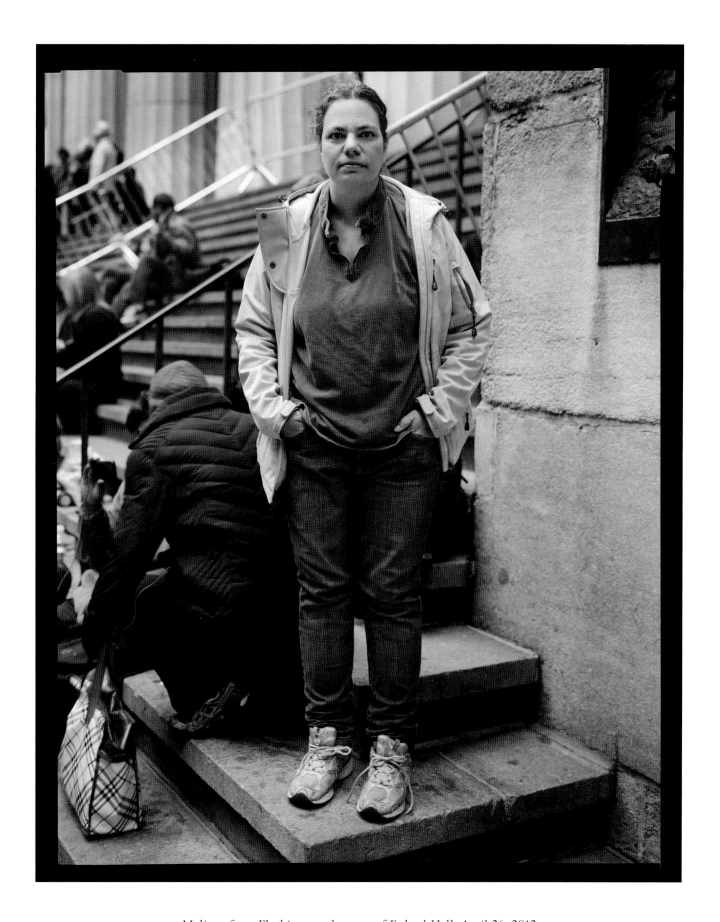

Melissa, from Flushing, on the steps of Federal Hall, April 26, 2012

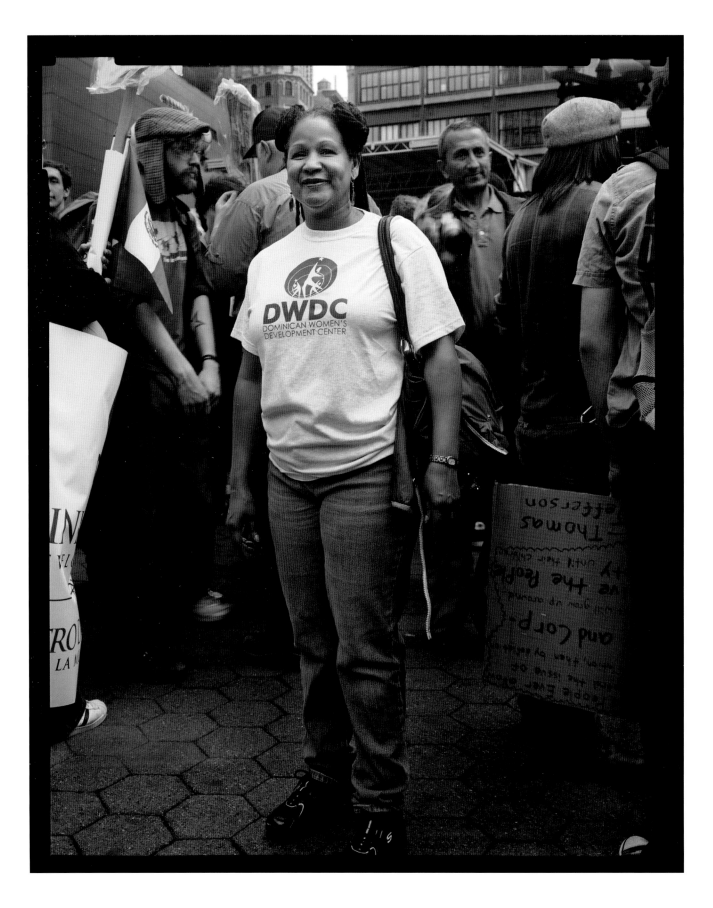

Rosita in Union Square with 100,000 other protesters, May 1, 2012

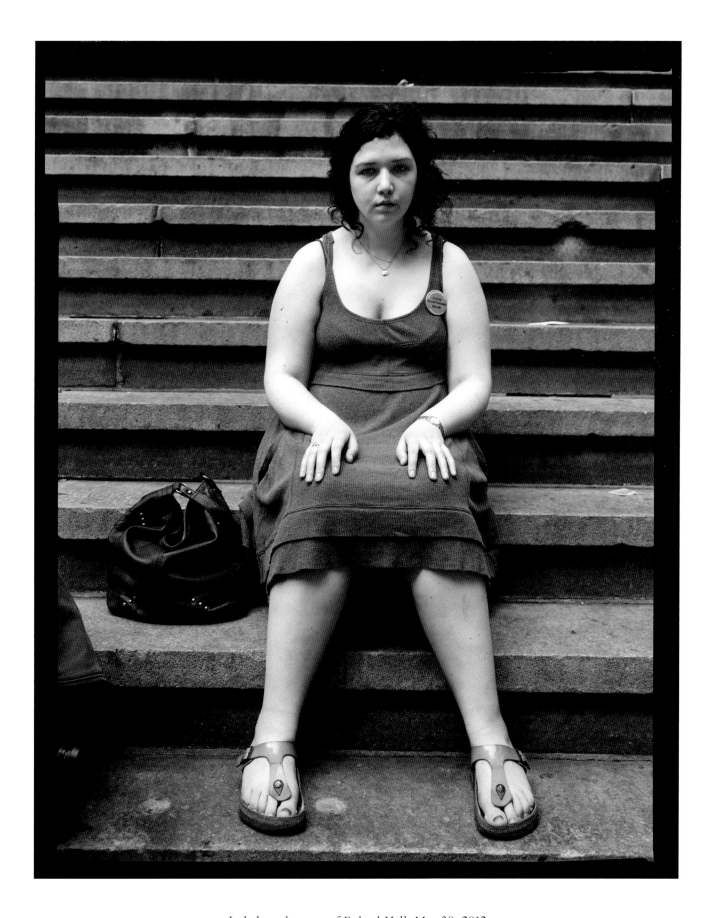

Isobel on the steps of Federal Hall, May 30, 2012

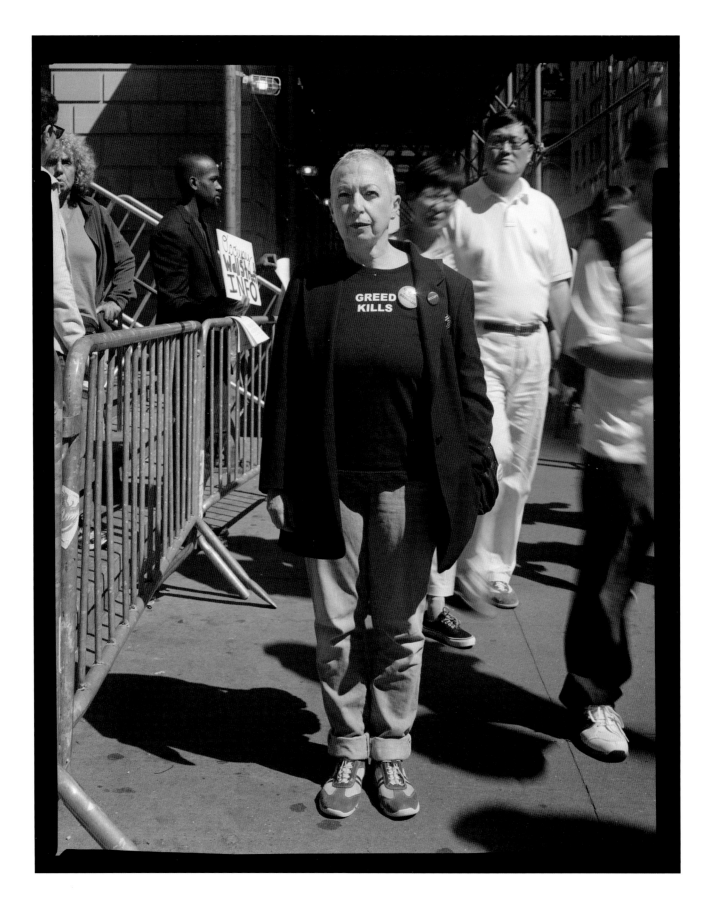

Jenny, member of the Granny Peace Brigade, in front of Federal Hall, June 6, 2012

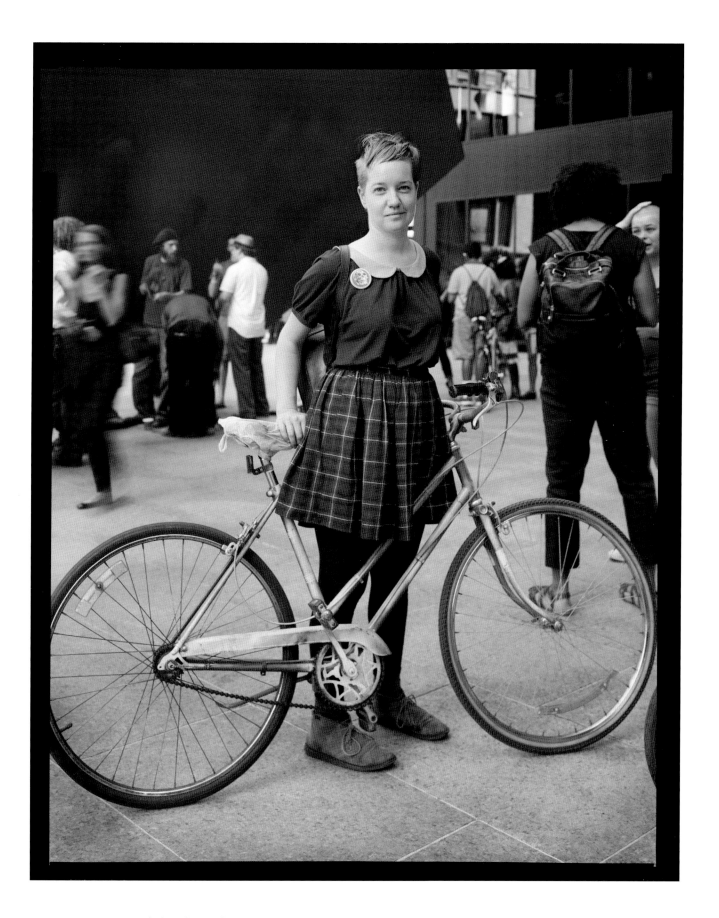

Rachel in front of Brown Brothers Harriman, across from Zuccotti Park, June 27, 2012

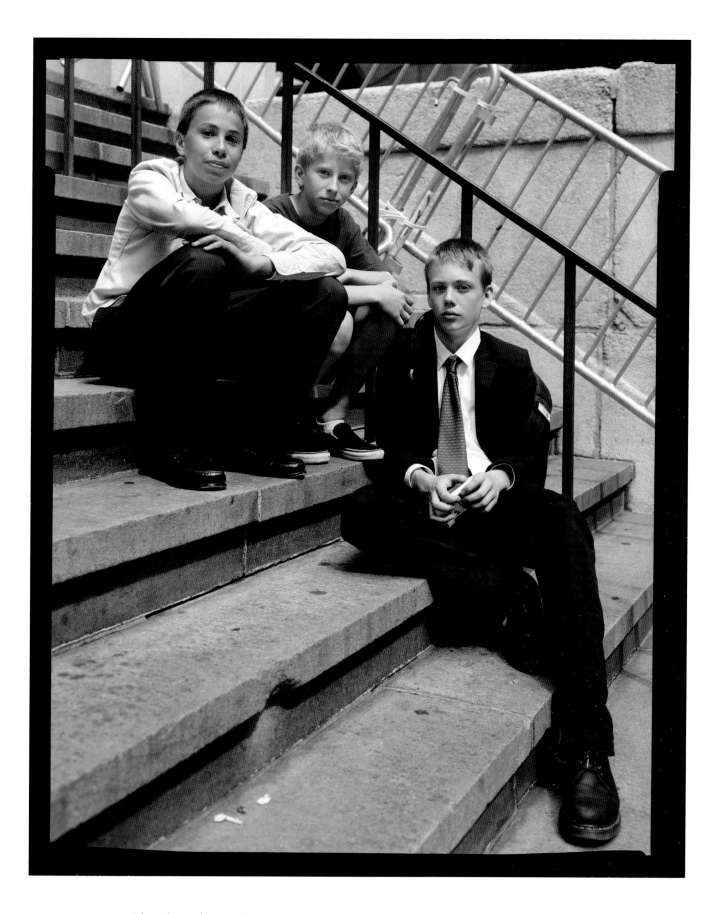

Three boys, from York Preparatory School, on the steps of Federal Hall, May 30, 2012

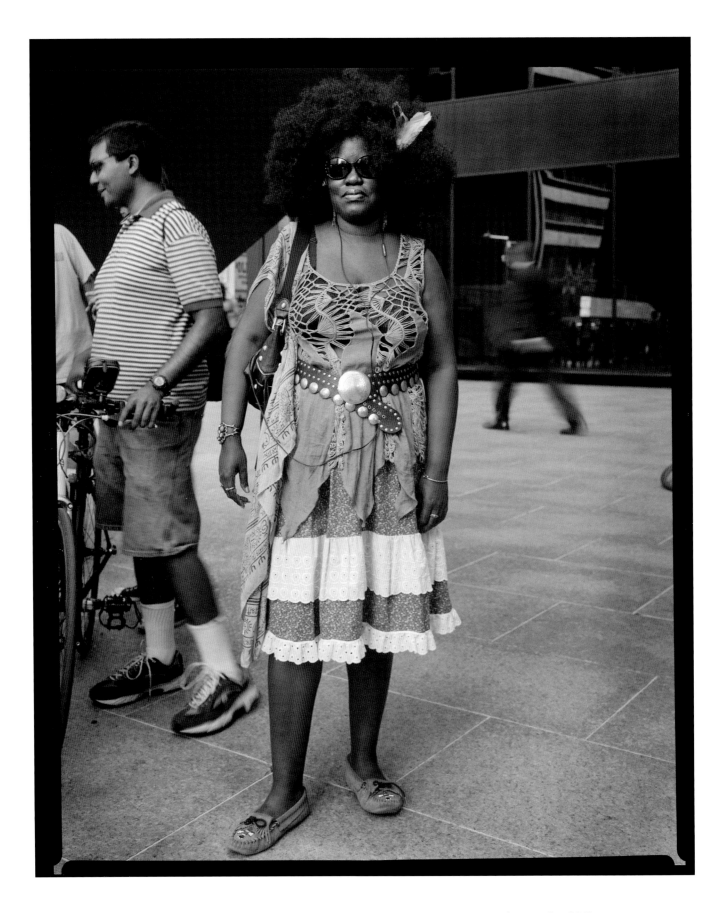

Kandia in front of Brown Brothers Harriman, across from Zuccotti Park, June 27, 2012

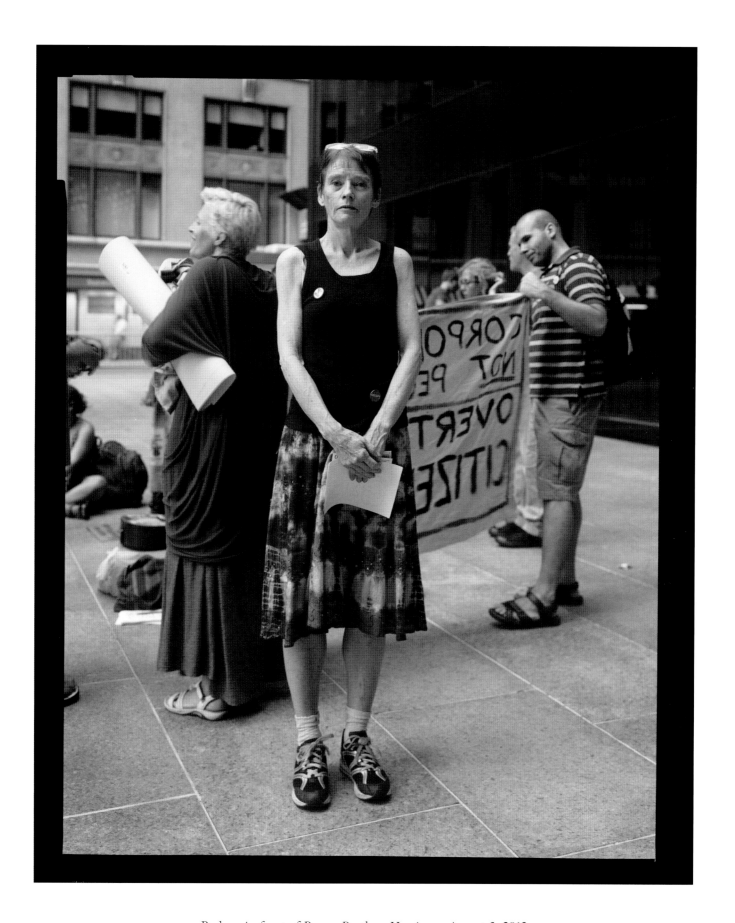

Barbara in front of Brown Brothers Harriman, August 3, 2012

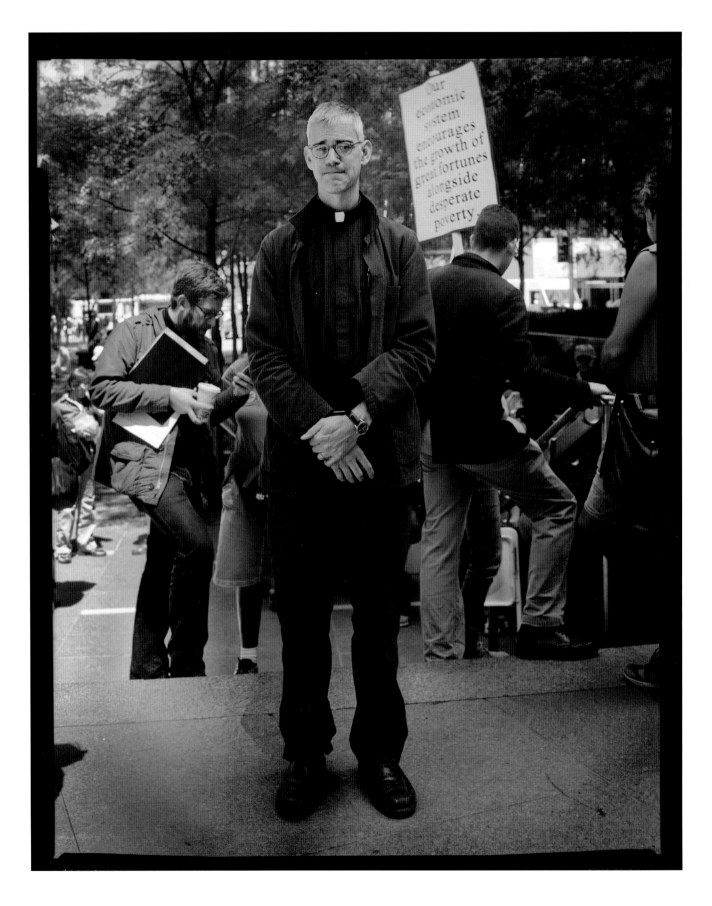

The Reverend John Merz at Zuccotti Park, June 7, 2012

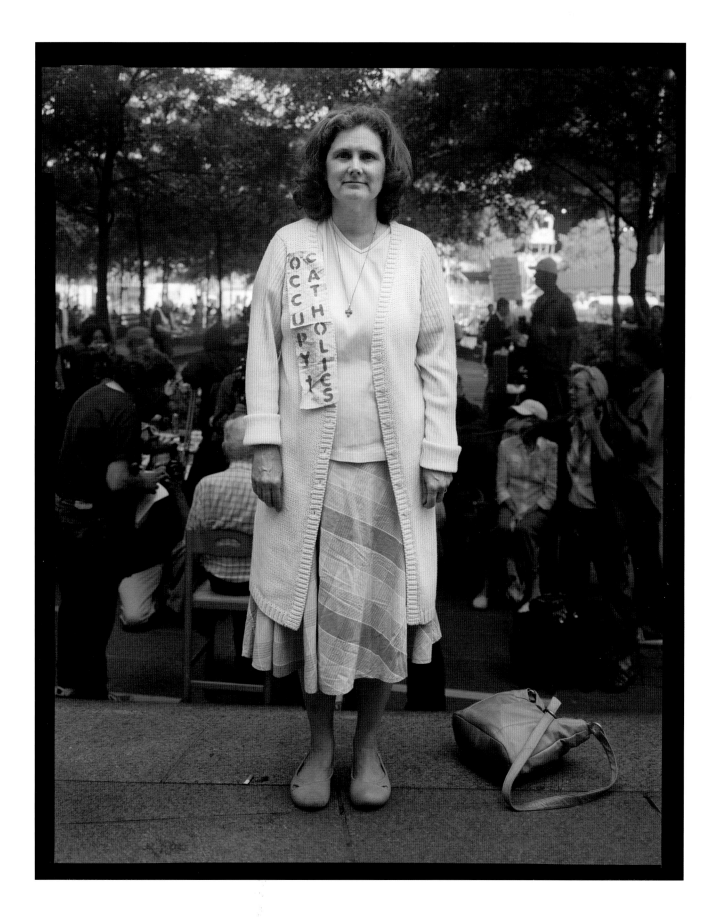

Sister Susan Wilcox at Zuccotti Park, June 7, 2012

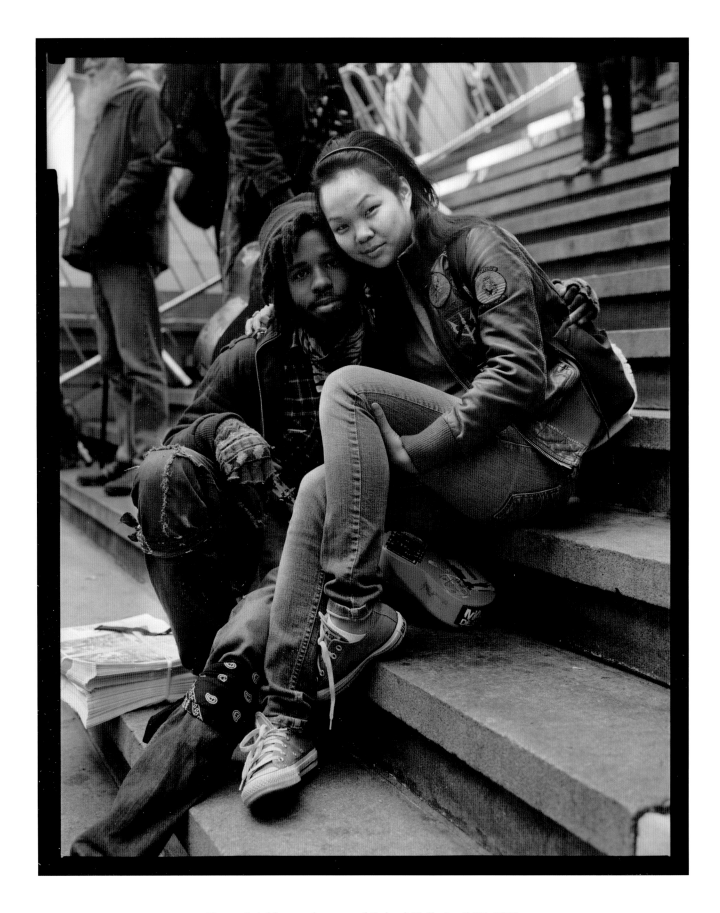

Dee and Ashley on the steps of Federal Hall, April 27, 2012

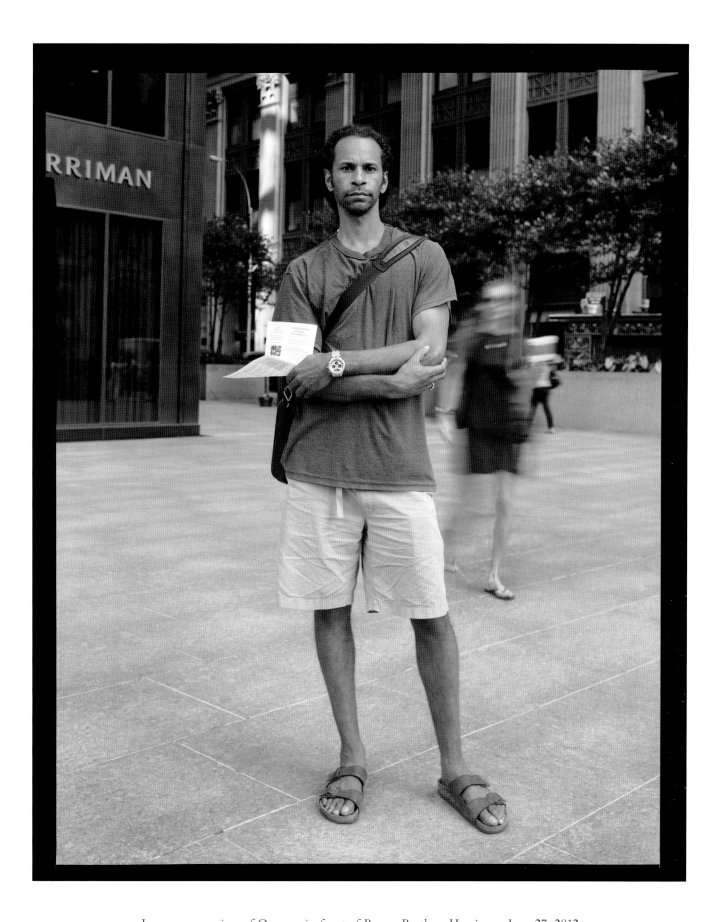

Jason, an organizer of Occupy, in front of Brown Brothers Harriman, June 27, 2012

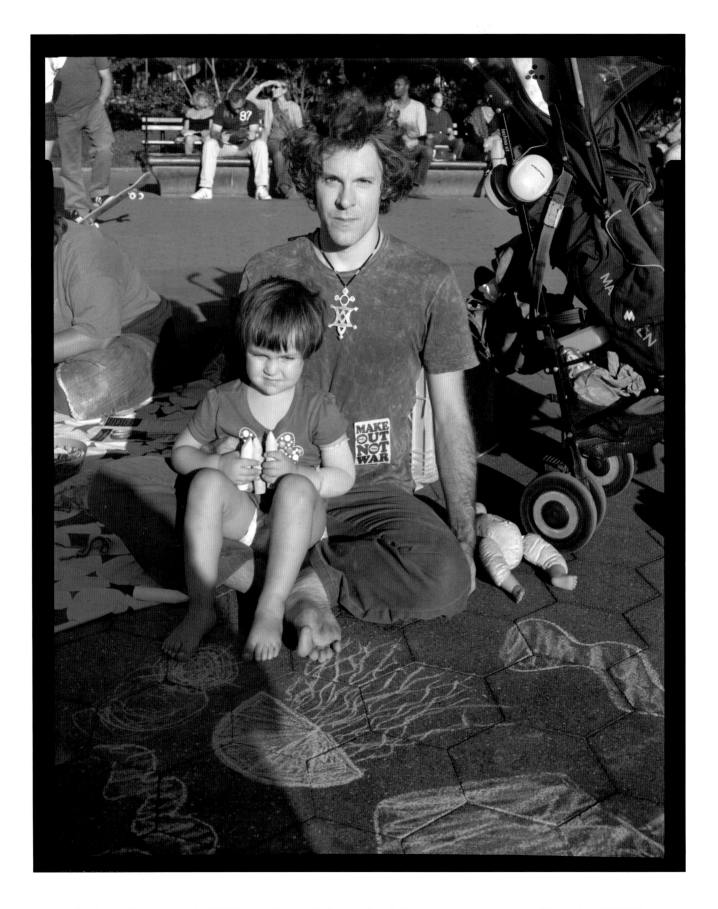

Jordan, with daughter in Washington Square Park, two days before one-year anniversary, September 15, 2012

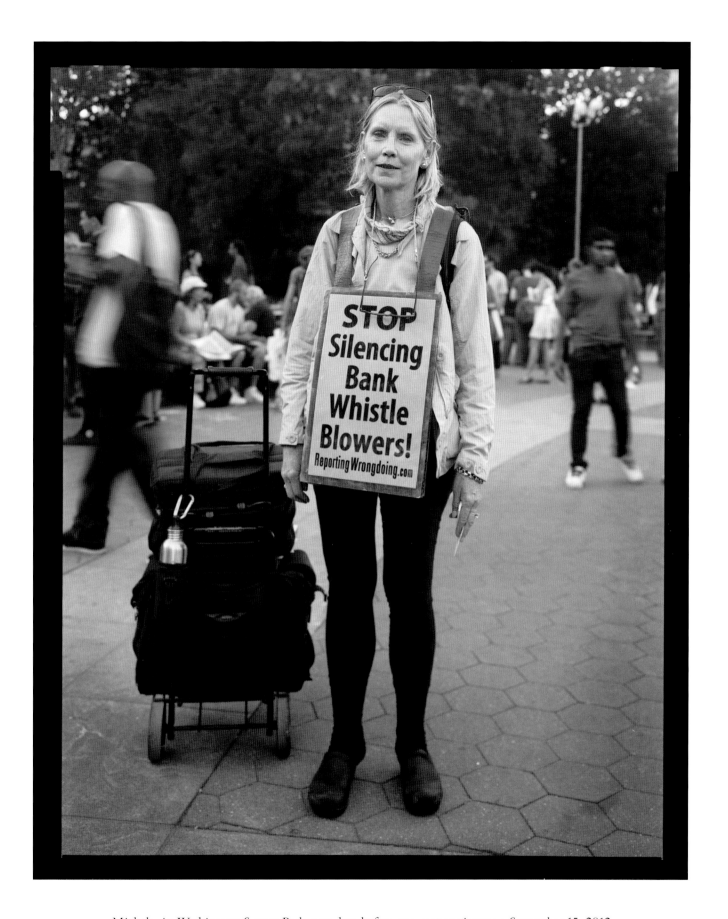

Michele, in Washington Square Park, two days before one-year anniversary, September 15, 2012

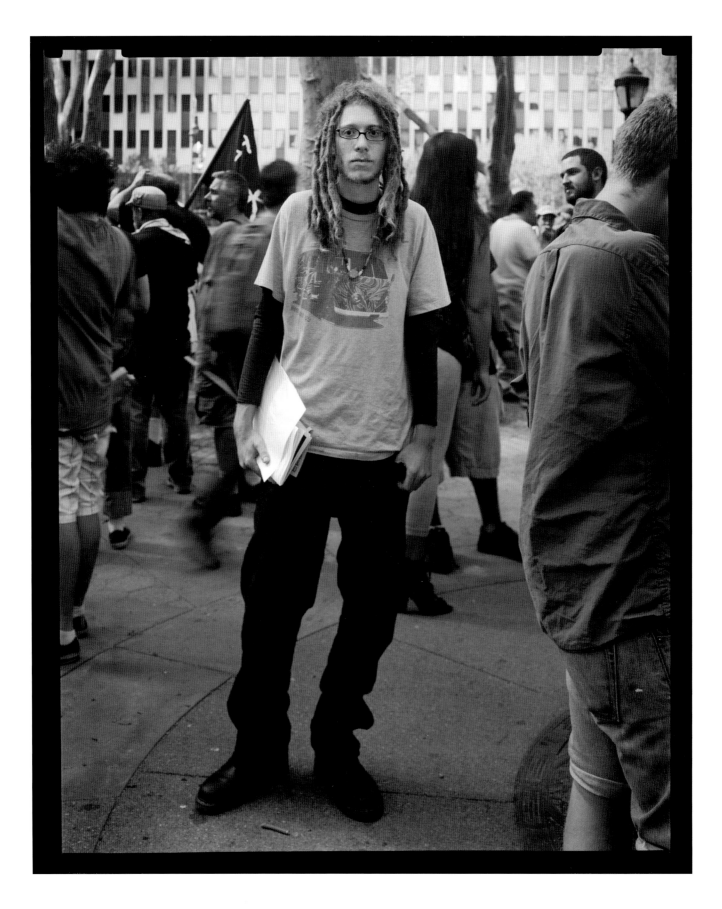

Nathan, in Foley Square, the day before the one-year anniversary, September 16, 2012

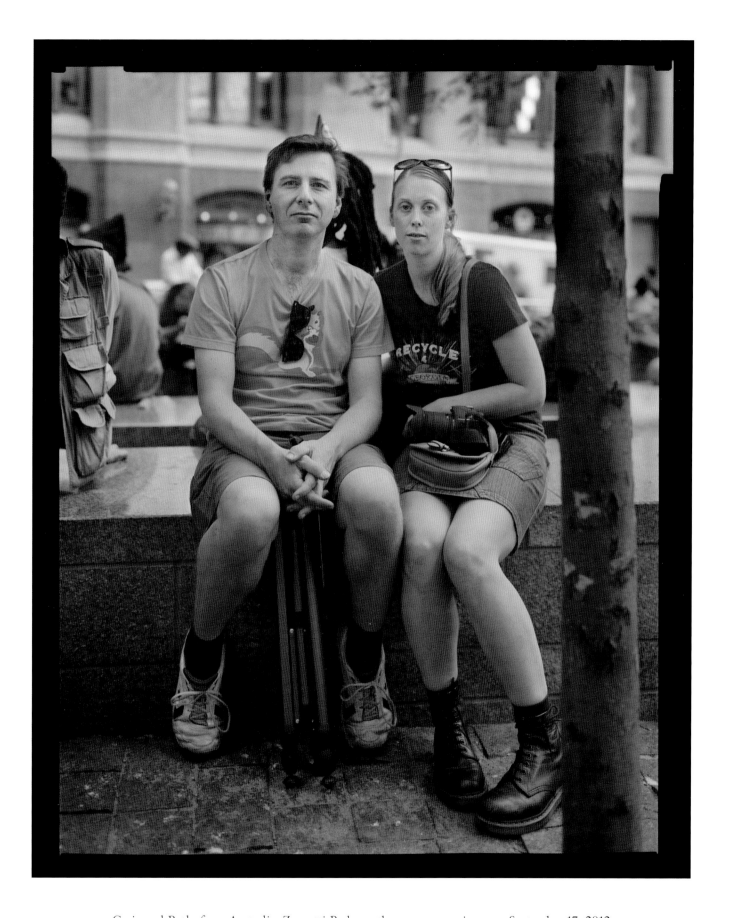

Craig and Beth, from Australia, Zuccotti Park, on the one-year anniversary, September 17, 2012

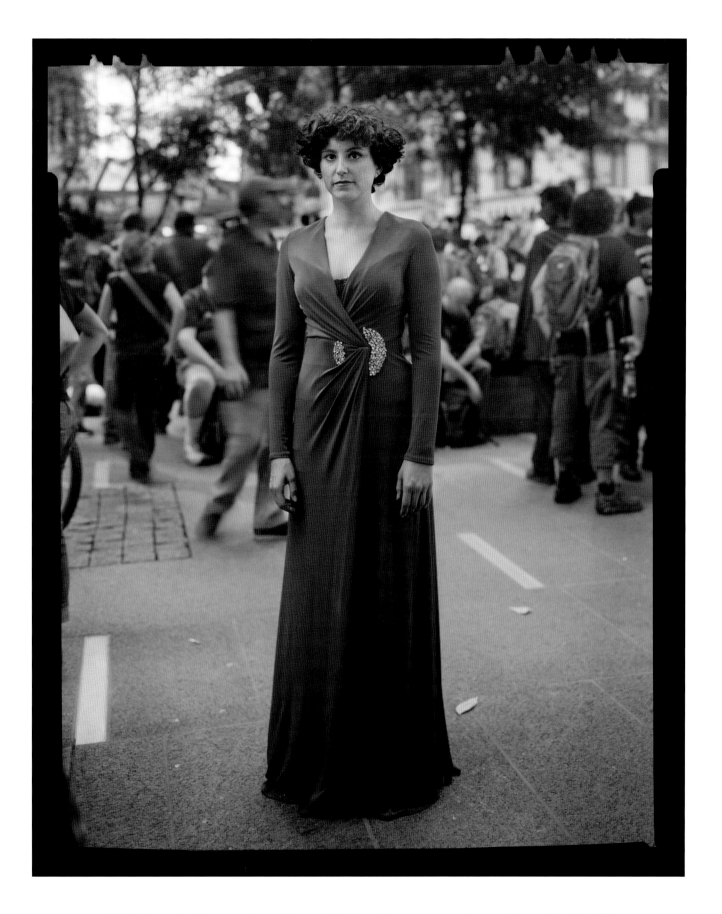

Ashlie Loren Smith, opera singer, Zuccotti Park, on the one-year anniversary, September 17, 2012

VI

summer

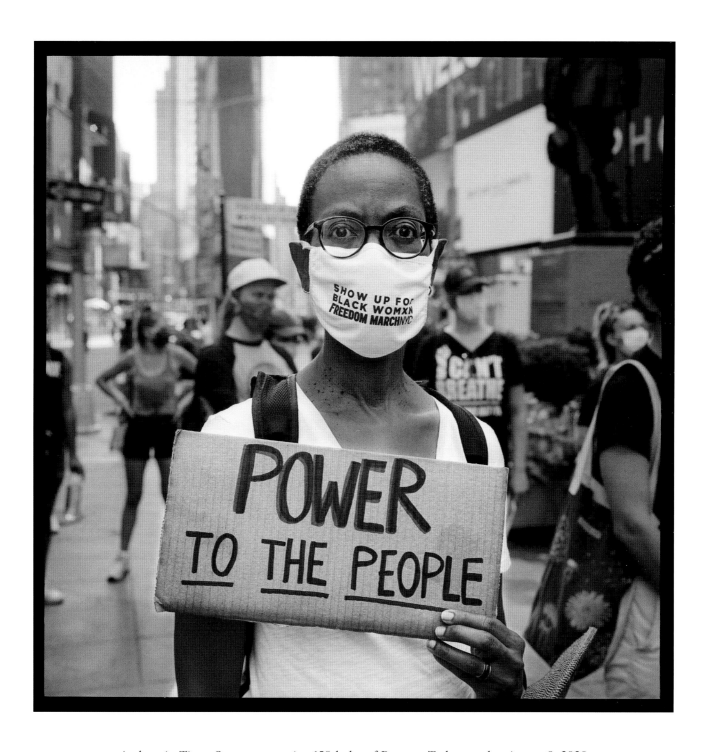

Andrea, in Times Square, protesting 150th day of Breonna Taylor murder, August 9, 2020

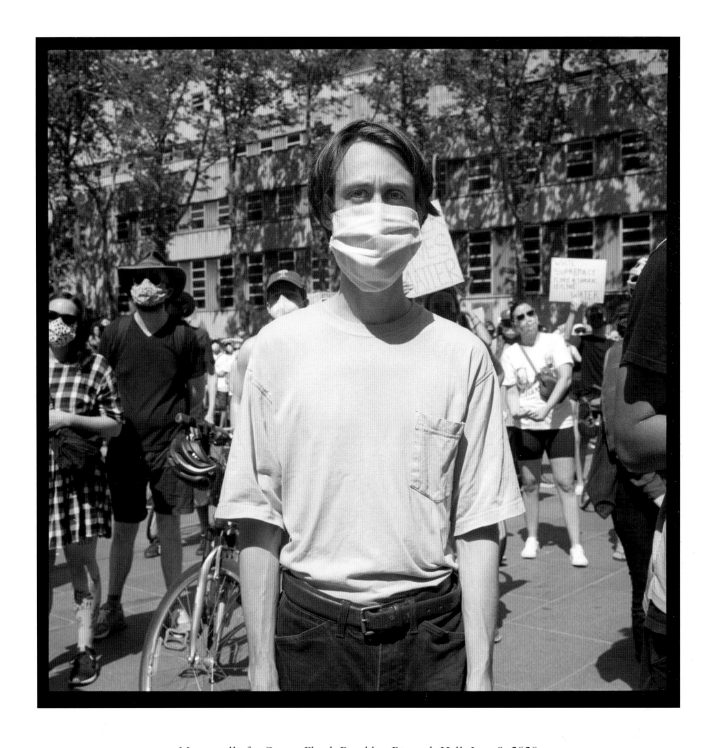

Man at rally for George Floyd, Brooklyn Borough Hall, June 9, 2020

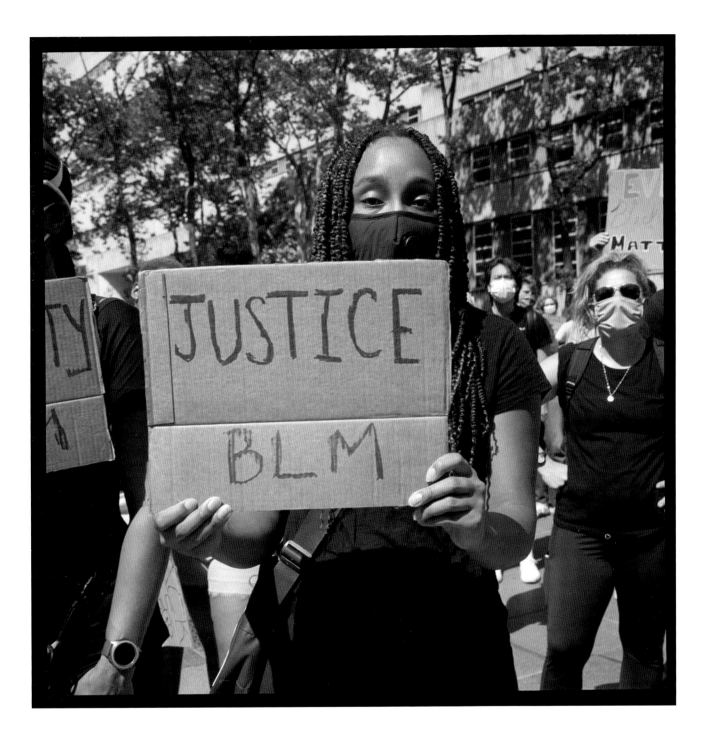

Woman at rally for George Floyd, Brooklyn Borough Hall, June 9, 2020

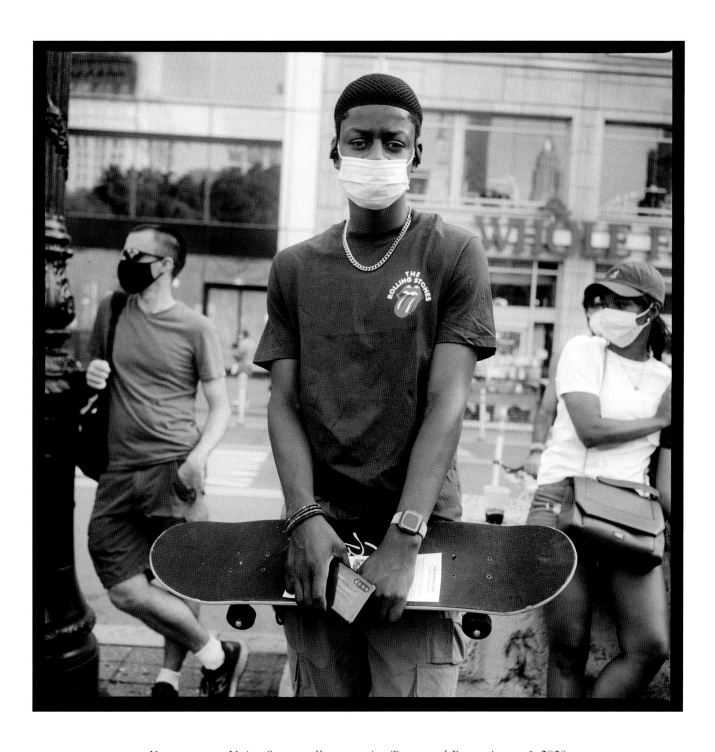

Young man, at Union Square rally, protesting Trump and Pence, August 1, 2020

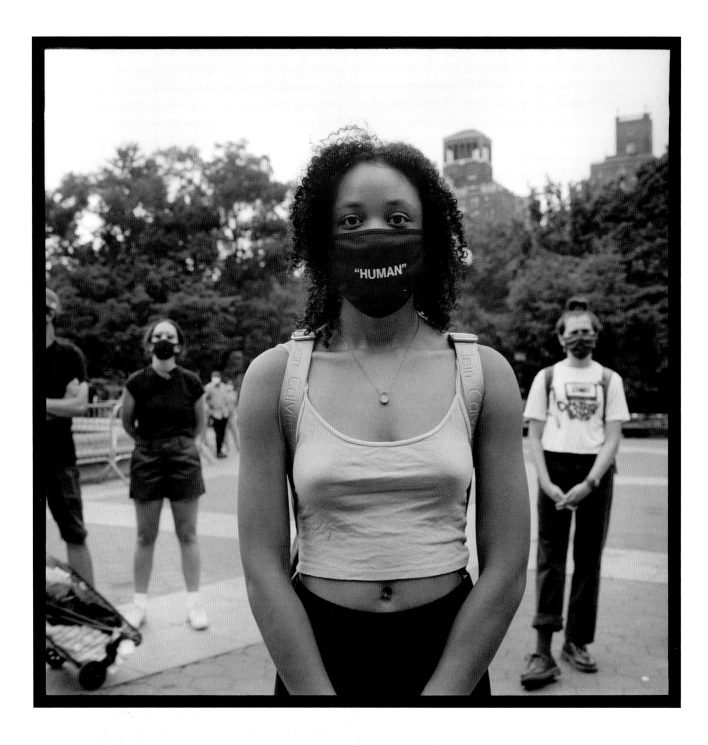

Woman protesting at Washington Square Park, July 7, 2020

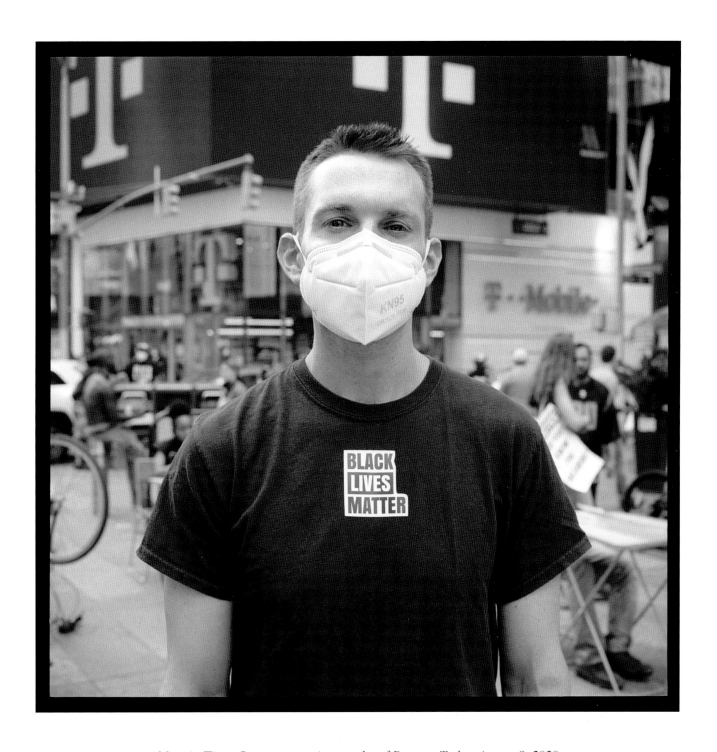

Man, in Times Square, protesting murder of Breonna Taylor, August 9, 2020

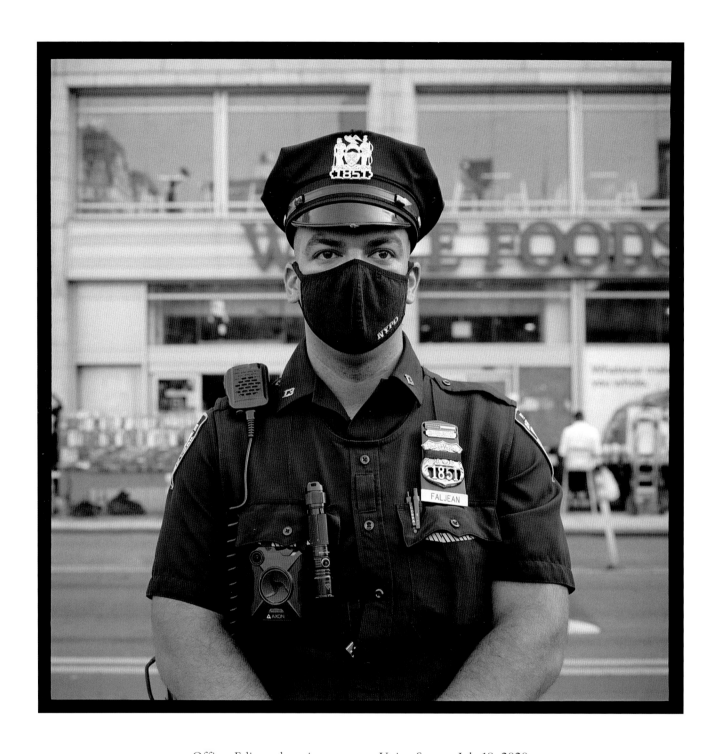

Officer Faljean observing protest at Union Square, July 18, 2020

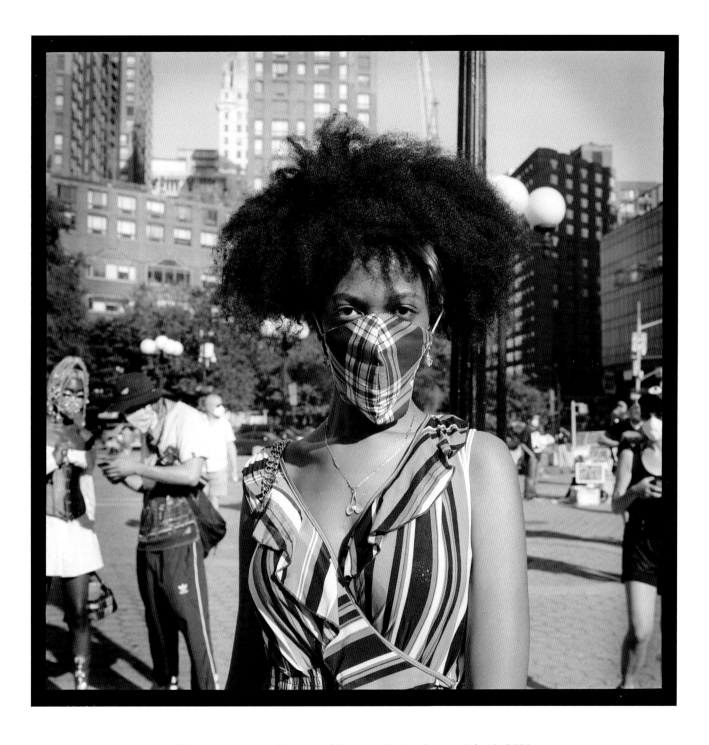

Woman protesting Trump and Pence at Union Square, July 18, 2020

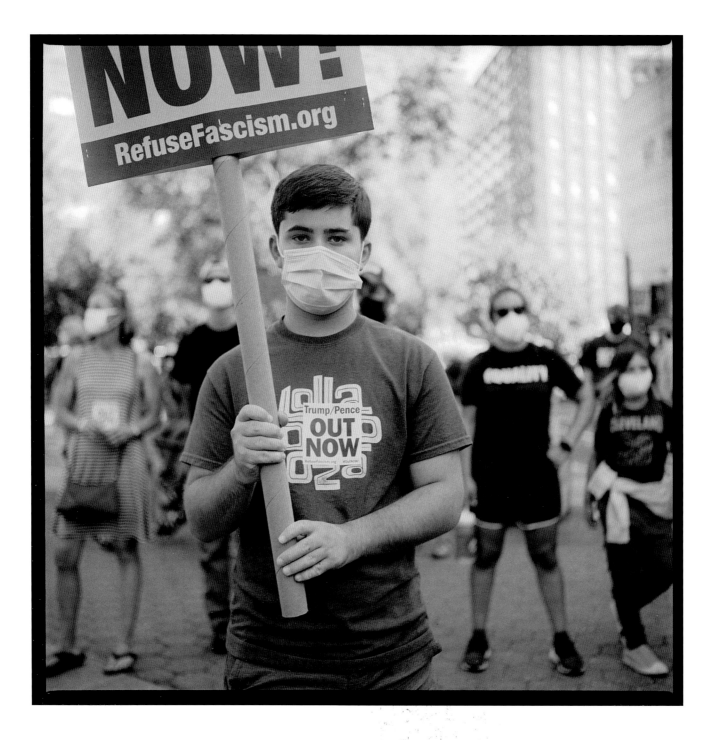

Young man at a rally to Refuse Fascism in Union Square, September 5, 2020

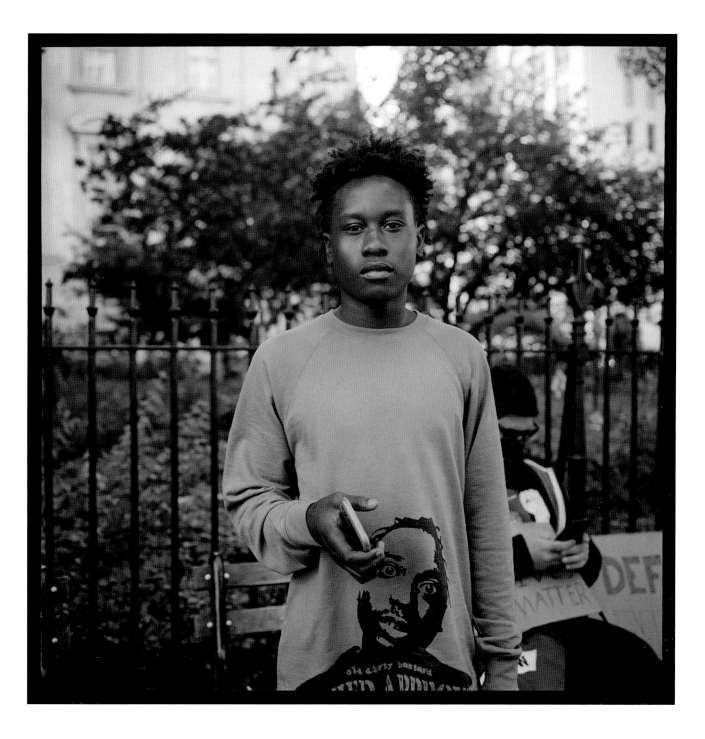

Man at Defund the Police rally in front of City Hall, June 23, 2020

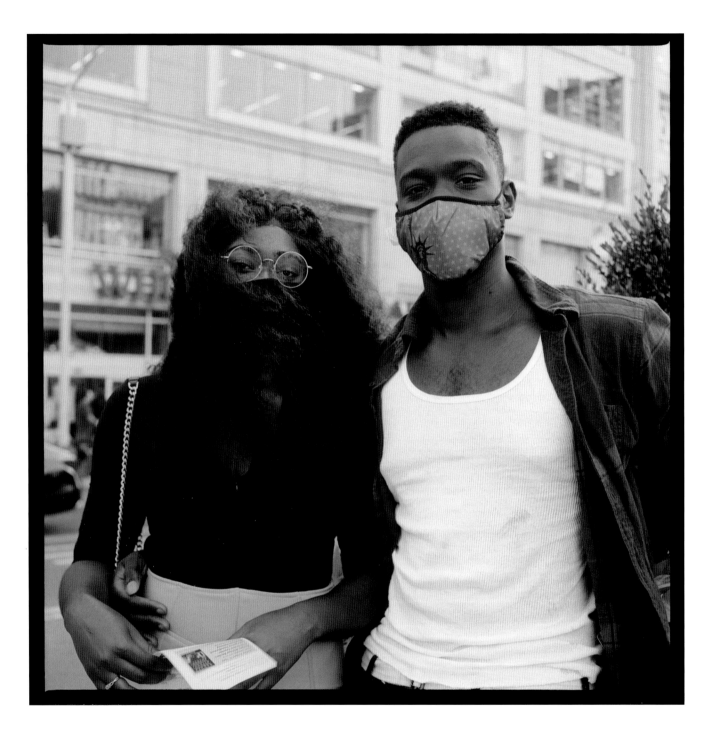

Young couple, at Union Square, protesting Trump and Pence, August 1, 2020

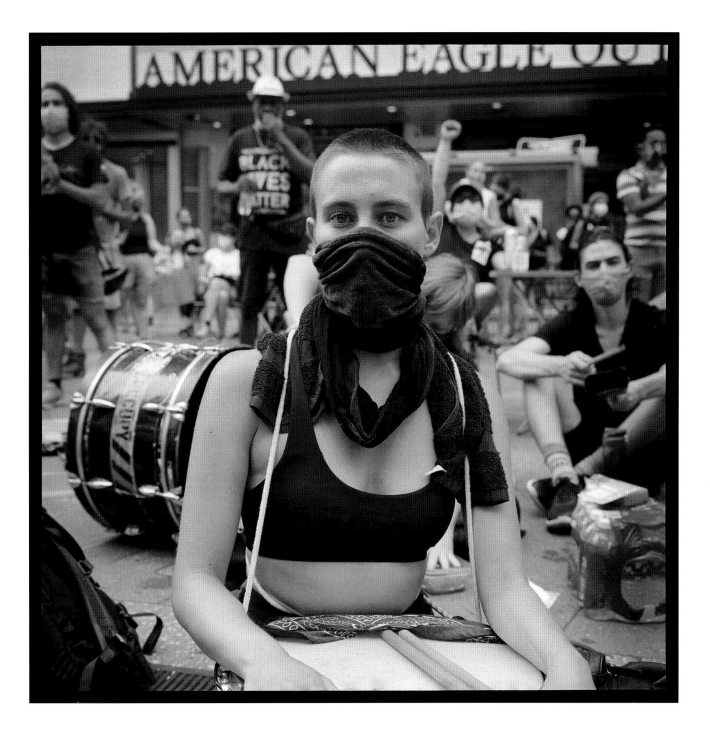

Young woman taking a break at rally in Times Square for Breonna Taylor, August 9, 2020

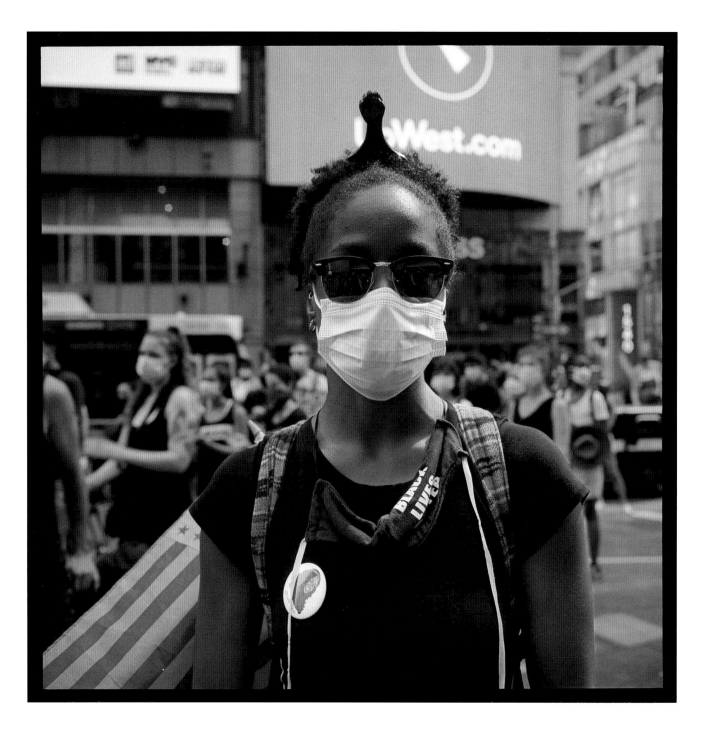

Woman marking 150th day without an arrest for murder of Breonna Taylor, August 9, 2020

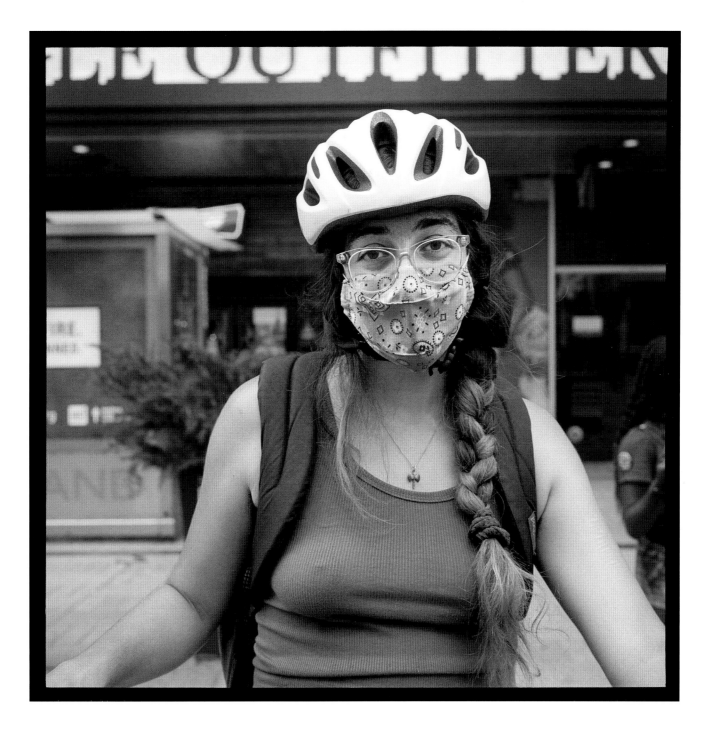

Woman, in Times Square, protesting the murder of Breonna Taylor, August 9, 2020

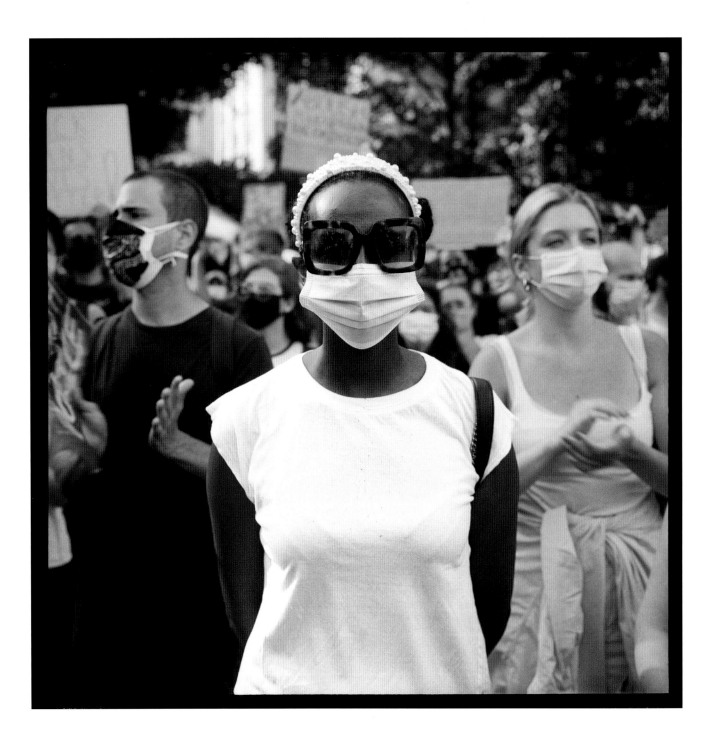

Woman, at City Hall, protesting to defund the police, June 23, 2020

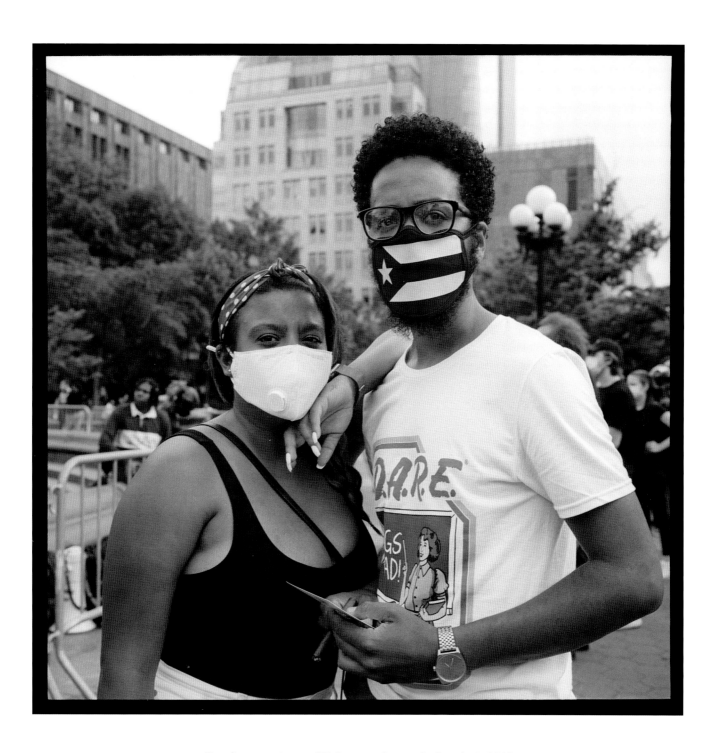

Couple protesting in Washington Square Park, July 7, 2020

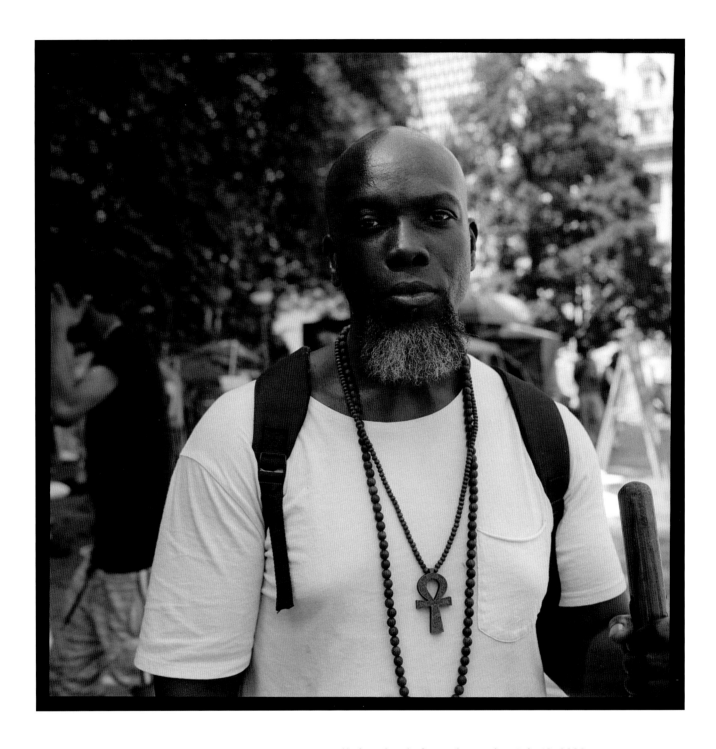

Defund the Police Occupation, City Hall, four days before police end it, July 18, 2020

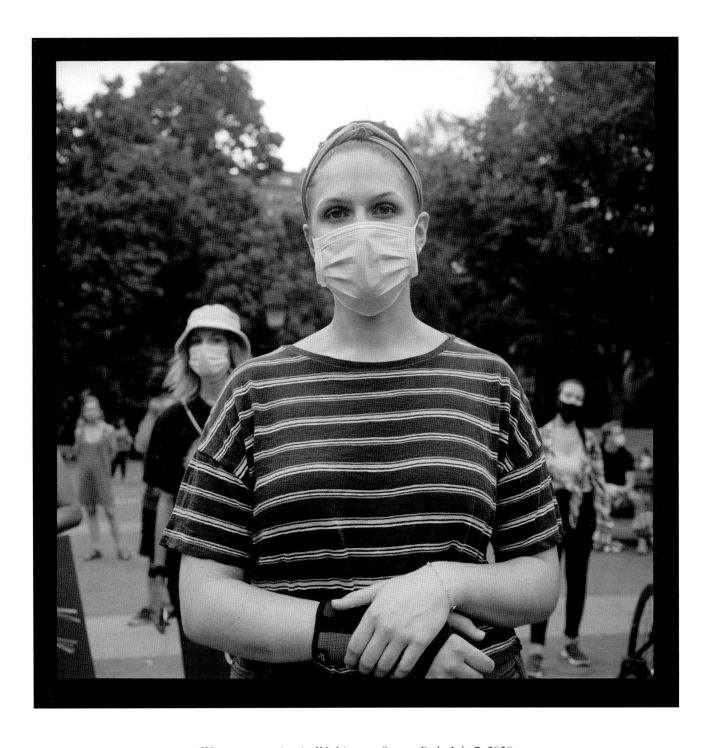

Woman protesting in Washington Square Park, July 7, 2020

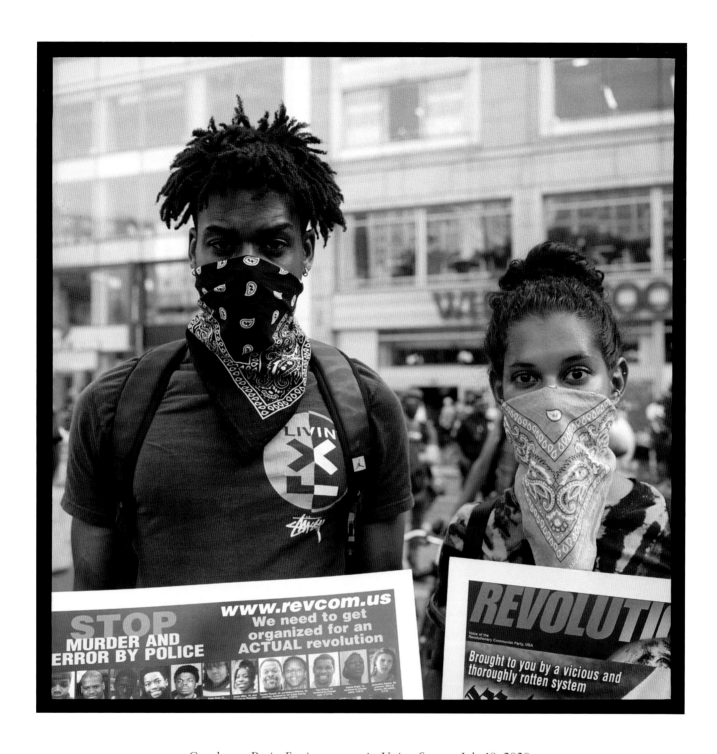

Couple at a Resist Fascism protest in Union Square, July 18, 2020

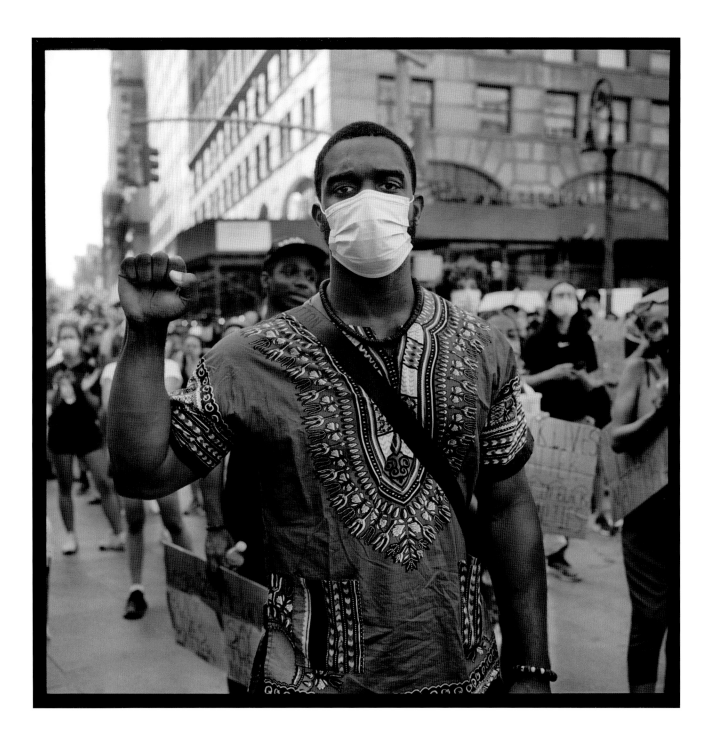

Man at rally for George Floyd, Brooklyn Borough Hall, June 9, 2020

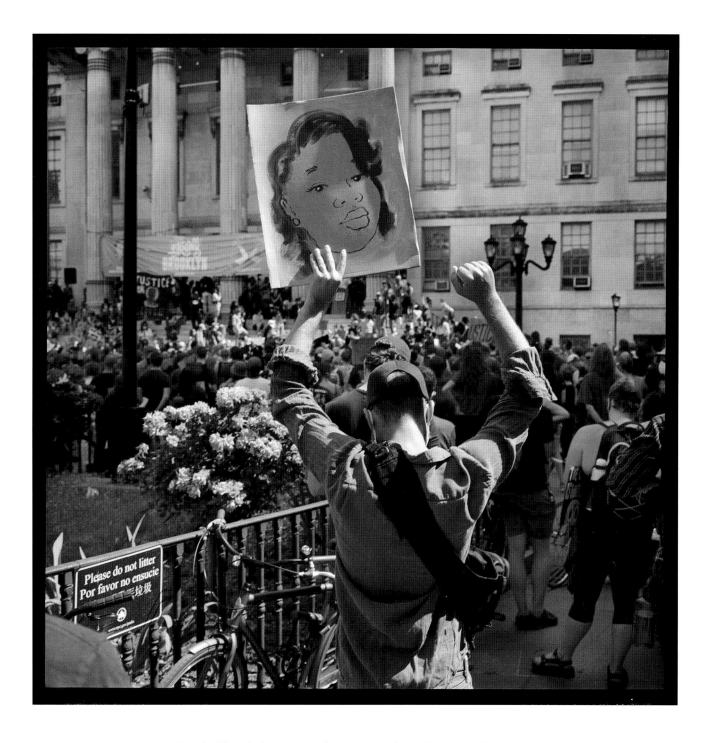

Man with a double-sided painting of Breonna Taylor and George Floyd, June 9, 2020

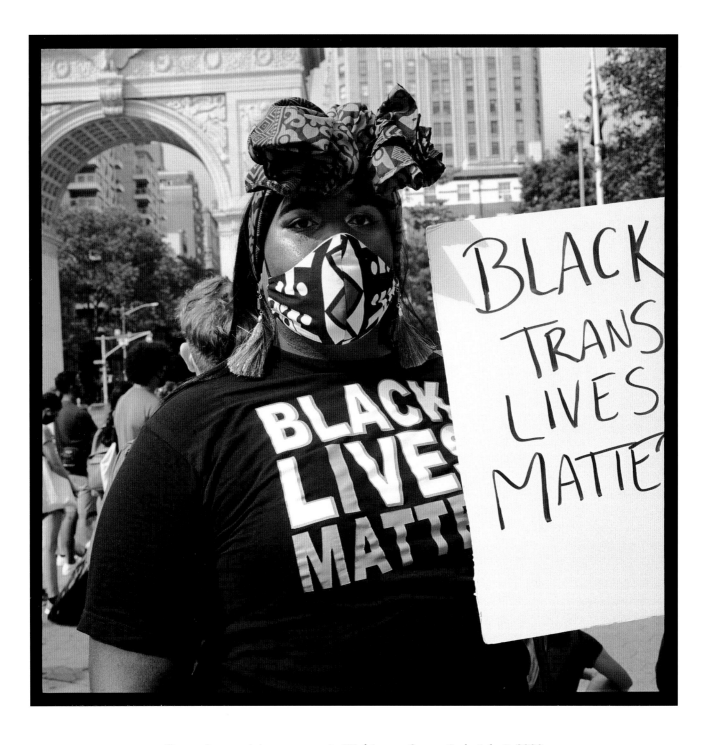

Qween Jean, activist, at protest in Washington Square Park, July 7, 2020

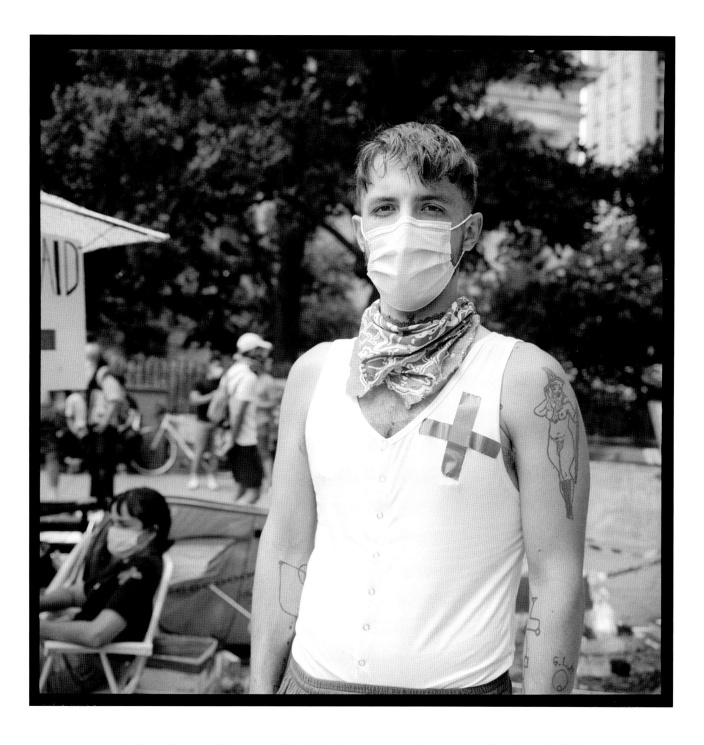

Medic at the second day of the City Hall Occupation to Defund the Police, June 25, 2020

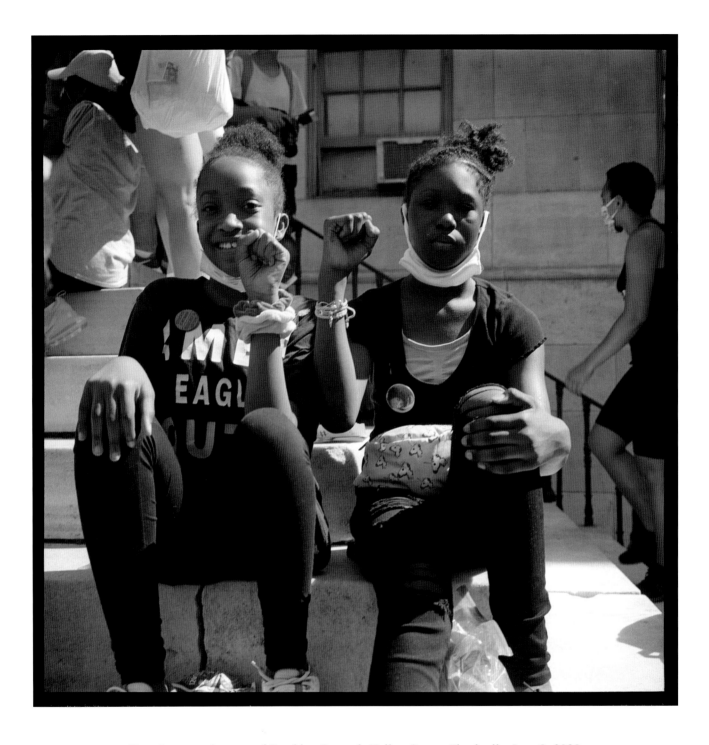

Two sisters on the steps of Brooklyn Borough Hall at George Floyd rally, June 9, 2020

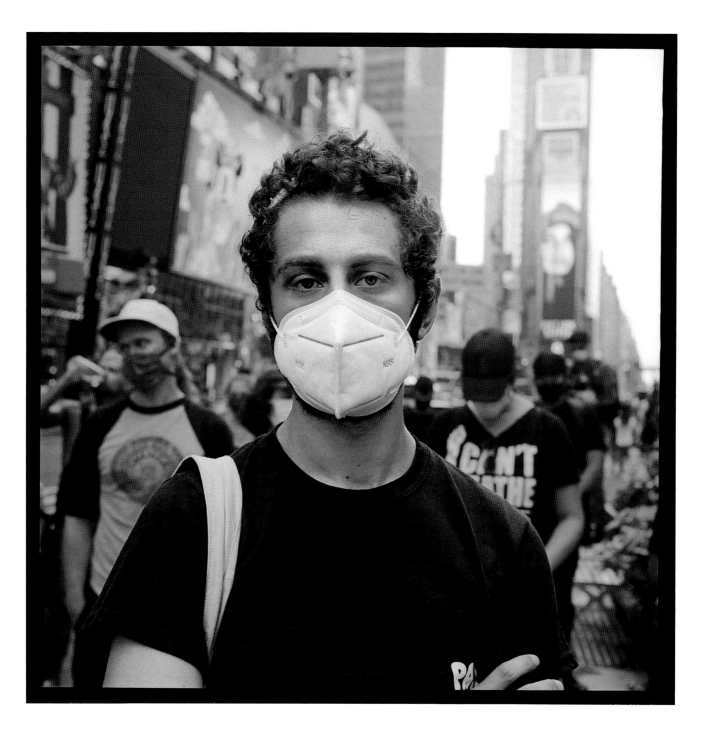

Man in Times Square protesting 150 days without an arrest for Breonna Taylor's murder, August 9, 2020

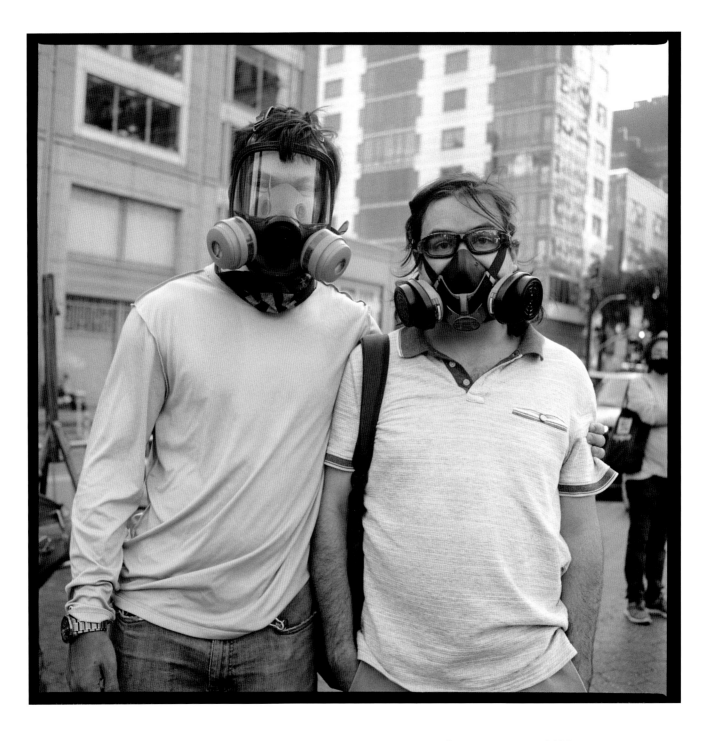

Two friends, in Union Square, protesting against Trump and Pence, August 1, 2020

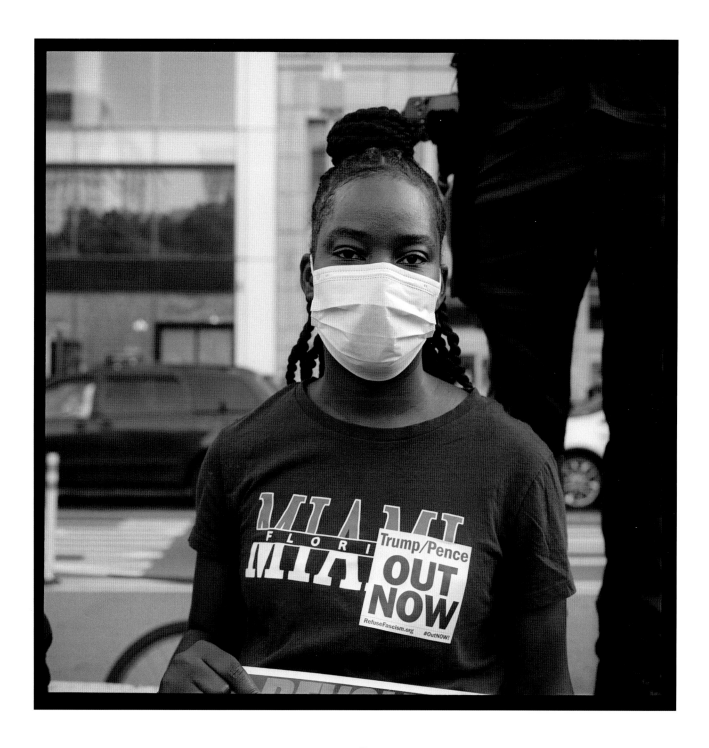

Young woman at a Resist Fascism rally in Union Square, July 17, 2020

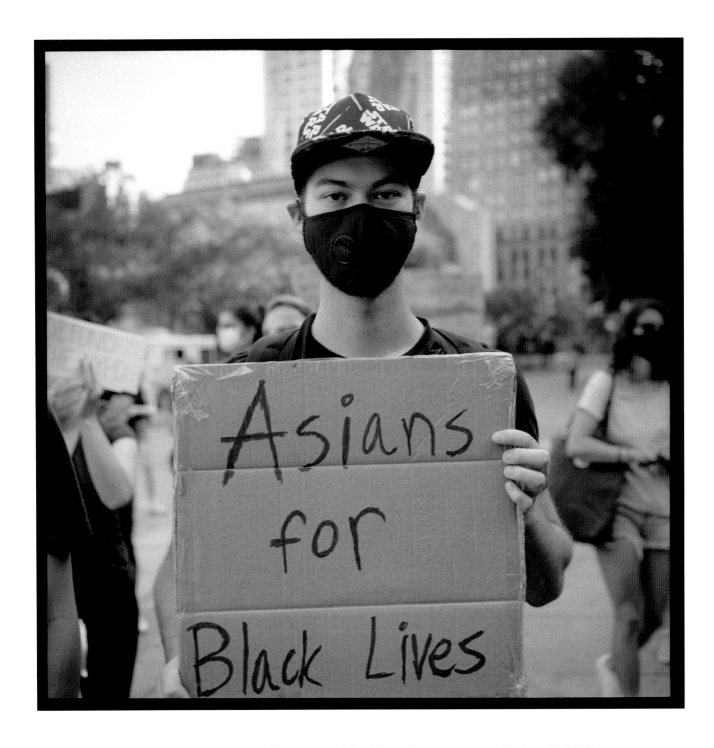

Man showing intersectional support at Defund the Police rally, City Hall, June 23, 2020

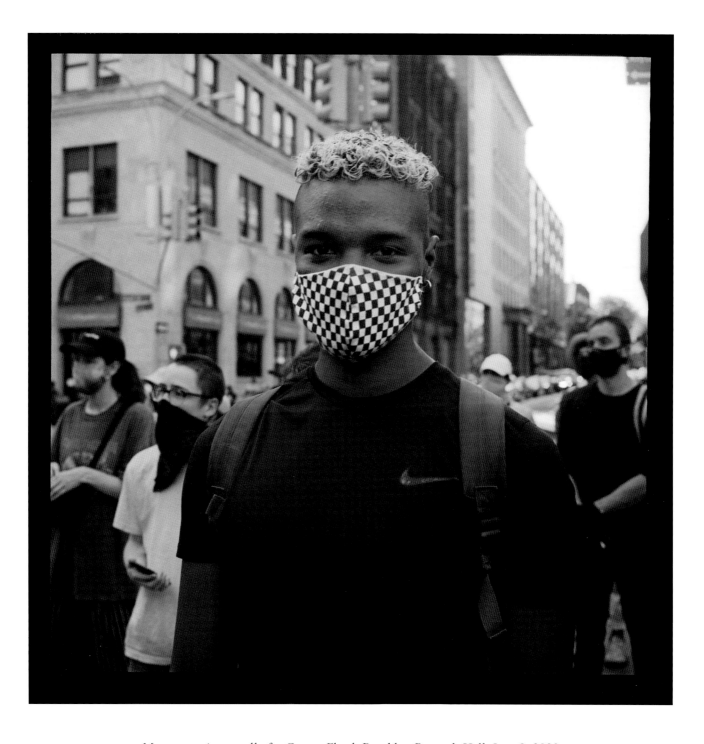

Man protesting at rally for George Floyd, Brooklyn Borough Hall, June 9, 2020

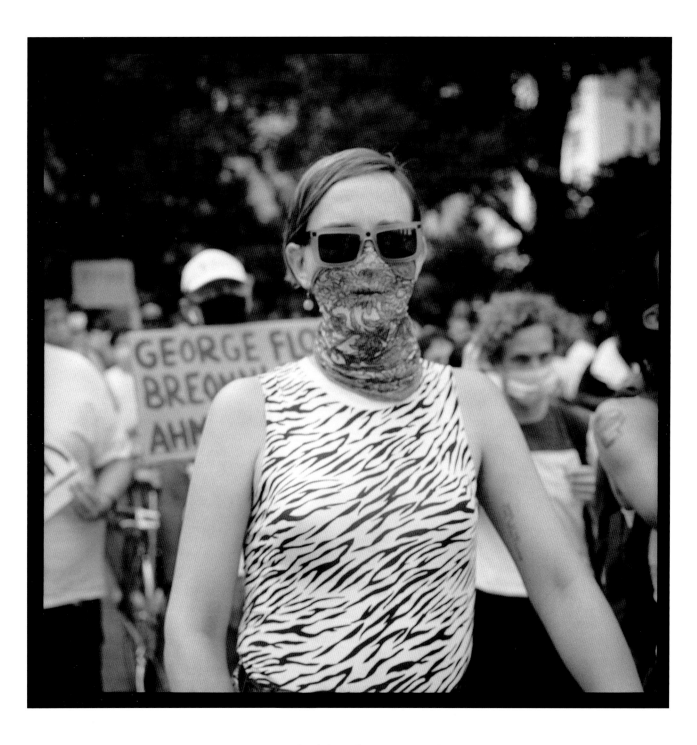

Woman at protest to Defund the Police at City Hall, June 23, 2020

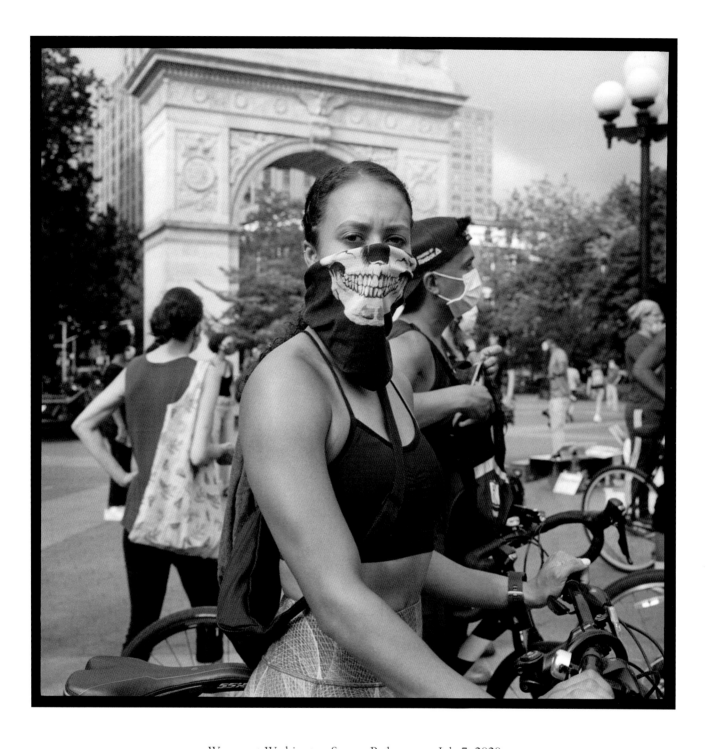

Woman at Washington Square Park protest, July 7, 2020

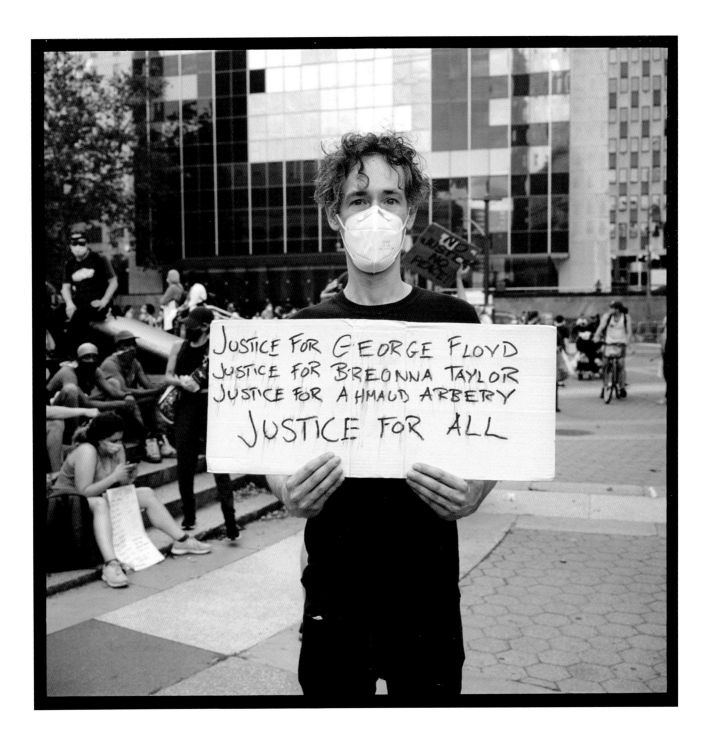

Man calling for justice in Foley Square, June 6, 2020

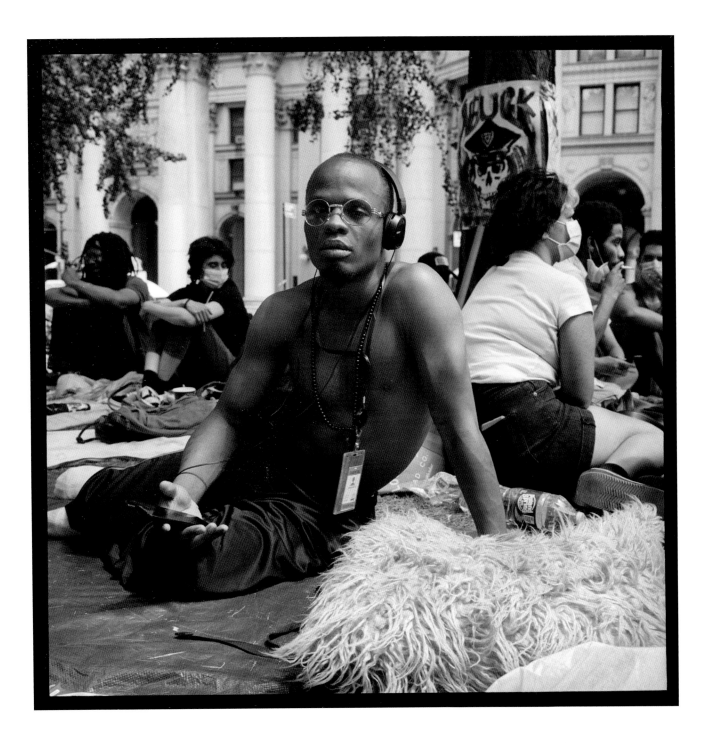

Man at second day of Defund the Police Occupation at City Hall, June 25, 2020

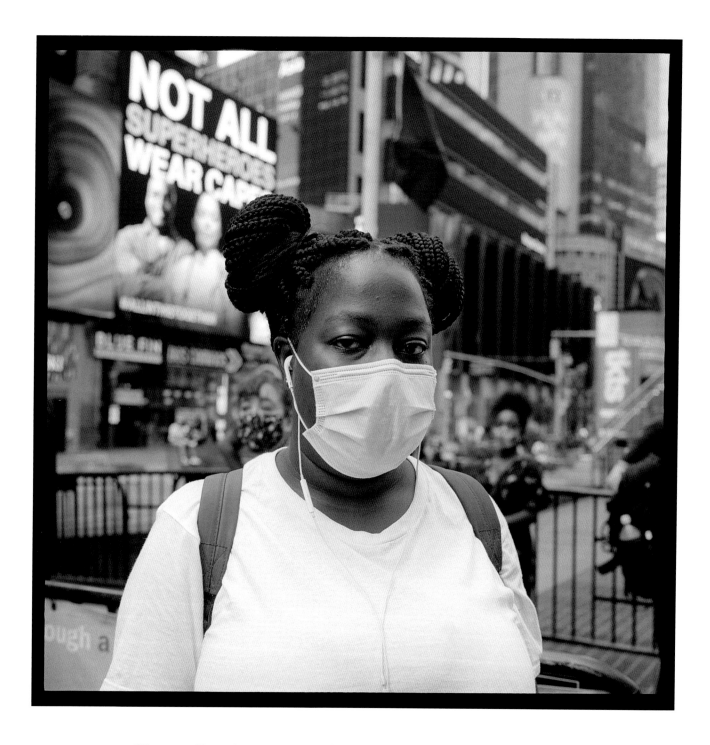

Woman, in Times Square, protesting for justice for Breonna Taylor, August 9, 2020

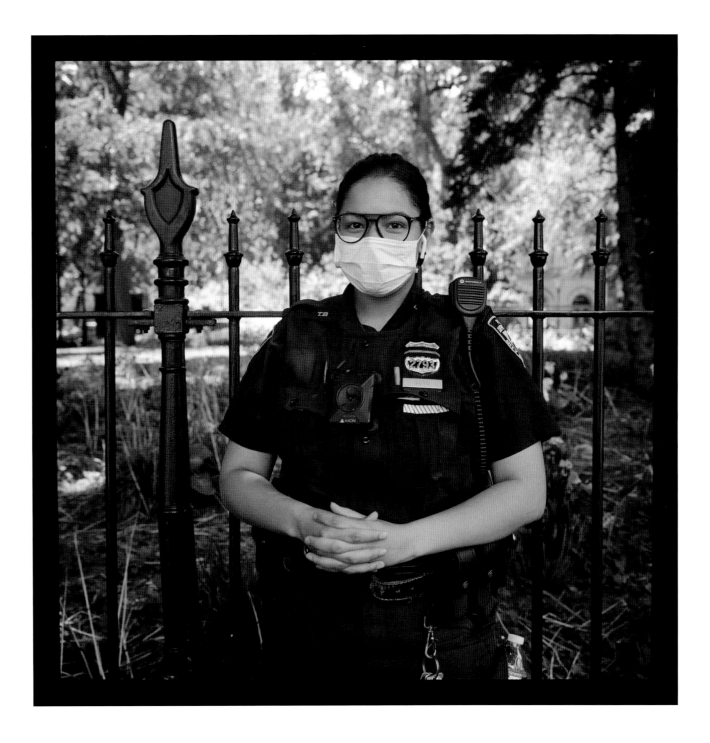

Officer Soto, Transit Bureau, observing Defund the Police rally, City Hall, June 25, 2020

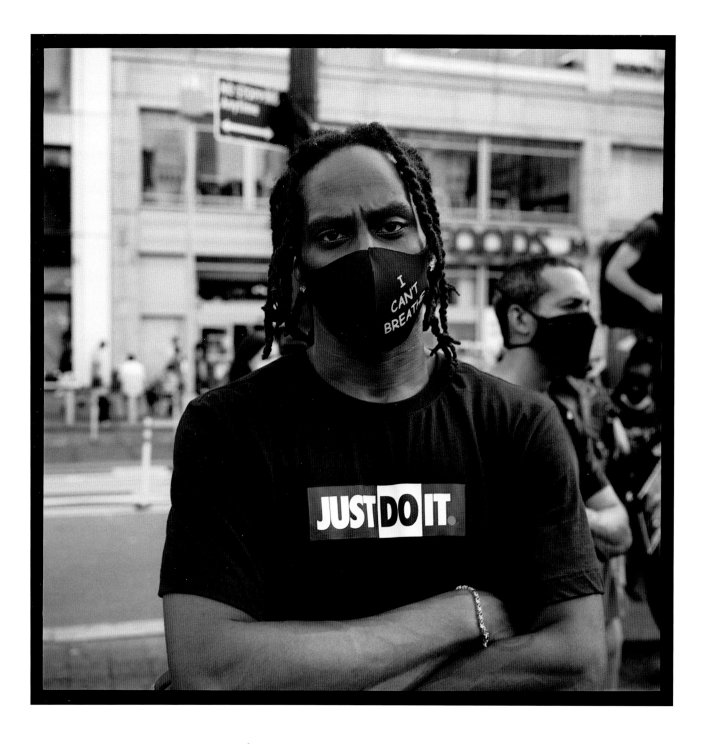

Man at Refuse Fascism protest in Union Square, July 18, 2020

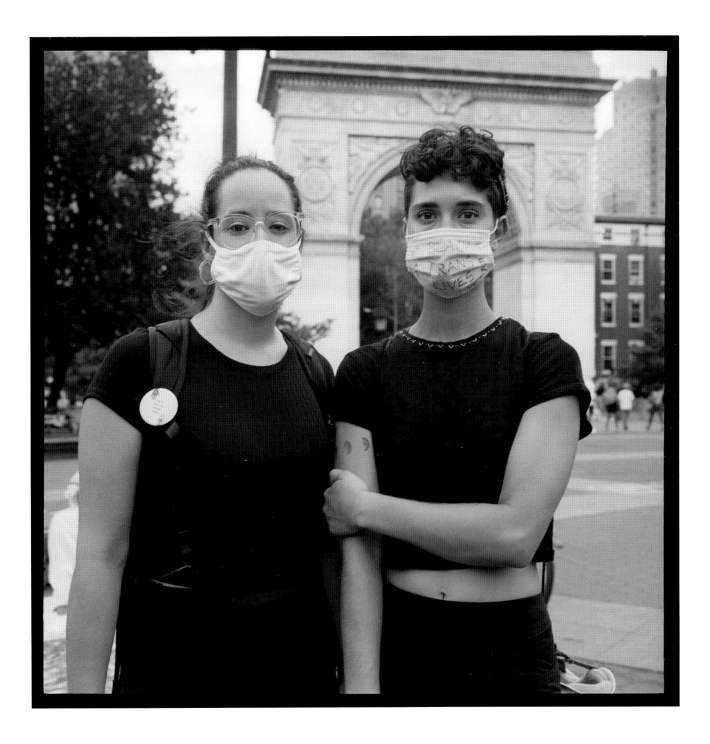

Two friends protesting in Washington Square Park, July 7, 2020

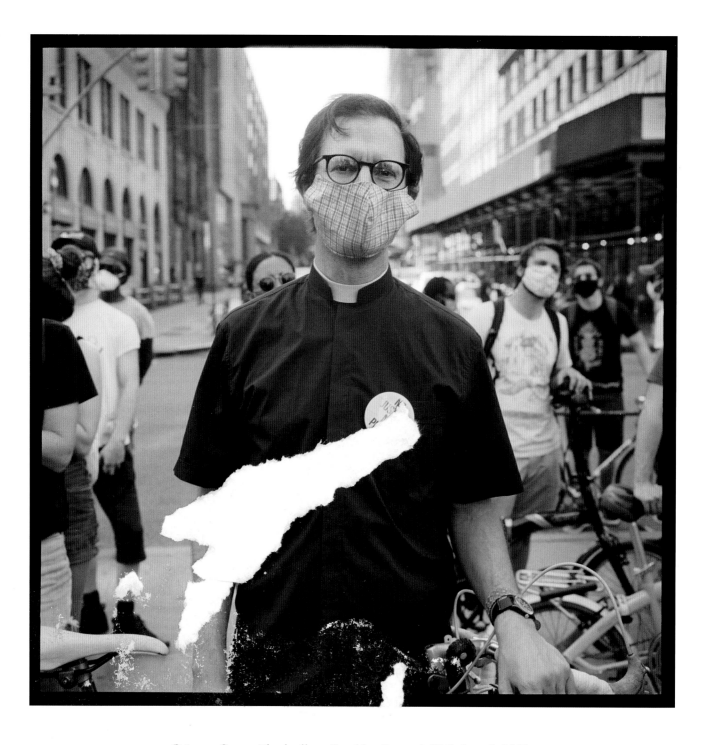

Priest at George Floyd rally at Brooklyn Borough Hall, June 9, 2020

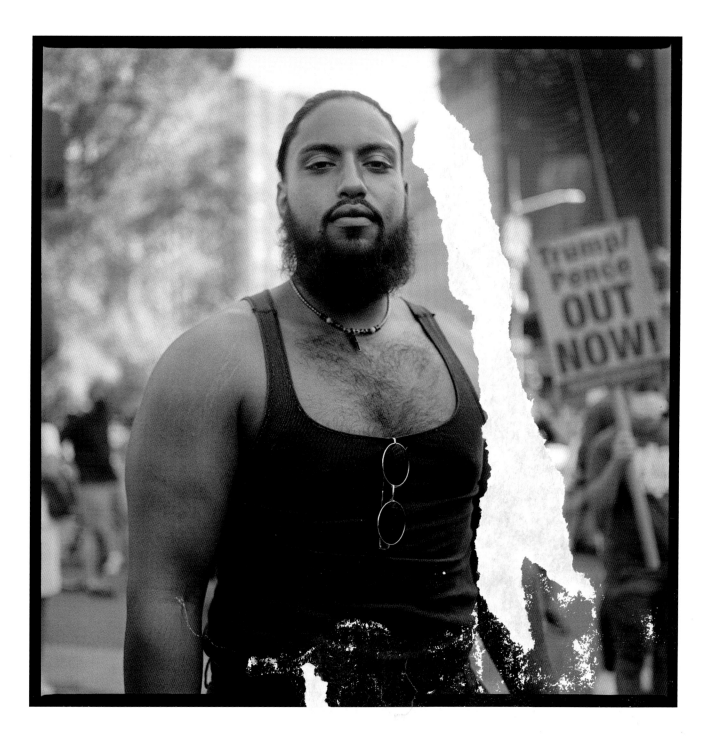

Shaman, activist, at Refuse Fascism rally in Union Square, September 5, 2020

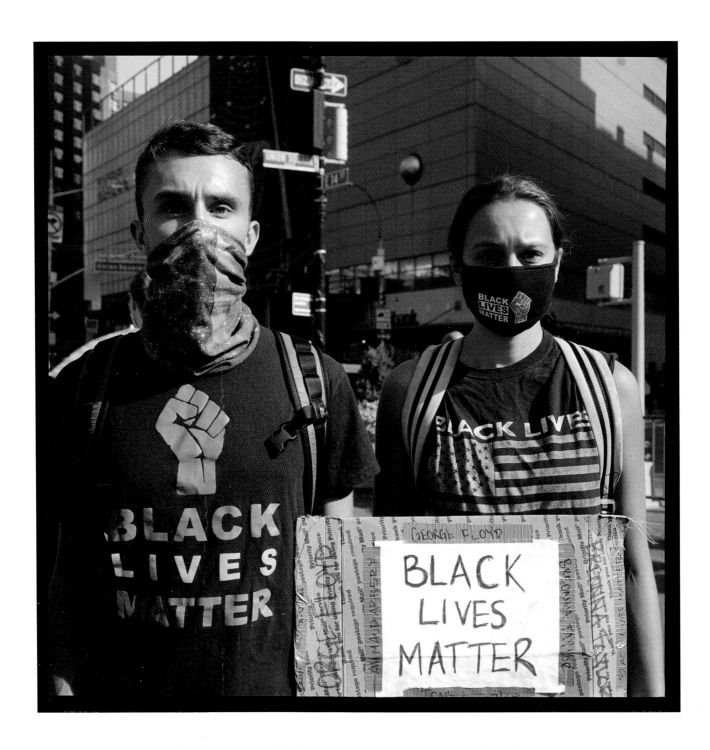

Couple supporting Black Lives Matter in Union Square, July 18, 2020

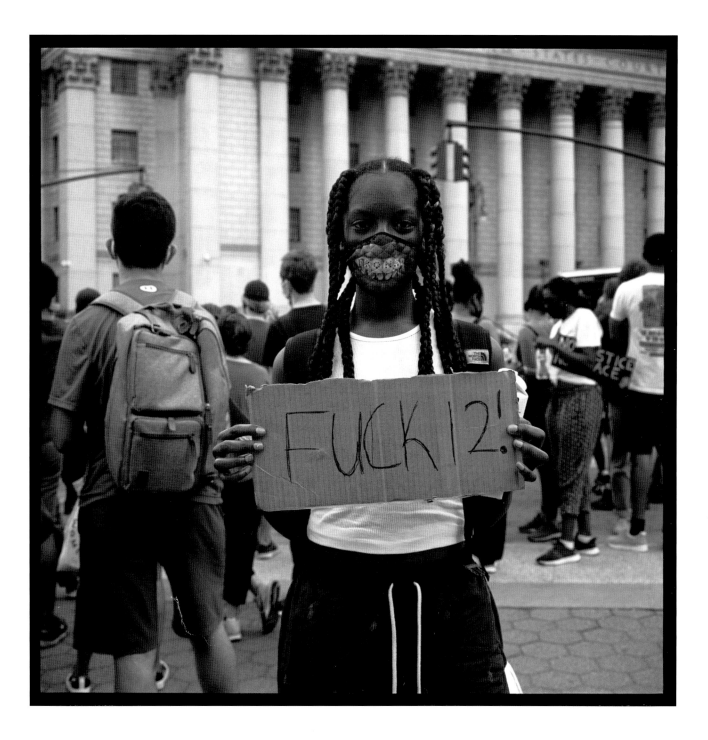

Young woman protesting police violence in Foley Square, June 6, 2020

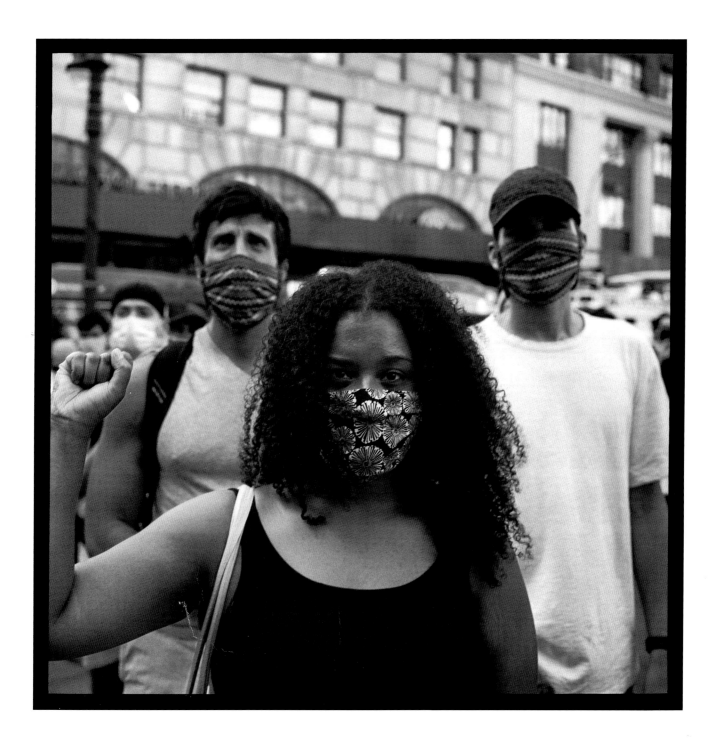

Woman with two friends protesting for George Floyd, Brooklyn Borough Hall, June 9, 2020

ACCRA SHEPP

Accra Shepp was born on the Lower East Side of Manhattan in the midst of the Black Power movement and the cultural change of the 60s. He is a photo-based artist whose work has explored our relationship with the natural environment as in his 2014 solo exhibition at the Queens Museum, which looked at the more than 40 islands making up New York City.

In September of 2011, news of a protest happening on Wall Street drew him to Zuccotti Park, the epicenter of the Occupy Wall Street movement. Immediately struck by the energy and earnestness of the protesters, along with their focus and organization, Shepp decided that he had no choice but to document events as they unfolded.

Nearly a decade later, while under lockdown from the Coronavirus (COVID-19), he began to document the pandemic. Accra's neighborhood was one of the most affected areas in New York City. And over time, as the virus changed, so did its effects within the community. The contagion led to a lockdown, which gave rise to mass unemployment. From the unemployment came hunger, which led to food pantries and food lines. And then it changed again. The murder of George Floyd triggered spontaneous mass protests not just in the United States, but globally. Each of these stages is a section in his latest work *The Covid Journals: Contagion, Hunger, and Justice*. It is selections from this third section, Justice, that serves as the final chapter of this book *Radical Justice: Lifting Every Voice*. Shepp lives and works in New York City.

Acknowledgments

This book would not be possible without the help of my parents, Archie and Garth Shepp who in addition to their love and support, taught me to question and encouraged me to be present. I am also forever grateful to Emmet Gowin whose generosity as an artist helped me become one as well. And my dear friends in the arts, Dawoud Bey, Phyllis Galembo, and Mark Sheinkman, whose fellowship and encouragement created community and were always there to help. And to Christina and Chris, who don't know each other, but both know me, thank you from the bottom of my heart for your help over the years.

SALAMISHAH TILLET

Salamishah Tillet is the Henry Rutgers Professor of African American Studies and Creative Writing and the director of Express Newark, a center for socially engaged art and design, at Rutgers University–Newark. She is a contributing critic-at-large for the *New York Times*, and the author of *Sites of Slavery: Citizenship and Racial Democracy in the Post-Civil Rights Imagination* (2012) and most recently, of *In Search of The Color Purple: The Story of An American Masterpiece* (2021). In 2003, she and Scheherazade Tillet founded A Long Walk Home, an organization that uses art to empower people to end violence against girls and women.